THE UNI
WINC

Moving without a Body

Technologies of Lived Abstraction
Brian Massumi and Erin Manning, editors

Relationscapes: Movement, Art, Philosophy, Erin Manning, 2009

Without Criteria: Kant, Whitehead, Deleuze, and Aesthetics, Steven Shaviro, 2009

Sonic Warfare: Sound, Affect, and the Ecology of Fear, Steve Goodman, 2009

Semblance and Event: Activist Philosophy and the Occurrent Arts, Brian Massumi, 2011

Gilbert Simondon and the Philosophy of the Transindividual, Muriel Combes, translated by Thomas LaMarre, 2012

Contagious Architecture: Computation, Aesthetics, and Space, Luciana Parisi, 2013

Moving without a Body: Digital Philosophy and Choreographic Thoughts, Stamatia Portanova, 2013

Moving without a Body

Digital Philosophy and Choreographic Thoughts

Stamatia Portanova

The MIT Press
Cambridge, Massachusetts
London, England

MIT Press books may be purchased at special quantity discounts for business or sales promotional use. For information, please email special_sales@mitpress.mit.edu or write to Special Sales Department, The MIT Press, 55 Hayward Street, Cambridge, MA 02142.

This book was set in Stone Sans and Stone Serif by the MIT Press. Printed and bound in the United States of America.

Library of Congress Cataloging-in-Publication Data

Portanova, Stamatia, 1974–
Moving without a body : digital philosophy and choreographic thoughts / Stamatia Portanova.
 pages cm. — (Technologies of lived abstraction)
Includes bibliographical references and index.
ISBN 978-0-262-01892-0 (hardcover : alk. paper)
1. Movement (Philosophy) 2. Human body (Philosophy) 3. Choreography—Philosophy. 4. Digital art—Philosophy. I. Title.
B105.M65P67 2013
701'.8—dc23
2012034239

10 9 8 7 6 5 4 3 2 1

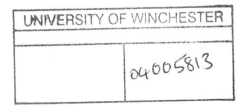

For Gerardo,
whose images move my thoughts

What is human movement in the absence of the body?

—Paul Kaiser

Contents

Series Foreword

"What moves as a body, returns as the movement of thought."

Of subjectivity (in its nascent state)
Of the social (in its mutant state)
Of the environment (at the point it can be reinvented)

"A process set up anywhere reverberates everywhere."

· · · ·

The Technologies of Lived Abstraction book series is dedicated to work of transdisciplinary reach inquiring critically but especially creatively into processes of subjective, social, and ethical-political emergence abroad in the world today. Thought and body, abstract and concrete, local and global, individual and collective: the works presented are not content to rest with the habitual divisions. They explore how these facets come formatively, reverberatively together, if only to form the movement by which they come again to differ.

Possible paradigms are many: autonomization, relation; emergence, complexity, process; individuation, (auto)poiesis; direct perception, embodied perception, perception-as-action; speculative pragmatism, speculative realism, radical empiricism; mediation, virtualization; ecology of practices, media ecology; technicity; micropolitics, biopolitics, ontopower. Yet there will be a common aim: to catch new thought and action dawning, at a creative crossing. Technologies of Lived Abstraction orients to the creativity at this crossing, in virtue of which life everywhere can be considered germinally aesthetic, and the aesthetic anywhere already political.

· · · ·

"Concepts must be experienced. They are lived."

Acknowledgments

I wish to thank Erin Manning and Brian Massumi for many things: for their trust in this project from its initial stages, for their constant support and encouragement, and for their incredible openness and sensitivity toward research-relation. Their precious comments and ideas have been fundamental for the completion of this work. My gratitude also goes to all the friends of the Sense Lab in Montreal, a breeding ground where unique generative practices have provided a challenging and fertile environment for the most abstract concepts of this book.

I am very grateful to the Social Sciences and Humanities Research Council of Canada, for supporting my research and granting me a scholarship that has provided time and space for reflection and writing. And I am also very grateful to Norah Zuniga Shaw, Antonin De Bemels, and Paul Kaiser, for the detailed information and insights on their exciting projects.

Finally, I also wish to thank Luciana Parisi and Steve Goodman for being sources of inspiration, and for nurturing this project with invaluable discussions. My gratitude also goes to Tiziana Terranova, for her friendship, and for her abstract and concrete help. And to Silvana, for having been the first teacher to show me how philosophy becomes life.

My special thanks go to Vincenzo (Al Paçio), Antonio and Sandro (the Lab 12), for being exceptional creative molders and true friends.

I especially wish to thank my family for their unfaltering support and affection.

In particular, I thank my husband Gerardo for his art, for being a partner in life and thought. To him I dedicate this book, and all its future developments.

Introduction: Thinking Choreography Digitally

We move in very abstract times, times overloaded with burning debates about the risks of an economy that has become purely numerical, and of a banking system increasingly reliant on number crunchers and algorithmic models without solid grounds: all that is solid melts in the air, as Marx and Engels reminded us. Even outside the weightless realms of high finance, many forms of physical expression have yielded to the same numerical abstraction, our dancing, playing, even suffering bodies being increasingly supported by the development of digital technologies of all sorts. A few examples: In 2010, the Forsythe Dance Company launched Motion Bank, a web-based project to provide a "context for moving ideas," and for the creation and presentation of "online dance scores."[1] Around the same time but in a different performative field, skateboarder and web designer Tony Hawk produced his new video game Shred, a motion-sensing skateboard/snowboard that (in Wii style) allows players to control the action with their feet in order to perform all sorts of tricks in the game.[2] And also at this time, Ailsa MacKenzie-Summers, a woman suffering from severe leg pains as a result of nerve damage, was equipped with a new pain relief implant using motion-sensing technology to activate, inside her body, a neurostimulator that automatically provides pain relief every time she moves a step.[3]

Based on the same technological ground, diverse domains such as dance, game design, and medical engineering are associated by an overarching idea, a fundamental underlying concept that is inspiring myriad innovative productions: the possibility to capture, store, and manipulate movement, abstracting it from the body and transforming it into numerical information, a data flow that can be used to activate further physical or mental, technical or creative processes. Similar innovations are occurring in other high-tech areas: for example, at home, when a detecting machine senses the presence of a burglar in the living room and switches all lights on, or at work, when another device senses the lack of movement in an office space

and signals it as free to book for a meeting. More and more we find our-selves in abstract environments, where movement has become the object of computers' perceptions, memories, and thoughts.

Nevertheless, the term *abstraction* is not used here simply to indicate the disembodiment provoked by digital technology; many theories and analy-ses have already extensively elaborated on this point. Rather, the notion of abstraction is used throughout this book in a more general philosophi-cal sense, as a way to distinguish the concrete experiences of the physical body from the abstract reality of mental experiences, without erasing their important relation. In *Moving without a Body*, *abstract* is everything that can be "abstracted" from the palpable materiality of the real, such as the pos-sibility of calculating the precise spatial and temporal locations of a body or an object, its reduction to a *datum*. Since, as demonstrated by many after Descartes, no element of our experience can be said to possess this calculable character in itself, we can only arrive at realities—such as pre-cisely located bits of material, or numerically definable entities—through a process of abstraction.[4] The relation between this definition of the abstract and the numerical transformation of reality into bits of information is evi-dent. But numerical technologies certainly do not exhaust the realm of the abstract.

Another clarification concerns digitalization. In this book, the notion of the *digital* coincides with two main senses. The first one indicates the spe-cific machine we define as a computer, a concrete technological application working according to a discrete logic (as opposed to analog technologies); a tool of abstraction. The second one refers to a mode of thought (going beyond the technology) based on formal oppositions; thus, a code (or a way to think) can be defined as digital when it is constituted by *digits*, count-able units that can be related or opposed to each other (not necessarily in a binary way).[5] Although obviously superposable and at times indistinguish-able, the definitions of digital *technology* on one hand, and of digital *code* on the other, will be deployed across this book in order to differentiate the concrete application from its abstract mode of processing, or its tendency toward abstraction.

Returning to our previous examples, the question that comes to mind is what really happens when the physicality of our movements is translated into a numerical code by a technological system (or when this physical-ity becomes *numbers*). The same question has been addressed by theorists, researchers, and practitioners in many fields: can these numbers be accurate enough to represent what we conceive as the plenitude of movement? The book tries to tweak this very concrete representational dilemma, arguing

that the question cannot simply amount to a technical testing of the software in its capacity to efficaciously record motion in the most detailed or nuanced way. In days of intense and pervasive digitalization, the numerification of movement requires a broader thinking, or perhaps a rethinking, of what movement itself is (or what it can become). And it is precisely this rethinking that is at stake here: Can it still be defined or thought as *movement*, when an actual, physical body has been replaced by a string of running data? What happens to the *thought* of movement, when movement is processed by a digital system? We will not start from any particular definition of movement, because the definition of what movement itself can be is the aim of the whole book. But it can be anticipated that the intuitive understanding of movement as a continuity will be displaced: the dissection of this continuity into bits, objects, or steps is not to be considered a retroactive limitation achieved thanks to a preconceived idea in the human mind, but a result of an implicit tendency already present in movement—motion as a multiplicity of potential cuts. And it is in this sense that the notion of abstraction returns: not simply as a dematerialization of physical bodily presence into 0s and 1s, but as a preoccupation for how to think movement in the absence of the moving body.[6] The need to similarly and simultaneously rethink most of our physical and cultural presuppositions makes of our present a very abstract time.

We should emphasize at this point that *Moving without a Body* should not be considered a book about motion capture, or about movement technology in general. While focusing on some examples of the ways in which dancers and choreographers have experimented with technology in various times, it does so only in order to use these examples as points of departure for a more abstract philosophical discussion, and for a consideration of the wider role this form of art can have in the production of new modes of thought today. A certain amount of dialogue with concrete dance/technology practices remains obviously essential. And yet, not being a survey or analysis of the field, and despite their chronological organization, the following pages aspire neither to weave a comprehensive historical account, nor to undertake a faithful technical discussion of the practical functions and results of technological tools for dance.[7] Some of the modalities in which dancers have encountered and experimented with apparatuses of all sorts (motion capture, video, softwares for composition and editing) are referred to, but these references do not simply make of this book a practical investigation. Preoccupations for the chronological newness of these examples, and for providing a description of the latest, most recent developments in the field, are also beyond the aims of this book.

In the same way, the book is not an enthusiastic apology for digitalization, nor does it warn readers about the necessary limits of these cold numerical systems. While it is undeniable that the ubiquity of software applications is generating interesting technical, aesthetic, and cultural effects on our relation with art (and, in particular, with dance, here intended as the becoming art of movement), this is not at all a book about concrete effects. Rather, it is an investigation of some of the conceptual implications deriving from the encounter between certain kinds of movement and certain technological machines, by which philosophy acquires the status of a practice in its own right, a practice of extreme abstraction. It is therefore not as suggestions for a possible design (of movements, of technologies, of the encounter between the two) that the following reflections must first of all be taken, but as reconceptualizations of movement and technology in the digital era. Being already the object of thought for dancers and choreographers, but also for videomakers and programmers, movement could perhaps receive new life in this new philosophical encounter and conceptual metamorphosis.[8]

Many experiments in the dance/technology field have in fact already been thoroughly and cogently analyzed via a series of different philosophical approaches, in which the critical focus has shifted from questions of cultural representation, language, and meaning, to the subjective experience of the body and its capacity to physically explore time and space, a capacity that has been seen as extended and amplified, or disembodied and thwarted, by the technological intervention.[9] In particular, for phenomenological readers, to retain the body as the basis of knowledge and experience means to pay repeated attention to the *I*: the lived experience is always his or her experience, and the approach is always in the first person.[10] An example of this is given by Susan Kozel's phenomenological account of motion capture and dance technologies, in which bodies become sources of intelligence and creativity, and philosophical concepts are always embedded in them.[11] It is a method that is corporeal, fluid, and subjective.[12]

Some of the most recent technical experiments with motion capture in performance art have adopted the same approach, taking the information gathered or "captured" about human movement as a starting point to shape the kind and scope of questions normally associated with technology. This kind of approach (adopted, for example, by Chris Salter's interventions in the field of digital performance art) applies the physical specificity of the body's experience to the design of "more fluid" human-computer interaction environments. In this case, the organic continuity and fluidity of the human movements directs the way in which technology is designed and

experienced. Despite the significance of these examples, what is not provided is a set of alternative concepts that can help us analyze the technology in its more abstract, autonomous conceptual creativity and influence. *Moving without a Body* aspires to complement such approaches by reflecting on the capacity of various technologies (analog as well as digital) not only to affect the way in which movement is performed or perceived, but first and foremost to redesign the way in which it can be thought. The aim is to give to conceptual reflection another capacity: not as an in-depth excavation of subjective, bodily, human experience, but as a superficial abstraction of concepts beyond subjects, humans, and even (human or technological) bodies.

It is also important to note that, although motion capture and other apparatuses of movement detection are present in many other sectors, including installation art, music, sign language analysis, gesture recognition studies, rehabilitation/medicine, biomechanics, special effects for cinema, computer games, simulation, and animation of all types, as well as in military and athletic training, all these would have constituted a too ample landscape for the present discussion. The focus of the book thus purposefully remains restricted to the dance/technology conceptual relation. The scope is not to go from a wider, more general ontology to an epistemological claim: how philosophical concepts become a concrete datum of experience in the external world. Instead, the aim here is to build, from a series of empirical examples, a speculative proposition for a philosophy of movement in the digital age.

A few more remarks are needed to better explain the speculative (rather than technical) character of the book. This speculative aim is no more than the consideration of technologies and dance as ways to think movement. It is the reason why technologies will be intended and described as actual applications of more abstract scientific ideas, while dance will be prevalently of interest in some of its choreographed forms, conceiving choreography as a possibility to abstractly compose, or to give form to, patterns of movement in thought.[13] As such, choreographic thought will also be distinguished from performance, or the physical execution of dance by one or more bodies. A body performs a movement, and a mind thinks or choreographs a dance. What the book is concerned with, therefore, is how to think choreography as a movement-thought. In the same sense, another crucial topic is the shift from an analog to a digital conception (rather than technical realization) of movement: not simply how movement is perceived (through the affectivity of the digital) but how it is thought (through the concept of the digital) under the light of its contemporary transformations.

With all its emphasis on the abstractness of thought, *Moving without a Body* is a speculative, immanent book. No thinker would in fact consider immanence as the erasure of all differences: thinking, it must be said, remains different from physical action; the mind is not the body, although one cannot work without the other, and sometimes they reach a point of indiscernibility. The mind, from this point of view, is not reducible to, or integratable with, sensory experience. On one hand, as Kozel recognizes, "There continues to be a sense that computers . . . engineer a duality between human and computer, material and immaterial, analog and digital, organic and inorganic, and body and mind."[14] On the other hand, it appears that not many accounts of movement, dance, choreography, or performance have managed to recombine the two while preserving their difference, and examples of embodied practice have been praised (as in the case of phenomenology) in clear opposition to the Cartesian detachment of the mind. Even when the intellect is called in, it is more often than not as an embodied mind. And even when the body becomes abstract, it does so while still coinciding with a sensation that is never totally distinguishable from the flesh.[15] In all of these accounts, practices of moving coincide with ways of living, physically performing, and bodily thinking. In a different way, by reevaluating abstraction in its own experiential and intellectual value, this book aims at correcting what seems a continuing imbalance, precisely in order to avoid any form of absolute privilege.

In this landscape, the book does not imply any predominance of either the embodied nature of movement or the abstractness of mental operations, and for this reason it refuses to give ontological precedence to phenomenal materiality; not everything is reducible to the body. Its main purpose is indeed to bypass dualism, but it acknowledges that one of the most fruitful ways to do this is by avoiding the equation of immanence with undifferentiation, and by trying to speak up for a tendency that, in post-Platonic and post-Cartesian times, has been overlooked and lost: the tendency toward *thought* as the most abstract moment of experience. For this reason, abstraction cannot simply be equated with the effect of digital technology: computers also have their bodies and minds, as concrete applications and as ideas.

One might describe the book, then, as an investigation into thought and its relation to movement. This exploration finds one of its main philosophical referents in Gilles Deleuze's endeavor to address the question of *what forces us to think*. In line with Deleuze, it is possible to recur to a notion of the *sensible* (or that which can only be sensed, that which brings sensibility to its nth, or transcendental, dimension) as the transsensorial

origin of thought. This notion is associated by Deleuze to that of the *idea*, as "something which is communicated from one faculty to another, but it is metamorphosed and does not form a common sense. We could just as well say that there are Ideas which traverse all the faculties, but are the object of none in particular."[16] In Deleuze's definition, the Idea, the object of a transcendental sensibility, also has a capacity of making "thinking, speaking, imagining, feeling, etc.," or all of the faculties, "one and the same thing," while paradoxically affirming their divergence.

At the same time, the question of how to think movement imposes new points of view on the problem of the Idea and its recurrence throughout all the faculties of the mind. One of these viewpoints is movement as the object of a transcendental sensibility: movement as an idea that can only be sensed, a *sentiendum*, or a pure aesthetic object. Following Deleuze's system, we see how this *sentiendum* is also always connected to a *phantasteon* and a *memorandum*, or respectively what can only be imagined and what can only be remembered, movement as the object of imagination and memory in their most transcendental exercise. Finally, the third characteristic of this transcendental exercise of the faculties coincides with the grasping, by *pure* thought, of that which can only be thought, or a *cogitandum*, the intelligible in movement. Here, as Deleuze states, "Rather than all the faculties converging and contributing to a common project of recognizing an object [for us, movement], we see divergent projects in which, with regard to what concerns it essentially, each faculty is in the presence of that which is its 'own.'"[17] In the readaptation of this project to a philosophy of movement, thought (for us choreographic thought) is considered the common transcendental denominator of the faculties: that which makes perception become imagination, that which transforms imagination into memory, and that which makes of memory pure thought. At the same time, dance is considered the object of the three transcendental faculties: that which can only be imagined, remembered, and thought, in and of a sensed movement, with examples of video, motion capture, and choreographic software as the concrete technologies associated with these abstract faculties.

The structure of this book is woven across three main threads: philosophy, technology, and dance. Or, more specifically, the book follows a tripartite path: (1) the development of different audiovisual tools, and the shift from analog to digital devices, with a focus on the consequent changes provoked by this shift in the conception of movement; (2) a description of some choreographic realizations accompanying these technical developments; and (3) the presentation of some philosophical concepts to analyze these experiments. These threads form three different, and at times

separate, readings, whose fragmented and alternated presences aim at making the book into the object of three main interests. In particular, the last thread also makes of the whole book a philosophical exploration of the *radically empirical* theories of Gilles Deleuze and Alfred North Whitehead, focusing on their converging but also diverging views, and on their respective conceptualizations of movement and thought.[18] This kaleidoscopic reading is associated with an articulated structure that, beyond its division and subdivision into main parts (I, II, II) and chapters (binarily numbered), divides the text into several *units of sense*, each unit being the coagulation of a technology and a choreography around a concept. It is hoped that a series of nodal thoughts will emerge, conceptual trajectories originating from but also deviating, converging and digressing from the actual choreographies and technologies, exploring the abstract pragmatics of the choreography-technology relation, the way in which it is sometimes thought and, even more importantly, the way in which *it can think*.

Technologies as Ideas

The first proposition of this book is therefore that a technical application can be considered as an idea: not an idea *in someone's mind*, but an idea *in matter*.[19] This nonsubjective notion of the idea indeed coincides with the same kind of *reverse* Platonism that founds both Whitehead's and Deleuze's philosophies, a Platonism that retains the important conception of a transcendental level of experience, while discarding all subjective and moral value attributed to it.[20] Our discussion of the digital will therefore start from a main presupposition: that the creativity of digital technology derives from the abstract but very peculiar potentiality that stands behind its materiality, namely the idea to cut things (into bits, pixels, points, or dots) and recombine them, ad infinitum. As Gregory Chaitin puts it, the "computer as an idea," or a tendency of the mind to think digitally.[21] Following this presupposition, *Moving without a Body* analyzes different technologies, but only to conceive them as concrete examples of analog or digital ideas. Rather than merely studying technical digitalization, the book therefore places computers and software side by side with older forms of technicity: sometimes digital videos sharing the same analog idea of a short film of the 1940s, sometimes dance notation techniques dating back to the seventeenth century and appearing as the precursors of contemporary software.

A second presupposition is that the running of the computer program does not constitute the *virtuality* of the digital, but only its *actualization*. Brian Massumi has defined virtuality as the abstract character of every

material body, its openness to an elsewhere and otherwise than it is.[22] In movement, this virtual openness can only be paradoxically sensed and thought as the body's possibility to reach the Earth's center, or to fall into its orbit. Captured between the law of gravity and the discipline of upright balance, a step is always accompanied by a sort of virtual resonance, always diffracted into myriad moments of centrifugal escape. These almost unnoticed transitional moments unveil in a glimpse the capacity of the dancing body to swerve between sky and earth, or its indecision between flying and falling. These apparently impossible virtual moves from the Earth's surface draw an abstract but nevertheless real diagram (that can be, for example, thought in relation to Bergson's theory of matter as the continuity of all movements): a molecular continuum linking all bodies, even planetary and subterranean ones, and thus extending the limited frame of the human body into earth and air. As an imperceptible suspension, the virtual coexists with the actuality of the movement, revealing the simultaneous concreteness and abstractness of dance, every displacement doubling itself into an incorporeal dimension of bodily potential, every perceived performance redoubling itself into a sensation and a thought. We can conclude that, for Massumi, the virtuality of a moving body coincides with its not being present in a fixed position or point but only in passage, with that moment of instantaneous emergence when infinite potentials arise and disappear, like the crest of a wave.[23]

Moving without a Body proposes a definition of the virtual as an incorporeal potential for variation: for example, in both technological and choreographic terms, the virtual can be thought as the unlimited potential that every numerical bit of a program, or every experiential bit of a dance (every gesture and step), has to change and be something else. But differently from Massumi's approach, this unlimited potentiality or infinitely multiple condition of experience is not equatable with any sensed or material continuity.

We will at this point reproduce Deleuze's affirmation that "the virtual is structure": all the elements and relations that form a structure are virtual, the structure constituting the complete determination of every object or process, a reality totally different from the concrete physical consistency of those objects and processes.[24] As shown by José Gil, every gestural unit is an aggregate of many microgestures, and presupposes multiple articulations of heterogeneous elements imbricated into each other (for example, the imperceptible movements of toes, ankles, knees, and legs as the different microscopic elements that compose a jump).[25] The superposition of all the micro and macro gestures a body *could* activate gives us the virtual structure

of its movements. This virtuality implies thinking the body as a structured map of all the possible (and impossible) articulations that are implicit in its composition, juxtaposing all the separate levels and systems of anatomy (skeletal, muscular, nervous, etc.), and drawing across these the complex plane of all the multiple, coexistent, sometimes incongruent vectors or tendencies. In this map, the simultaneous performance of a backward and forward movement would be contained as real, as well as the 360-degree rotation of the neck: a virtually real possibility, the extreme magnetic pole determining the various degrees of rotation that each different body can actually reach by stretching itself. It is by virtue of the attraction of these virtual coordinates, which can only be abstractly thought, that the verisimilitude of the actual is generated.

This unlimited potential of the moving body, it has been argued, cannot be reduced to the limited organizable alternatives calculated by a computer program: the digital is not virtual, but a simple arraying of "alternative states for sequencing into alternative routines," i.e., *possibility*.[26] The following discussion will try to unravel the noncoincidence as well as the productive relation that can be established between digitalization (a limited grid of possible alternative states) and virtuality (the infinite and open structure of potential moves). For this purpose, this book will unveil the virtuality that is implicit in some digital applications, by revealing the abstract modes of thought hidden behind their concrete ways of functioning: it will, in other words, try to formulate the principles of a radically empirical digital philosophy.

Philosophies as Methods

The book explores Whitehead's theory of extension, a method of scientific/philosophical reflection, as the most relevant thought for a philosophical redefinition of the digital. But what is extension, and how can we adopt this thought as a method of analysis and theorization?

Extension (or "extensive connection") was described by Whitehead as the relation existing between all physical entities (for example, between the moving bodies on a stage as the actual entities, or "occasions of experience," analyzed by the technology of motion capture).[27] In mathematical terms, extension can be described as the systematic divisibility of the world into *wholes* and *parts*: extensive relations are the relations through which an entity becomes (or does not become) part of another.

At the same time, the notion of extension is inextricably coupled to that of "prehension": in every actual occasion of experience (such as a step, or

the thought of a step), an object is prehended by a subject.[28] It is important to note here the nonanthropomorphic nature of prehension as a nonhuman affective response and as the immanent affective ground of all physical and conceptual experiences: the stone prehends the water it falls into.[29] Every step prehends the other, and can never be physically separated from the other. At the same time, prehension also defines a relation with and between ideas (or the "eternal objects" of philosophy, such as a discrete and a continuous conception of movement). At this point, we can draw a conceptual association between prehensions and extensive connections. This association allows us, in Whitehead's terms, to understand the relations of reciprocal inclusion/exclusion (or negative/positive prehension) existing between individual bodies or between individuated ideas: in this sense, both bodies and ideas come to form serial systems of overlapping wholes and parts included or excluded by each other.[30]

In light of this thought, the philosophy of extension as a method becomes a way to abstract the wholes and parts, the physical bodies and the abstract ideas, the concrete and eternal objects of every occasion of experience, together with their relations. As an analytical method, extension is thus adopted in this book to constitute an *abstractive perspective* on the analyzed examples, proposing the possibility of a simultaneous exclusion/inclusion between concepts, choreographic ideas (as ways to think movement), and technologies (as ways to think the whole world) as separate but interrelating entities.

Instead of constituting a physically embodied or kinesthetic perspective on the choreographic/technological encounter, extensive abstraction provides a sort of detached, separate, or divided point of view that immediately presents itself as diametrically opposed to phenomenological observation.[31] It is indeed an experience, but one in which the body is not the only source. At the same time, an abstractive perspective does not coincide with the illusion of an *objective external eye*. In relation to the methodology as well as the style of these pages, it is to be recognized that every form of writing refers to a lived experience of some sort.[32] But the point of view from which observation originates is not fully equatable with the subjective experience of the writer; rather, it coincides with a sort of ideal mediator internal to the field: a concept or, in Deleuze and Guattari's words, a "conceptual character." It is the concept that observes. This formation is similar and parallel to the "partial observer" of science, the latter being an entity introduced by the two philosophers in order to abolish the illusion of the objective external eye, without recurring to an embodied subject of the enunciation. The main example is that of perspective, a scientific methodology that consists

in the placing of a partial observer at the vertex of a cone, an eye that is able to grasp contours without at the same time perceiving the qualities of a surface (which in their turn indicate a different position of the observer). The observer, in this case, is thus neither objective nor subjective.[33] *Moving without a Body* installs at the focus of its reflections a series of conceptual observers: concepts observing the technology/choreography relation, in order to grasp from it abstract forms and contours.

And yet, as a method, extension also presents itself as quite different from Deleuze and Guattari's conceptualization of philosophy as an *intensive* practice of derealization, a practice in which the connections, rather than the discontinuities, between entities are emphasized. This difference has here been carefully thought as an exigency of our times. As Steven Shaviro very importantly remarks about Deleuze and Guattari's philosophical method, "The question that haunts [us] today is whether such strategies of derealization are still practicable, in a time when negation and counter-actualization have themselves become resources for the extraction of surplus value."[34] Or when, in other words, counteractualization, as the intensification of life and the blurring of all boundaries in the name of connection, has become the key word and strategy in capitalism's chaotic use of technology.

Differently from Shaviro, the response to this impasse will be sought not by converting Whitehead's philosophical system into the foundation of a new postmodernism (a philosophy of fluid affective relations "without criteria") but by performing a recombination between intensity and extensity, or between the necessity of bodily affective continuities and ideal conceptual clarity.[35] According to Shaviro, Whitehead's philosophical theory is a constructivist system based on the nonexistence of foundations, with an ontological emphasis on Becoming rather than Being. This is a different reading from the one proposed in this book, in which the necessity to reestablish new (immanent) foundations, and to reaffirm the coexistence of Becoming with Being, of discrete rationalizations and continuous affects, becomes a conceptual necessity in the reading both of the American philosopher's work and of our own times.

Choreographies as Examples

In many contemporary explorative and creative projects, the main problematic idea associated with digital technology remains how to analyze and reproduce the external shape, as well as the internal nature, of a gesture.[36] One of the main answers often provided to this dilemma is the inescapable difficulty, if not impossibility, of "dealing with a phenomenon which is

indisputable but which nonetheless cannot be grasped, either in the sense of comprehended or physically captured: movement in the form of dance."[37] Relegated to the double status of tool for physical capture and mental comprehension, technology is confronted with the same impossible task: how to make stable, understandable, or cognizable something that is not.[38]

By affirming the difference and the interrelation between the undecipherable continuity of movement and the clear discreteness of steps (or between body and mind), the book suggests a Spinozan consideration of movement and dance as two aspects of the same event: a body is felt as moving, this event constituting the uncapturable and untranslatable experience of movement as a sensation; and a body is thought of as dancing.[39] The consequent notions of body and mind that emerge from this relation follow Spinoza's distinction between "extension" and "thought" as two attributes of the same substance. Spinoza's concept, however, is here reformulated from the point of view of Whitehead's terminology, in which extension is not the materiality of the body but a way to think it, and therefore a mode of thought, corresponding to the atomicity of matter: extension as a thought that is in matter, different from its fluid continuity.[40]

The specificity of a dancing body therefore starts to appear in thought: rather than considering choreography as a previous or successive moment of appropriation forcing the body to adapt itself and its mysterious forces to the structures of thought, it is in thought that a movement, with both its qualitative and quantitative aspects, with its fluidity and extension in space and time, becomes a dance. It is the reason why a flock of birds, or a queue of cars, can sometimes be defined as dancing, whereas many stage performances can easily fail this definition, depending on whether they are thought as choreographed. And it is the reason why this book has chosen choreography as one of the most interesting examples of how the same event can be two things at the same time: every street passerby can indeed appear as a dancing body, when it is thought as such.

We have now arrived at a definition of dance as a movement form deriving from the mode of thought of an expressive medium (the choreographic mind), whereas movement is, from this point of view, a body's mode of action. The specific mode of thought of a medium, or its capacity to elaborate ideas, appears through its automatisms or, in other words, through the processes of automatic reproduction that constitute its *code*. It is only through repetition that the virtual openness of ideas can emerge. And it is through rehearsal, as a form of bodily repetition, that the choreographic ideas of the mind are actualized. Coded repetition and creative ideas compose, in their alternation, two different modes of thought. Complex

articulations are, for example, often performed by a trained body in the spaces and times of the everyday: gestures such as the geometric flexing of an ankle or the improbable rotation of the hips required in order to enter and move on a crowded pavement can appear as a dance, and a sort of microchoreography emerges in the encounter between physical anatomy, everyday habit (or trained technique), and the conditions or constraints of the external environment. What is at stake is not a question of who, what, or where a mind (or a dance) can be, in opposition or relation to a body (or a movement), but simply the basic fact of their ontological difference. The metamorphosis from a simple pavement walk into a dance is an event of the mind.

Merce Cunningham's choreographic practice is, for example, one of the most philosophical and scientific, abstract and rational (or "mental"), of the arts. This practice is based on a main choreographic idea of disarticulation, such as when his dancers' bodies are required to move from *whiplash fouetté* to *penchée arabesque* without evident transition or continuity. The digital choreography (or choreography through software) realized by Cunningham appears as an example of how the conversion of movement into numerical data transforms it into an apparently fluid sequence of bits that does not logically suggest or require the necessity of cuts: on the screen, movements can be performed with no spatial or temporal limit. Or even better, it is not that the cut disappears; rather, the cut becomes arbitrary, while the impression of movement's continuity is paradoxically accentuated. Take, for example, the choreography of the performance *Polarity* (1990): the computer is evidently used for the creation of legs, arms, and torso movements that are totally autonomous of one another, reflecting the choreographer's tendency to think the body as an aggregate of disconnected parts. The *organic* experience of the pavement's walk, with its twists and turns dictated by the environment and its landmarks, is replaced here by the sensation of movement as a continuity potentially divisible ad infinitum: an extensive continuum. Not being a critical exploration of dance but a philosophical discussion of movements and technologies, *Moving without a Body* does not aim at expressing the feelings experienced when performing such movements, and neither does it aspire to go from a comprehension of these movements to a more general clarification and understanding of choreography as an art form, or to a more sophisticated understanding of the technologies as tools.[41] Rather, the aim is simply to see how the idea of the *cut* can articulate a choreographic thought.

What the book finally aspires to offer its readers is the analysis of some examples of choreographic technology under the light of a radically

empirical thought, and the proposition of a digital philosophy of movement. The digital, in this sense, becomes first of all an event of thought: not a simple hardware/software application, but a complex and visionary mathematical way to think. In the same way, choreography simultaneously appears as a way to scientifically and creatively think movement beyond the application of bodily techniques on stage: gestures and steps are repositioned in the realm of what can be numerically composed.

I Imag(in)ing the Dance: Choreo-nexus

A material body is not merely a mechanical device for the execution of tasks; it is also the technical or technological realization of an imaginary idea. The idea, as an object of the imagination, is simply the way in which the mind *imag(in)es* or enriches the world with a new image. The image does not emerge from the void but is cut out of reality, its originality consisting in the newness of the cut, which is shaped by the idea. As a capacity for *imaging* (or contributing a new image to) the existing world, imagination is not only or not prevalently human, but a capacity for cutting that is a prerogative of all bodies. Or even better, of all minds. The idea is what, imaginatively, bridges from the body to the mind.

Computers, from this point of view, realize the idea of dividing objects and events into discrete units, compressing the complexity of the world into a series of algorithmic strings or instructions expressed in the same discrete language. The algorithm as a discrete world image is in fact much older than computers, and appeared before digital processors came to light. It is, as information theory has explained, a mode of imagination that could be attributed to all material, organic, and even human entities: nature as an imaginative programmer that computes the universe through a precise algorithm.[1] From the same point of view, we can think of dance as the execution of a movement algorithm in space and time. Even the simplest physical operation, such as raising a hand or rotating a foot, is persistently echoed by an image, the concept of what the gesture will be (in the immediately preceding past of the performance) and of what it was (in the immediately following future). The thought of the gesture is not to be considered here as a transcendental script directing the movement a priori, or reflecting it a posteriori. It is more like an idea regenerating itself alongside the body's displacement, as if the body-mind was imaging movement, not in discrete bits but in gestures. Passing through the pattern of its own gestures, the body-mind weaves an image not *of* but *in* the world. Abstracting

this image as a pattern of gestures and steps is what allows movement to be perceived as dance.

The principal choreographic images of classical ballet (such as *arabesque*, the "sculpture-like pose on one leg, with the working leg extended to the back and the arms complementing the line") are ideal images: "No one has ever done arabesque; they've passed through an approximation of it. Arabesque will always remain primarily a prescription, an ideal."[2] Thus, passing through an arabesque becomes for a dancer what executing an algorithm is for a computer: the gesture, in the words of choreographer William Forsythe, not as a simple task but as an equation to be solved by innumerable bodies-minds in innumerable forms.

Between the empirical profundity of its contents and the seductive superficiality of its forms, the image enriches perception with the possibility of finding an original solution to the enigmatic complexity of the real, or of creating rather than simply observing and describing things: in order to be perceived, images have first of all to be imagined. Whitehead based his whole scientifico-philosophical speculations on this capacity for imagination, for him a method that, "like the flight of an aeroplane . . . starts from the ground of particular observation; . . . makes a flight in the thin air of imaginative generalization; and . . . again lands for renewed observation."[3] In this way, imagination "supplies the differences which the direct observation lacks. It can even play with inconsistency; and can thus throw light on the consistent, and persistent, elements in experience."[4] In the same way, Deleuze and Guattari, the philosophers of aesthetic imagination, shared Nietzsche's fascination for the capacity of examples to seduce the senses before convincing the mind. This part of the book will explore some examples of how videochoreography imagines movement as dance, trying to adopt a split visual focus rather than an immersed kinesthetic perception, in order to abstract the conceptual axes around which the examples seem to rotate.

How can an image be defined as digital? Take Antonin De Bemels's video *Light Body Corpuscles* (2005, dancers Melanie Munt and Ugo Dehaes): ethereal light particles dance against a black background. Gradually, the particles grow and become human body parts. The outlines of two whole figures begin to emerge: a man and a woman convulsively alternate on the screen, until they suddenly fuse into one, still body. For the whole duration of the sequence, our perception is deceived and confused: How many different dancers can we distinguish in the dark? One, a couple, an infinity? And how many angles/positions/frames have been really used in the video? Should we not perhaps stop counting and let ourselves be simply

seduced by what we see and hear? In the end, what we are left with is only the qualitative intensity of an image, one indivisible occasion of audiovisual experience fluidly mutating and becoming *with* us. Even in relation to a proliferating digital image, the question of quantification, of counting, immediately seems badly posed and out of place: numbers are certainly not the real point here, or in any other aesthetic discussion. Or are they?

Digital Affectivity . . .

In the last century, images of dancers have scattered and multiplied across many analog and digital screens, realizing a performative/audiovisual form of artistic expression alternatively defined as *dance for the camera, video-dance*, or *dance on screen*.[5] But even when the video technology becomes a very complex and sophisticated digital apparatus, it is generally believed that our way to aesthetically (and philosophically) relate to it goes through the qualitative resonance of its perceptual effects rather than, for example, through its computing capacities.

And yet digital technology, differently from analog, is absolutely numerical, not only in the algorithmic functioning of the software, but also in the imaginative logics it often elicits: the digital stroboscopic technique used by De Bemels for the production of *Light Body Corpuscles*, for example, is based on the juxtaposition of different layers (or shots) in the editing program, and on a simple operation of mathematical montage between them. The whole sequence is composed of four juxtaposed layers whose frames are selected according to a mathematical principle. The result is a stroboscopic discontinuity and alternation of frames/figures/movements at variable pace.

Nevertheless, the perception of the bodily movements unraveling on the screen inevitably leaves us with the impression of a continuous and almost ungraspable, indivisible qualitative experience.[6] From this point of view, it has been recognized that even the cold nature of technology can reveal signs of aliveness and affective potential, thanks to the capacity of perception to transform a series of bits into a folding of sensations. In Steven Shaviro's words, for example, the critique of cinema and, more generally, of all audiovisual arts can only be founded on Deleuze and Guattari's aesthetics of sensation, and on their proposition that *sentio* precedes *cogito* (and, consequently, also *numero*) in all of our aesthetic experiences.[7] This conceptualization seems to allow for a recuperation of the quantitative nature of digital technology, transforming it into a further qualitative element influencing the perceptual process: "Nothing is purely digital," Shaviro

argues. "Digitisation may, to some extent, be 'felt' on a nonconscious level, because of the way digital images seem to have less depth, and a somewhat lesser tonal range of color. . . . Not to mention all the sorts of special effects, involving lighting, image transitions, motion smear, juxtapositions of images, and dividing the screen into multiple windows, that are basically dependent on digital technology (even though they can sometimes be replaced by analog means): these are definitely different *agencements* of the visual and sonic field."[8] The presence of numbers, or digital bits, is somehow felt, or experienced, through its effects.[9]

At this juncture, the fundamental critical point implied by Shaviro's affective theory seems to be the necessity of redefining the *sentio* beyond human subjectivity, and also beyond the phenomenological universality of an organic sensibility: thinking feeling as a "non-conscious perception [that] may, with a certain amount of ingenuity, be argued to apply to nonorganic matter."[10] At the same time, this redefinition of feeling could undergo a further widening/contraction, one that could allow us to include in its experiential range not only the inorganic but also an infinite and infinitely minute, elastic, and abstract matter such as *number*.[11] Can numbers be felt? Luciana Parisi argues that, rather than having to go through their qualitative transduction into colors and sounds, the abstract numbers of the digital "are indirectly felt as conceptual contagions . . . conceptually felt but not directly sensed."[12] Let us see how.

. . . or Digital Definition?

According to Valentina Valentini, the phenomenal difference between a live dance performance and a screen-mediated image dissolves under the light of a unique *mise en scène* realized by both the human and its technological double, as the staging of a concrete perceptual reality.[13] Our initial question therefore makes a 360-degree turn, shifting to the opposite point of view: not how to relate the alive and the digital on a common affective platform, but how to distinguish them, how to specifically identify the different images appearing to our perception as live or on screen, through analog or through digital technologies, once their common luminous and acoustic dimensions have been recognized. At the same time, this question would also require that we overcome the limited range of a medium-specific determinism through a more speculative criterion that can help us to define the specificity of each particular apparatus as the concrete actualization of an abstract idea.

0 To Perceive Is to Abstract

Diagram

One of the most original ideas emerging from Deleuze's thought is the conjunction of the conceptual experience of philosophy with the audiovisual experience of cinema, a parallel woven through a series of different connections: between the concept of the image and the image as a cinematic sensation, but also between a human image and the image as function of a perceiving/thinking camera.[1] Directors and cameras, in other words, have first of all to imagine, and then create, reality through moving images. From the same point of view, another interesting parallel is drawn by Deleuze between the invention of cinema at the beginning of the twentieth century, and the simultaneous conception of a modern choreography, intended not as a form composable from preexisting immobile poses (such as with ballet), but as a complex and continuous movement infinitely decomposable into "mobile sections," or images.[2]

Already implicit in the mathematics of differential calculus (introduced in the seventeenth century by Leibniz and Newton), the scientific analysis of movement as a juxtaposition of infinitely approximating sections was physically reanimated and concretized at the end of the nineteenth century by James Clerk Maxwell, with his description of light as a series of infinitesimal shifts undergone by an electromagnetic wave. In the same period, cinematic and choreographic experiments were like the different practical confirmations of a basic principle: the possibility to decompose and abstract movement in its internal "instants-whatever," rather than to construct it from a series of external, preexisting poses or steps. In this sense, the technology of cinema starts to acquire an aesthetic as well as a philosophical value, by virtue of the *abstractive* (or *extractive*) capacity that it shares with perception and language, and with philosophy itself, the latter intended as an abstraction of concepts from the phenomenal experience of the world.

Technology and the human, perception and thought seem to be recoupled, this time not only in the name of their common material ground, but also under the common denominator of their similar propensity for abstraction.

Loie Fuller's performances were among the first dance events to be filmed by pioneer inventors of the cinematograph, from Thomas Edison to Georges Méliès, from the Lumière brothers to Pathé.[3] Her revolutionary practice consisted in manipulating a circle of silk panels worn from the neck: through the rotation of two rods extending from her arms, she was able to create a twisting line of winding fabric, at the same time combining the effect of her moving multicolored veils with those of stage light. Movement was thus staged as a luminous continuity of electromagnetic particles, a flow of polychromatic light perceptually divisible into successive figures: the woman, the flower, the butterfly.

But can we really define Fuller's *Serpentine Dance* (1892) as a dance image? Her performances highlight the nature of movement as an infinitely decomposable continuity: almost no identifiable human body, almost no distinguishable choreographic pattern, appears on the stage, but only a multicolored wave progressively and indiscernibly morphing into innumerable shapes. While several readings have interpreted Fuller's practice as the example of a particular choreographic style, this practice somehow seems to escape the definition of choreography adopted in this book: the

Figure 1
Loie Fuller, *Serpentine Dance* (dir. Auguste and Louis Lumière, 1892).

composition of dance as a pattern or a form in thought.[4] Or rather, it represents a peculiar realization of this definition, one in which the form has not fully determined its own difference, its "presence and precision," from the continuities of matter: a continuous process of formation, rather than a form.[5] Her performance thus very closely resembles the flowing frames of early cinema, a flow in which no narrative scheme or montage editing yet appears, but only a frenetic succession of stills: Loie is perceived, or sensed, as moving, but can she be thought as dancing on the screen? Her motion is not really cut in any part, but potentially cuttable at any of its immanent points. Not the absence of choreographic imagination, but a choreographic imagination in germ, in potential, appears in these first steps of the choreographic-cinematic apparatus, exposing a light matter that already seems to magnetically attract an infinity of possible cuts and recombinations.

In "The Geology of Morals," the chapter of *A Thousand Plateaus* that constitutes the most detailed presentation of their methodology of abstract materialism, Deleuze and Guattari introduce the notion of "matter" as a continuity of intensities (or a plane of consistency) that goes across all physical, organic, and human formations; a continuum with no orders of magnitude, scales, or distances, no distinction between the natural and the artificial, no discreteness or discernment of shapes and figures.[6] This material flow is not totally chaotic but follows its own logic: a material logic that is revealed by cinema with a fascinating clarity.

The technology of cinema is in fact apparently dependent on a rigid hylomorphic model of predetermined photographic capture: in this model, a preexisting reality (for example, a dancing body) imposes its form to mold a sensitive film and cut the cinematic frame.[7] In fact, every mold hides an active modulation: you do not have to think of a passive matter waiting to be shaped and cut by a dancer, a camera, and a director, but a dimension, already present in matter, of "pure qualities" (or "intensities") with their own tendency to materialize (or to acquire certain consistencies), and a dimension of "pure numbers" (or "tensors") with their own tendency to take form.[8] Qualities and quantities ("traits of content" and "traits of expression") already constitute an immanent material "diagram" from which images are cut: the capacity for imagination is thus implicit in matter. Matter, in other words, already contains in itself all the qualities and forms, all the luminosities and sonicities, of cinema. It is in this sense that Deleuze and Guattari can found their critique of the hylomorphic model on the existence of a qualitative dimension proper to all materials, but also on the movements of "a number unto itself," an autonomous organization or an intensive quantification occurring before the emerging of any consciously

countable quantity or measurable size. Their terminology implicitly conveys the sense of a matter that, before any transcendental calculation by a godlike director/creator or by a mechanical apparatus, distributes its own properties, dividing and relating its own qualities according to an implicit number that does not correspond to any external superimposed measure.[9]

This conceptualization allows us not only to identify qualities (for example, frequency and speed) as the immanent properties of the material wave of light, but also to individuate a corresponding level of implicit quantities and forms (different combinations of light/shade, gradations of nuance/definition) as the potential events of distribution and disposition of these properties. Invisibility and visibility of bodies, degrees of darkness and luminosity, shade and contrast, precision of contour and modulation of nuance, constitute the intensive numerical events that distribute the qualities of light. Matter and form, light and image, become in this sense two thresholds of a qualitative and numerical modulation. Filmmaker and camera enter the process (for example, through the organization of reflected light by a lens with a specifically chosen focal length, through the registration of a material duration by a shutter with a particular selected speed, or through the reaction of photosensitive chemicals to light for a determined amount of time): technical and human processes following a capacity to perceive images that is already in matter. It is this logic of a material diagram, before any technical or physical, psychological or cultural determination, that is concretized by the machinic assemblage of Fuller's cinematic images, by abstracting luminosities, or perceptual forms, from the movement of the dancer.

According to Deleuze, a visible form does not correspond to the form of an object or a body, but to a form of luminosity that allows the body to exist as a flash, a scintillation or, in other words, a sensation.[10] The confrontation of these flashes generates the structure of an image, as based, for example, on contrasts of darkness and light.[11] The plane of intensive consistency of light's continuum is infinitely traceable, or abstractable, into images as objects of perception. But how are images defined by perception?

The actual dimension of separate, identifiable, perceivable bodies, things or objects—what Deleuze and Guattari call "strata"—is therefore ultimately connected to an intensive material diagram of sounds and lights. At the same time, this intricate entanglement between the intensive/extensive dimensions of matter is mirrored by a third, immanent virtual field that does not entirely coincide with the physical. More precisely, we can say that the gradations of darkness and light in film are inseparable from the composition of actual images, forms, or figures, but they also correspond

to another, more abstract diagram, a series of virtual entities or ideas. From this concrete/abstract diagram of sensations and ideas, perception abstracts its images of the world. Traveling at the speed of thought, ideas do not preexist but emerge in the microscopic fissures that open in the subject, in its tools, and in their relation, pure virtualities to be differently experienced, actualized, and expressed. The expression of ideas happens at the intersection of action and abstraction. Ideas, in other words, can only be generated and imagined when the aspiration to thought (the human dreamer) encounters material re-action (the mechanical automaton), by always maintaining a sort of acrobatically balanced, metastable composition of body and mind.

Deleuze and Guattari identify the most important and difficult outcome of art with the capacity to grasp the volatile, acrobatic fugacity of ideas and bend with them the concreteness of matter, abstracting from it an image-body that can "stand on its own feet."[12] For the philosophers, there is an abstract possibility that is not related to physical possibility but to imagination, an unlikely possibility that gives the most acrobatic postures of body and mind the strength to be abstractly balanced. This imaginative geometry sustains itself entirely on an idea, or a differential of thought.[13] As an example of this conception, the artistic definition of movement as dance can be thought as an effort to modulate, to surrender to, but also to bend, the limits of anatomical principles, through the daring abstractness of an idea.

Scientific disciplines such as anatomy and neurophysiology express movement as the predictable and clearly delimited spatial displacement of a body on a geometric plane, from one position/pose to another. In fact, it has been argued that every gesture can already be seen as a multiplicity or a swarm: a gesture is always an aggregate of microgestures. These interrelated microgestures are like myriad potential ideas allowing the moving body to be imagined as articulated in a very complex way, an almost infinitely divisible and combinable body that is very different from that of the everyday. Dance itself is nothing but a model, a diagram of these ideas. In the same way, the abstract differential idea of cinema corresponds to an abstract divisibility and relationality of visions and sounds, or of movements, to the form of a separation and the pattern of a connection, which is different (but also dependent on) the physical succession of the cinematic frames. These forms and patterns, these separations and connections, only seem to appear in germinal form in Fuller's experimental images, in which the qualitative and quantitative diagram of matter, its pure intensities and numbers, emerges with its still pure, undivided potential.

Knowledge

The cinematic idea can therefore be thought as the form of a moving image or, in other words, a "bloc" of space-time, a "locus" of simultaneous occasions united by a particular spatiotemporal relation.[14] In order to understand spatiotemporal simultaneity in cinema, we can draw a techno-scientific link, and connect the appearance of montage with the introduction of Einstein's theory of relativity in physics.

We have already seen how perception atomizes and cuts, or abstracts the continuum of matter, into images. In this sense, every image is a delimited region of the world and emerges as the aftereffect of a process of individuation; this process reaches its most complex level with the appearance of a point of view, a power of arranging cases from the inside and, therefore, a condition for reality to appear (for example, through the human eye but also through the camera aperture, as internal to the process of image visualization). According to prerelativistic (or pre-Einsteinian) notions of space-time, there would only be a unique duration for each point of view (which means one image for one observing subject at a time), and the same duration would also contain all the contemporaries of that occasion. We can see a concrete example of this situation in early cinema and the linear succession of the frames, in which the lack of durational complexity and montage, and the absence of a parallel sonic field, could be easily associated with the perceptual illusion of a linear monoperspectival unfolding. If looked at from this point of view, early silent cinema is, or even better, looks, pre-Einsteinian. The formulation of relativity contributed, in the same years, to unveil this illusion, introducing the possibility for the same occasion to be part of many simultaneities, or contemporary durations, at the same time (many images to be perceived by one subject, or many possible subjects to perceive one image, simultaneously).

In this theory, the propagation of the light wave between an observing subject and an observed object is not instantaneous but has a duration. The speed of light becomes the reason why two events appearing simultaneously to one observer may not be simultaneous from the point of view of another observer. And it is exactly in this sense that the first examples of montage editing in film apparently constitute a cinematic realization of relativity, by showing the possible coexistence of different points of view on the same event. Generally speaking, modern edited cinema could therefore be considered a technology that perfectly exemplifies Einstein's hypothesis, one of its main outcomes being the presentation of a movement as belonging to many different, simultaneous durations.

With Dziga Vertov, cinema had its first concrete example of multiple-perspectivism. Viewing a film such as *Man with a Movie Camera* (1929) is as much about the camera lens as it is about the human perception of moving images on the screen. The result of this double, human/machinic point of view is the construction of a different reality, a reality captured and reconstituted by the eye of the moving camera, an eye that is *in* nature, in things and events, in situations and objects, as much as it is *on* them.

Despite their profound differences, Busby Berkeley's musicals such as *Footlight Parade* (1933, dancers James Cagney and Joan Blondell) and *Gold Diggers of 1933* (1933, dancers Warren William and Joan Blondell) seem to closely intersect with Vertov's shooting and editing techniques: a series of kaleidoscopic images (usually taken from above but also from many other angles) contract and dilate, turn on a vertical axis, or change into each other, revealing an implicit accord between the immobile gaze of man and the mobile, omnipresent eye of the camera. It is an eye, as Deleuze would say, *in* matter, a perception that is proper *of* matter, a particular point of view that is able to extend from the beginning to the end point of an action or a movement, crossing the scene and filling all the intervals between the observer and the observed, choreographing an infinity of possible points of view.

The relativity of cinema is thus given in the set of all takes, and in the juxtaposition of all the bodies, objects, and things that will be made to interact on the same spatiotemporal plane. A relativity implicit in all the intervals occupied by the camera's eye, together with the eye of the director and the spectator. For Berkeley (as well as for Vertov), montage becomes thus a way to abandon a vision of nature that is still too organic, or too human, and linear: thanks to the moving camera and to the juxtapositions of montage, perception can now coincide with matter and its simultaneous points of view. This simultaneity has significant effects on the movement, which abandons its individual confinement in the human body and becomes a movement of matter, a movement of the whole world.

And yet, despite this analytical connection between the montage of the musical and the scientific idea of relativity, something still remains mysteriously unclear. How can the whole be held together, despite the plurality of its parts? It is important to remember that the paradoxical connections realized in musicals can only emerge thanks to their insertion into a common and uniform spatiotemporal dimension that provides a sort of constant background to the protagonists' anomalous, sometimes abrupt, singing and dancing. If, on one hand, relativity posits perceptions as different and in contrast with one another (as moments or points of view of

different subjects, but also of the same perceiving subject), on the other
hand a uniform possibility of observation is needed as the precondition for
multiple contrasting occasions to take place and be connected, or dialogue,
in experience.[15]

In the temporal unfolding of movement as a series of occasions (one
step after another), the conception of an absolute relativity would make it
impossible to go beyond the juxtaposition of different, contingent, unre-
lated instants and pass into an edited, or danced, dimension: no subject
experiences twice in the same way, as Whitehead says.[16] The montage of a
film or the choreography of a dance could therefore never be experienced
as such. In short, what the theory of relativity seems to highlight is the
need for a complementary explanation of how different moments, percep-
tions, or takes can coincide and make sense on a unique perceptual field.

The uncertain and inexplicable coexistence of perspectives offered by
the musical is in fact coherently threaded across the uniformity and repeti-
tion of particular spatiotemporal structures. In the "Coffee Time" dance
routine of Vincente Minnelli's *Yolanda and the Thief* (1945, dancers Fred
Astaire and Lucille Bremer), for example, the five-count dance phrase and
the four-count musical phrase are held together by syncopated repetition,
while the black and white striped floor provides a repetitive optical back-
ground for the chaos of multicolored costumes and multiple movements;
finally, thanks to a carefully woven plot, the protagonist is able to pass from
his world into another, and to enter and dance into a girl's dream.

The idea of a general relativity is therefore not enough to give consistency
to the prodigious relations of the musical, and explain how perspectives
encounter each other. Montage puts this scientific theory into question, at
the same time revealing a further ontological necessity for uniformity. In
the same way, by equating reality with the contingency of matter (every
perception is to be explained as a function of the light wave, and therefore
contingent), the Einsteinian methodology makes any stable, objective cri-
terion of observation actually impossible: reality is always materially bent,
or spatiotemporally curved, delayed and lapsed, by gravity. This lack of a
solid ground is among the main objections moved by Whitehead to general
relativity: not a critique of the intellectualization and spatialization of time
operated by the scientific theory but, to the contrary, an underlining of its
too fragile foundations. The main necessity, for Whitehead, is to establish
how, in the case of light, gravitational variation does not take place.[17] This
obviously does not mean that light cannot be deviated by a gravitational
field, but simply that what Whitehead defines as its "universe line" can-
not change. Conceiving a stable, invariable universe line for light allows

various observers to obtain a unitary perception, and to almost completely and simultaneously describe a fixed point in space-time, or to take part in the same event.

Associating cinema and dance with philosophy (as Deleuze did) implies, from a Whiteheadian point of view, subtracting their logic from a purely aesthetic perspective, or even better, reassociating aesthetics to the field of a possible *knowledge*: every aesthetic perception is accompanied by a knowledge, in the sense that it starts from an integration of indiscernible sensations and ends up with the capacity to discern an image. Despite its obvious connection with the conscious dimensions of experience, the Whiteheadian notion of knowledge is certainly one that is never totally closed and detached from the vague, nonsubjective halo of sensations, or feelings, nor is it oblivious of the more rational functions of the mind. Knowledge, in short, is a selective, ordering, and structuring force traversing, rather than being originated by, the knowing subject; it is a force always exposed to the precariousness and instability of its own openness (rather than simply to the contingency of matter).

In films, for instance, the connection of the frames can produce a chaotic becoming of superimposed events that do not need to respect any logical linearity; each event has its own different duration and belongs to its own universe, but they are all realigned and recomposed into complex and yet systematic structures. The durational whole of the film, and of its single scenes, is (unlike Bergson's duration) always spatiotemporally structured thanks to a repetition of elements and relations (such as returning stories, returning characters, or simply the repetition of images, visions, and sounds), and this returning "structure is uniform because of the necessity for knowledge that there be a system of uniform relatedness, in terms of which the contingent relations of . . . factors can be expressed. Otherwise we can know nothing until we know everything."[18] Watching a film does not imply a need to know everything: to know all the possible relations between characters, things, and events extending beyond its actual duration, beyond what appears. In this sense, a film presents us with a series of mysterious facts, mysterious in the sense that nothing is shown beyond them: neither what happened one second before, nor what will happen one second after the beginning or the end of a shot, of a scene, of the whole film. And yet we are (almost always) able to watch, follow, and know a film and its events. In the same way, in a musical, we know we are watching a dance image, even without perceiving the whole bodies of the dancers, and even if not every element of that movement is given to us. Despite its hidden, unknowable trajectories, a uniform plane is always at work across

each of the film's levels, making of it a systematic structure that stands on its own feet.

It is important to remember that, for Whitehead, the structure of spatiotemporal uniformity presupposed by occasions does not derive from the necessity for an extraexperiential concept of the understanding, and does not imply the imposition of any preexisting Kantian category; to the contrary, this frame is like a form, a model derived from reality itself. This returning uniformity affirms itself as a transcendental presupposition of experience, arising from experience itself but never limited to its purely physical, and therefore contingent, character. It is not founded on the preexistence of judgment criteria, but on the constant return of mathematical and geometric principles or patterns of space-time connection, in experience. The Cartesian absoluteness of reason gives place, in Whitehead's philosophy, to its fundamental role as an almost magical force of abstraction and order always immanent to experience: when the dancer hears the music, the rhythmic counting and snapping of the fingers starts, and the dance automatically, magically becomes a dream. Counting and dreaming become thus part of the same experience, in which fantasy is perfectly combined with the most precise choreographic and musical rules, hallucinations interspersing the linearity of the understanding with their fantastic gaps, as if one dimension could not be given without the other. The fundamental question, for Whitehead, would thus be not simply how to do without rational criteria or rules, but how to continuously repropose them as parts of experience, in a way that can simultaneously take into consideration the continuous mutation and magical unpredictability of the world. It is by reason and magic that images appear.

We can see how the history of cinema shows many different editing criteria (for example, organic or dialectic, quantitative or qualitative) through which films perceive or imag(in)e reality (intending perception as a form of imagination, or image abstraction), and thus realize the convergence of sensation and knowledge.[19] Following the progressive evolutions of some dance images in relation to filmic montage would thus allow us to achieve a particular understanding of this mutating convergence: these images realize in fact a metastable balance in which the knowledge of the dance (the imagination of an ordered choreographic structure) becomes inextricable from the most visceral and chaotic sensations of movement. Since, from this perspective, all perception is an imagination, a form of knowledge based on the original idea of a cut, a better definition of these images will be gained by identifying them with what Whitehead defines as a "nexus," or a series of disconnected occasions held together by the uniqueness of

an idea. This idea integrates the movement, as a multiplicity of different perceptual sensations, into the imagined togetherness of a dance nexus (or a choreo-nexus).[20]

Causal Nexus

A dance sequence can be considered a nexus of different perceptual occasions. In his "philosophy of the organism," Whitehead puts forward a theory of perception based on the interchange of two species or "pure modes": causal efficacy and presentational immediacy.

The first mode refers to the temporal continuity, or efficient causality, of perceptual occasions, and "makes the body the starting point for our knowledge of the circumambient world."[21] Causal perception is in other words a feeling of the past, or the inheritance of the past occasion as a vague bodily sensation. In this modality, the body is felt like a system of contrivance through which an actual occasion reflects the experiences of its antecedent moments and projects them into the future.[22] The oscillation between reenactment and anticipation can be already defined as the work of a mind implicit in a body: a contact or a relational embrace between the subject-in-formation and its own past-future self, a sensation leading to an imminent perception that also contains a germinal thought.[23] A subject (we could call this, in a very limited way, a perceiver, or a spectator) is not already there to perceive a world of already present objects-images: they both form and trans-form themselves along their mutual participation in the perceptual process.

Bergson also conceptualized a similar form of causality as the infolding of a past perception, a sensation, or an affection presupposing an "invitation" to act in the future: subject and object are not formed yet, but are invited to appear on the scene.[24] In this inviting sensation, a multiplicity of diverging and converging potentials (intensity) is felt as a moving in-between, preceding and following the actual perception of a step but always in relation to it. To perceive an actual body in movement appears then like the subtraction of a form from this relational field of potential, in a sort of four-dimensional volumetric compression. But what remains analytically crucial is the edge, or even better, the interval, the moment of indetermination or resonation when the potentiality of an affection is being realized in the apparition of a moving-body image. We can call the system in which a particular moving body develops from an interval or a point of affective indetermination a *causal nexus*. In this particular system of image perception, movement forms a coherent set with a before and an after, a cause

and an effect, a stimulus-response circuit that can be indefinitely broken, subdivided, contracted, or expanded, without losing its organic integrity.

It is true that, according to the Deleuzian distinction between "movement-image" and "time-image," the insertion of a dance sequence into the linear causality of a film already constitutes a disruption, plunging the plot and its coherent sequences of action-reaction into an absolute and meaningless temporal dimension.[25] Dance images are always out, while being simultaneously in, the film. On the other hand, Whitehead's terminology and its redefinition of the sensorimotor circuit as one of causal efficacy allows us to better understand the temporal character of this circuit, explaining it as a conformation of the future effect to its immediate past cause.[26] From this point of view, it is easy to see how dance images are still strongly attached to a model of sensorimotor development (action-perception, affection-reaction, cause-effect, before-after), and this model becomes particularly evident when the camera focuses its attention on the faithful representation of the linear development of the dance step. With its unmotivated presence, a dance sequence can therefore act as an abstraction from the causal organization of a whole film, while still preserving its own causal or sensorimotor linearity. In the filmic plot, the dance cuts a hole and magnifies it, outlining "a dreamlike world as it goes"; but it is nevertheless possible to see that same dance as a continuing movement and an integral causal sequence in itself.

In many dance short films of the 1930s and '40s, the movements of the camera and the operations of montage editing are subordinated to the organic development of the action, which sometimes comes to occupy the whole spatiotemporal structure. In some of Maya Deren's films, for example, a whole causal geometry of the image is developed, and the imaginative constructivism of the camera is made explicit. The camera thus perceives or imagines the dance, by transforming the point of inflection of a gesture into a fully formed curve, and by following the formation of the movements in their continuing forward from past to present. Examples of this choreographic geometry are different, and vary from the representation of recognizable whole dance shapes such as *fouettés* and *grands jetés*, to the alignment of different frames into one spatiotemporal bloc (such as when dancer Talley Beatty changes the scene with a turn of his foot, in *A Study in Choreography for Camera*, 1945). Here, the camera is concretely imag(in)ing the movement, together with the dancer.

Another example is given in *Ritual in Transfigured Time* (1946, actresses Rita Christiani, Maya Deren, Anaïs Nin), when the serpentine line of the party guests' movements becomes a vector of symmetric exchanges, or

when freeze frames or repetitions operate according to logical laws that transform an interval into a point of regression or a cuspidal point. The punctuation of the action repeatedly marks the *befores* and *afters*, transforming handshakes and embraces, bodily movements and image transitions, into the twofold or circular structures of a continuous dance. This dance is always based on the existence of centers, even if they are multiplied: focal centers for revolutionary or circular movements (*Ritual*), gravitational centers as attractors for an equilibrium of forces (*Study*), and, in all cases, subjective centers as points of irradiation for a performer/observer rhythmic transmission.

The same causal logic predominates in many other examples of dance films and videos, independently of the material ontology of their medium; digital film- and videomakers sometimes also seem to take this organic geometry of movement to the limit, by highlighting a nexus of images that does not simply express movement but magnifies its temporal relation to the interval. For example, in Antonin De Bemels's digital short film *Se fondre* (2006, actors Ugo Dehaes, Melanie Munt, Bruno Marin), one sees a series of conventional causal relations between everyday movements and gestures, phrases and attitudes, while at certain points the movements are infinitesimally disturbed, accelerated, and disordered, little gaps are opened in the narrative lines, and also in the continuity of the movement itself. The organic, sensorimotor lines and volumes of movement are still there, although sometimes blown up, reversed, or microscopically and frenetically multiplied from the inside.

Presentational Nexus

In the geometric volumes delineated by the causal nexus, movement can still be perceived as an irradiation *from* and *toward* the self: the performer as the point from where the dance starts, and the perceiver as the point where it ends. In other words, the self remains the central locus of a sensation that draws the rhythmic connection between the performed and the perceived movement. The vagueness of this rhythmic sensation is counterbalanced by a perception of the structure of the dance in its causal logic and in its form: a confused sensation accompanied by the incipient, anticipatory, almost automatic thought of an order and a sense of dance.

It is, however, to be remembered that the bodily viscerality of "causal efficacy" is always accompanied, for Whitehead, by another perceptual modality defined by him as "presentational immediacy," or the site where perception is contaminated by thought, and imag(in)es things.[27] The

perception of a quality (for example, of red in an object) happens as a projection of ideas and internal sensations onto an external perceptual region, a projection that relates different perceptual entities (the perceiving organs, the perceived object) along the vibratory frequency of a particular atomic oscillation (the red portion of the chromatic scale).[28] This kind of perception is like the instance of a territorializing thought, in the sense that it makes the world appear not in continuity, but as a subdivision of atomic actualities or spatiotemporal quanta (the red portion of the quantum scale, corresponding to a red portion of time-space, or a red object).[29] A world of contemporary occasions in the present (the eye, the object) can successively become part of the same historical or causal route: the past is reflected and objectified into the present, so that an object can continue to be red across time. But in itself, the presentational immediacy of perception gives no temporal information and no sense of continuity: it is an almost scientific abstraction, dissection, and illustration of the qualities of the present, or of "a portion of the presented duration" (for example, its color), in which the contribution of the mind starts to become significant.[30] We will call this qualitative mode of image perception a *presentational nexus*.

For Deleuze, a different kind of perception, one very similar to Whitehead's immediacy, is already at work in the images of modern cinema (defined by him as time-images), a perceptual recognition that only retains qualities, and only illuminates movement, in its present. In the modern cinematic image, definition is purely applied to the qualitative elements, while the perceiving subject as a point of view becomes "a principle of indeterminability, of indiscernibility: we no longer know what is imaginary or real, physical or mental, subjective or objective, in the situation, not because they are confused, but because we do not have to know and there is no longer even a place from which to ask. It is as if the real and the imaginary were running after each other, as if each was being reflected in the other, around a point of indiscernibility."[31] The electromagnetic flows of electronic video appear as the most indicative example of the indiscernibility of this qualitative, presentational perception.

It could be noted that video styles are multiple, and that, echoing a Deleuzian distinction, they can for example show two different poles according to their technical modes of production: one proceeds by rich and overloaded means (dissolves, superimpositions, deframings, complex camera movements, special effects, manipulations in laboratory), going toward abstraction; the other is very restrained and works through clear cut and montage-cut between concrete objects.[32] But in both cases, what really counts is that the qualities of the movement are cut out and remodulated,

and a qualitative fragment (a "crystal") is abstracted from the sensorimo-tor circuit: montage becomes "montrage," while perception fully incorpo-rates in its functional concreteness the qualitative abstraction of thought.[33] Presentational immediacy as the imaginary psychedelia when perception becomes pure imagination.

As Maurizio Lazzarato has argued, electronic machines introduce dif-ferent material processes of image formation and perception.[34] Following Nietzsche and Bergson, the theorist proposes a peculiar version of techno-logical essentialism, delineating the basis for a materialism of the image beyond the subject/object, matter/spirit, sensible/intelligible, or human/technological dualisms, revealing subjectivity (or the apparatus of image formation) as simply a concatenation, or a *dispositif*, based on processes of material contraction/solidification. In other words, processes of image formation are not merely human or technical, but are at work in the whole natural world, acquiring different peculiarities according to the propensi-ties of different media (such as, for example, with the automatic tendency of electronic video to work on the quality of the signal). In fact, it is not so much the material contraction and cutting of signals that counts in the electronic image, but the emergence of a different qualitative modality of the imagination, or a different idea.

Together with Shigeko Kubota and Charles Atlas, Nam June Paik was among the first artists to develop electronic video as the object of a qualita-tive imagination. In particular, Paik's work seems to borrow from experi-mental cinema the taste for an isolation and cutting out of pure audiovisual situations that do not so much make felt the organic, continuous flow of a movement or a dance (as in continuity editing) but reveal its qualities: two rock'n'roll dancers are accompanied by a proliferating trail traced by their own luminous doubles, while performing on a background constituted by their own magnified images; a traditional Korean dancer elegantly moves on the color-saturated images of a metropolis; a varieté dancer dissolves into colored spots . . . (*Global Groove*, 1973).[35]

It might be noted that all this is a product of the technicality of the medium, and that all the effects are lent by the electromagnetic modula-tion of video to the dance image. The dancing body and the scene-stage can, for example, be separated and recombined through the incrustation technique of *chroma-key* (the embedding of an object into an autonomous background), thanks to the modulability of the signal.[36]

In fact, the most famous incrustation scenes (for example, those of Merce Cunningham dancing on blue, white, or transparent backgrounds in Nam June Paik, Charles Atlas, and Shigeko Kubota's *Merce by Merce by Paik*, 1973)

Figure 2
Merce by Merce by Paik (dir. Nam June Paik, Charles Atlas, and Shigeko Kubota, 1973).

can nevertheless be easily related to an already existing cinematic feature, the tendency to place the characters in amorphous spaces with no Euclidean coordinates but only qualitative features (Michelangelo Antonioni was in this sense a precursor or inventor of video-artistic landscapes, for example in *Il deserto rosso*, 1964). It is by virtue of this tendency, or of this cinematic idea, that the focus of perception can become distracted from the form and integrity of a movement pattern, simply focusing on or *cutting out* the qualitative indiscernibility existing between the dancer and the movements of matter, or between the dance and the shifting of its background.

Sometimes, video can transform this indiscernibility of the dance sequence into a subjective tendency toward the expression of memories, dreams, or fantasies indiscernible from the real.[37] Dance, again, as a dream, but this time, differently from the musical, more vivid in its qualitative than in its formal relations. In Davide Pepe's digital video *Body Electric #1* (2005), for example, the dance starts with the dancer (Miriam King) sitting on a chair, maybe asleep; the image seems to suggest that she will dream all her qualitative metamorphoses, from the microscopic nervous electroshocks to the impossible mechanical deformations and manipulations of her body.[38]

Sometimes, to the contrary, the logic of the video is taken toward a more objective direction and toward the abstraction of pure movement qualities, such as in De Bemels's *Scrub Solos* series (dancer Bud Blumenthal, 1999–2001). Thanks to the digital scrubbing technique and to its audiovisual scratching, everything in these videos is generated by the inflection, the microarticulation or microgesture of the videomaker's hand that, like that of a DJ, leaves its mark on the flow of images.[39] The manipulation combines the digitalization of the dance, the microscopic cutting of movement, and the granulation of sound, with the isolation and magnification of particular qualitative traits amplified and distorted in an almost painterly way. The result is a rhythm that allows for digital freezing and qualitative continuity, or for discrete and continuous geometries, to coexist. Instead of following and recognizing the movement, imagination is only preoccupied with dissecting and distorting its qualities and effects. The choreo/logic appears therefore like a topology of modulations and projective transformations that draws the movement of the dancer like an open spiral or a shell-shaped unfolding of volumes in-between the cuts.

We have seen how the idea of a causal nexus allows the camera to imag(in)e movement as a dance, by following its sequentiality: it is, in other words, the particular relation between a before and an after that makes a dance. The presentational nexus, on the other hand, determines the disappearance of the sequential form, and its dissolution into a field of qualities: beginning and end are not distinguished anymore, and even the dancer is incorporated into a continuity of motions. Whereas the very recognition of the dancing body seems to lose its importance, the definition of dance is applied to the movements of matter: a particular combination of colors could make, from this point of view, of any material movement a dance.

Digital Nexus

One definition that Gilbert Simondon could have given for digital technology is that it modulates movements in a definitive manner; in other words, the digital is not a modulation but a codifying mold.[40] The digitalization of an image implies a codification of electromagnetic particle-waves into fixed numerical chunks, and a structuring of this information according to the possibilities of a Cartesian grid.[41] In relation to perception, this digital mold produces a loop. First (input) phase: from material image to numerical grid. Following this principle, digital video reduces a moving figure to a series of numbers, and then a constellation of luminous and acoustic pixels that, disposing themselves according to the combinatoric of the algorithm,

constitute a field of perceptual potential. Second (output) phase: from the pixelated grid, perception gets a new, emerging figure.

But the figure/grid perceptual loop is not entirely closed. According to Erin Manning, perception always follows a tendency to perceive what she defines as "more-than" (more-than figure, more-than grid, more-than pixels): every perceptual event generates an openness that stretches the perceiver/perceived relational in-between, as a resonating dimension of potential.[42] At the same time, this perceptual resonance is channeled by a precise selective function: to perceive something or someone means to abstract a form (a figure, but also a single pixel) from the potential field. Expanding on Manning's argument, it can be noted that form is already, paradoxically, a "more-than." A perception in fact characterizes itself as the construction of an almost hallucinatory reality that does not preexist its formation: imagination. The construction manifests its hallucinatory character in the selection operated by the perceptual apparatus (a filtering of potential) and, as Brian Massumi says, in the production of excess "seeings" (or hearings), a cutting out of potential and an addition of something that gives "more to reality than it is given": a form.[43]

For Whitehead, the appearance of a form corresponds to the association of an eternal object to a particular spatiotemporal portion of the world, a portion whose progressive extension derives from a series of multiple perceptions, all sheltered under the common denominator of a unique idea. The ingression of an idea into the occasion happens, as he argues, as a conceptual event: eternal objects are introduced through conceptual feelings.[44] These conceptual feelings, or the feelings of ideas, make up what Whitehead defines as "the mental pole," an abstraction at work everywhere in the world, from human to organic or inorganic nature: even a stone, in this sense, has a capacity to abstract the world in its own way. Every perception is always an impure or mixed event of physical and conceptual feelings, in which the physical qualities of matter appear under the structure of determined ideal relations, and according to the corresponding ideal possibilities of separation and division between them. Even a stone cuts out its own reality, by falling into water.

In Whitehead's words, these virtual divisibilities are ideas that "exhibit the definiteness of mathematical relations" or, in other words, numerical ideas shaping the divisions and relations, the forms, of all actual occasions, and making the world into an extensive continuum.[45] Ideas, in other words, are possible numerical divisions and relations that shape the world. A common framework of numerical divisibility and relationality acts like the background for all potential objectifications to be realized, for all forms

to be produced. Together with Whitehead, we can argue that "by reference to this framework the variant, various, vagrant, evanescent details of the abundant world can have their mutual relations exhibited by their correlation to the common terms of a universal system. Sounds differ qualitatively among themselves, sounds differ qualitatively from colours, colours differ qualitatively from the rhythmic throbs of emotion and pain; yet all alike are periodic and have their spatial relations and their wave-lengths."[46] The constructive reduction of the world's qualitative multiplicity to series of numerical relations is not a simple distortion of the human intellect but a mental necessity, a germ of mentality in the material world. Matter quantifies and counts through its own vibrations (for example by counting red as a particular frequency and wavelength of the chromatic spectrum).

The relation between a dance performance and digital video implies the quantification of all its different aspects, and their actualization and objectification into numerical data. But the material quantification operated by the software is not enough to explain the logic of the digital nexus: it necessitates its coupling with a particular way to imagine, to *mount*, or to know the world. It is not only the reduction of images and their materiality that abides to numerical code, but the montage of the frames also recomposes the spatiotemporal blocs, the visual and acoustic elements of the dance, into a *nexus* whose relations are simply mathematical. Having an idea in video-dance, as we have seen, implies the outline of a precise perceptual and editing geometry: for example, following the causal linearity of the movement or highlighting its qualitative nuances. A third, peculiar kind of image-nexus appears as a consequence of the possibilities offered by digital montage, when the editing becomes mainly directed by a purely quantitative criterion.

De Bemels's *Trilogie stroboscopique* (2003–2005) is a digital videochoreographic triptych that explores the dancing body through the stroboscopic effect, a vibration and fragmentation of movement through the pulsed alternation of video sequences frame by frame. As a very specialized kind of cinematic montage, the stroboscopic technique was already famously used, in its analog version, by Norman McLaren for the production of multi-image effects in many of his works, such as the short dance film *Pas de Deux* (1968). Although apparently similar, McLaren's and De Bemels's stroboscopes refer to the different ontologies of analog and digital audiovision; but even more importantly, they appeal to two very different ideas.

In McLaren's film, the bodies of two classical dancers (Margaret Mercier and Vincent Warren) fragment into separate, superimposed phases of movement. The technique is a very peculiar one: a high contrast positive

is exposed many times successively onto a new optical negative; the same shot is thus exposed on itself, each time delayed by a few frames. In this way, the stroboscope makes, as Manning points out, the "preacceleration" or virtuality of an incipient movement emerge through the intervals or the in-between-frames.[47] In most of his animation films, McLaren uses the in-between not as a means but as an end in itself, in order to make the very nature of the interval felt as a continuous flowing sensation. By foregrounding the continuity of movement through an accentuation of the interval as in-between passage, McLaren's dancing images remain suspended between the flowing temporality of the causal nexus and the qualitative indiscernibility of the presentational nexus. In the film, the "refrain of past movement in future becoming" accompanies the linear development of ballet's formal precision; at the same time, all the displacements resonate with the qualitative singularities of the movement.[48] Whether as an organic line of displacement or as a folded multiplicity of qualities emerging from the same pose or step, the film is all played around the idea of continuity and flow.

In a very different way from McLaren's fluidity as analyzed by Manning, De Bemels's *Trilogie* performs a continuous halting of the movement, blocking the fluidity of the relation and putting in its place a sensation that involves a different idea: that of the cut in itself. The three videos of the *Trilogie* can therefore be analyzed as examples of a digital nexus and of an imag(in)ing logic that could be defined as an *intuitive mathematics of the cut*: a logic more interested in the numerical division and structuration of the image than in its causal or qualitative fluidity. The difference is important: whereas the relationality of the causal nexus implies a continuity of past and future (organic geometry of the dance), and whereas the cutting out of the image's qualitative relations in the presentational nexus implies an indiscernible fluidification in the present (topology of the dance), the digital nexus implies a cutting out and a magnification, *in* the image, of that quantum divisibility and extensive relationality, of that extensive continuum along which all relations of space and time take place, not only in dance performances but in the whole physical world. The digital stroboscope becomes thus like a magnified illustration of the microscopic mathematical operations continuously at work in the world.

1 Digital Abstractions: The Intuitive Logic of the Cut

Digital Cut

The static torso of a doll is attached to the moving limbs of a human body that, eyes closed, head swinging, fidgets against a black background. The mechanical fluttering and wriggling movements of the arms shatter and multiply the unity of the image, before the recomposition of a final meta-static moment. Granulated sounds accompany the broken motions of the dancing figure. Everything is minutely and precisely cut, under the sign of a microscopic divisibility allowed by the digitalization: video frames, movements, sounds, a whole apparatus of disjointed bits and pieces frenetically converging toward an illusory, impossible unity.

As the creative acts (or automatisms) associated with digital art, sampling and sequencing are the main technical procedures used by Antonin De Bemels in *Il s'agit* (2003, dancer Ugo Dehaes), a video in which each digitally cut frame becomes the microscopic building block of a simple logic. We could say that the image is composed as a nexus of *digi-signs*: the chromatic and acoustic qualities of the image, the tensions and relaxations of the moving body, are all cut and metrically measured as binary units.[1] As with all digital images, the intensive nature of movement and time, of optical and sonic effects, freezes in measurement and coding. But is this process of total quantification really to be considered a loss of potential?

It should be pointed out that the qualitative nature of the time-image, a purely optical and sonic image conceptualized by Deleuze in contrast to the more quantifiable character of the movement-image, was indispensable for the philosophical and aesthetic liberation of modern cinema from the linear chronology of traditional film plots. Modern cinema, in other words, is the place of endless affection, rather than action. This exclusive emphasis on qualitative richness (or on the presentational rather than the causal nexus) cannot retain the same countercultural and philosophical

Figure 3
Ugo Dehaes in *Il s'agit* (dir. Antonin De Bemels, 2003).

radicalism today, in a time when quality-quantity and space-time hierar-
chical oppositions have become the real ontological trap, and the intensity
of time is no longer to be preferred, or opposed, to its metric spatialization.
If, on the one hand, the dense qualitative character of contemporary elec-
tronic images disrupts the linearity of traditional cinema even more than
modern cinema used to do, quality itself is often used as a subtle instru-
ment of cybernetic power and control. As an example, we can think how,
thanks to their excessive and fluid mutability, the qualities of the images
produced through interactive technologies and generative algorithms are
able to capture (and anticipate) their viewers' affects and sensations, and
are therefore deployed as tools of perceptual design and control.[2]

De Bemels's videos are about neither control nor disruption, but rather
only about the microscopic cutting of the digital and its endless repetition.
The procedure seems a total retreat into a Cartesian computational, quanti-
fiable dimension; but in fact, what seems to really govern the microscopic
composition of these digital videos is a visionary search for the infinite
under the finite. Here, the digital technique shows a capacity to affect

perception and imagination in a way very similar to that of the first micro-scopic lenses. Already in the seventeenth century, the use of the microscope introduced a new way to see things, thanks to its capacity to disassemble the atomic consistency of matter. An imaginative, almost hallucinatory vision was unfolded, constituting a visionary field where art and philoso-phy could meet and share a particular taste (a *way of treating things*) with science: "When [scientists] see what microscopes show them, they see a confirmation of it: the microscope is the instrument that gives us a sensible and confused presentiment of this activity of the infinite under any finite relation."[3] For the visionary scientist, it did not really matter that the dis-section of cells, compounds, molecules, or atoms could not go on ad infini-tum, insofar as it showed a way, or a tendency, toward the infinite.

For Gottfried Leibniz, the scientist-philosopher who invented infinitesi-mal calculus, the infinite was equivalent to the myriad of inconspicuous perceptions, "infinitely minute elements" composing the clear conscious-ness of every single moment, but without individually standing out enough for us to be aware of them.[4] As a sort of contemporary microscope, digital technology is all about extremely minute temporalities and inconspicu-ous small-scale entities. But the Leibnizian concept of a "microperception" cannot be simply made to coincide with a digital fragment: the dissect-ability theorized by the philosopher was not of a binary but of a fractal nature. And yet the digitally cut bits reveal a peculiar potential, becoming the testimonies of a renewed propension, a tendency, the idea to reach the unreachable, the obscure depth of minute elements that fuzzily connect the whole world to each of our single perceptions.[5]

For Deleuze (after Leibniz), infinity (or, this time, the infinite potential-ity of an idea) can be expressed very precisely (and paradoxically) through the mathematical formula of differential calculus (dx/dy).[6] Because an idea (such as the very idea of infinity) is neither a fixed quantity or quality of the understanding (x), nor a quantitative or qualitative variable of intuition (y), it can be defined as a pure "quantitability" and "qualitability" (d), or a mathematically precise indeterminateness. Not a perceivable or sensible color, sound, or velocity, but the very idea of color (for instance, the *redness* of color), of sound (the *metallicness* of sound), or of velocity (the *rhythm* of a speed). As a susceptibility for quantification and qualification (for fre-quency and hue, wavelength and saturation), the differential of the idea of red does not possess a determinate or a variable value, but only indicates a quantitative and qualitative indetermination that is, paradoxically, very precise in the expressions that it guides.

The speed of a movement, for example, can also acquire various quantitative and qualitative values, according to the more or less precise

measurements of the moving body and to its sensations: speed as a fixed measure or a varying variable. But the idea of speed is simply equivalent to the momentum of acceleration or slowing down when a body acquires a speed, or to the rhythmic differential of every movement variation.[7] At this point, it would be easy to give in to the temptation, and intuitively associate this differential of the idea with the universal unit of the digital: a bit, like an idea, is very precise, and yet it is highly indeterminate in its infinite possible actualizations.

It is indeed important to remember that digital technology reduces the infinity of ideas into the limit of a possible binary choice: the actualization of ideas only happens between 0 and 1. Nevertheless, equating digitalization with its binary circuits is like reducing thought to the mechanics of the brain. Instead of proposing a simple juxtaposition between the digital bit and the differential idea, it seems more useful to consider the digital itself as an idea, or more specifically as an audiovisual idea, insofar as it can be made to designate a nexus or a relation associated with the structure, the composition, the nexus of a particular kind of image.

It is now possible to delineate some of the characteristics Deleuze attributed to the idea and, accordingly, to trace a relation with the digital nexus or image. These characteristics, very simply, are: (1) precision, (2) immutability, and (3) an abstract autonomy from the physical world. All three seem in fact to coincide with the attributes (or limitations) that are often highlighted in relation to the digital and its perceptual effects: (1) digital relations possess an extremely precise mathematical character and cannot be reduced to infinitely small quantities (or to the infinite).[8] (2) Digital divisions and recombinations are too static and immutable. (3) Digital algorithms are totally disconnected from the physical field. Now, in relation to point (1), we should remember that the Deleuzian theory of differentials in fact explains very well that the mind, the plane of ideas, cannot be considered the imprecise, intuitive continuity of a sensible field, more than it can be perceived as a striated world of discrete actualized objects: it is more like an infinite continuity of very precise differentials, or an infinity of potential moments of differentiation and relation, of potential ways to realize the cut (more than to an infinitely small cut). As the differential, or the *bit*, of the mental field, the idea acts only as an "ideal cause" for both continuity and discreteness, a division/connection yet to come.[9]

At the same time, in relation to point (2), the idea presupposes a quantitability or qualitability (d) susceptible to acquiring different quantities and qualities, but without corresponding to any general or particular value, and therefore differentiating itself from a variation or a variable (x, y). The idea,

in other words, loses its mutability or its property of variation, and "represents only the immutable" of a relation.[10] Ideas share the static nature of the virtual, in the sense that they have a capacity to congeal and last, or remain the same, for the whole duration of their concrete actualization. Residing neither in a metaphysical realm nor in the embodied dimension of perception or in the automatisms of the machine, the idea is more like a predictive memory of what has to come.

Finally, coming to point (3), by defining ideas as autonomous effects (or attracting tendencies of a process of taking-form) that are independent from concrete bodies and their causes, Steven Shaviro, after Deleuze, identifies them with a series of "sonorous, optical, or linguistic 'effects,' or what in the movies are called 'special effects.'"[11] These effects are not to be intended as actual mixtures or variations of physical bodies, but simply as abstractions without any causal efficacy or presentational immediacy. Ideas, in other words, are the "special effects" constituting the virtuality of the real, the phantasmatic entities abstractable from the corporeality of movement, like "a faint incorporeal mist," or "a film without volume."[12] The idea, for example, of a possible transition between the frames. Every effect (such as a particular cut, or dissolve, of an image) is therefore first of all an idea. It is worth remembering here Deleuze's quote of Émile Bréhier, and his identification of "a new attribute, that of being cut. The *attribute* does not designate any real *quality* . . . it is, to the contrary, always expressed by the verb, which means that it is not a being, but a way of being. . . . This way of being finds itself somehow at the limit, at the surface of being, the nature of which it is not able to change. . . . It is purely and simply a result, or an effect."[13] Being different and separate from physical causes (for example, from the algorithms of the software), cutting and being cut become logical attributes, abstract ideal forms shaping the passage from one physical state to another, from one frame to another, from one gesture to another: a way of making the image, of combining its elements into a whole. From these three points of view, the Deleuzian description of ideas as precise, immutable, and incorporeal seems to coincide with that of the digital, allowing its redefinition as a way to make the image.

Whitehead's philosophy can also help us understand the digital as an idea in itself. Whiteheadian ideas are of two kinds: qualities, as the pure potentials or the general virtualities of experience (the idea of timbre, for example, as the sameness of all sonic timbres), and the corresponding mathematical or quantitative relations.[14] Ideas can be qualities and numbers. For Whitehead, an idea preexists an occasion of experience (a gesture, an algorithm) and enters it, not in the sense of its residing in a transcendental

nowhere (although he repeatedly underlines the closeness of his eternal objects to Platonic "forms"), but in the sense of constituting the formalized, patterned element of a past that has already been objectified once, and is now awaiting a new actualization.[15] The temporality of the occasion's physical becoming is always interpenetrated by the eternal character of ideas, of permanent patterns that, with all their potential indetermination, do not change and are always the same for all entities, while at the same time being differently and infinitely actualizable by them. When the idea becomes actual, the limit between mutability and invariance, between the potential multiplicity and concrete unity of the occasion, becomes a genuine cut.[16] The differential of the idea is thus not precise, but it is what determines the precision of the cut.

At this point, an important discrepancy between Deleuze's and Whitehead's conceptions of the idea is revealed by their different mathematical understandings of this cut, and of the process of actualization.[17] In the case of Deleuze, a precise inflection first of all generates continuous qualitative foldings more relatable to analog expressive techniques (such as the fluid modulability of electronic video); quantifications such as those of the digital only intervene successively and retroactively on a reality already actualized. In the case of Whitehead, eternal objects determine the continuous discreteness of occasions, as if constituting a sort of mathematical schema for the world.

The problem, in fact, is not so much to oppose the qualitative affect and feeling of movement to its geometric or mathematical description, and even less to oppose an intensive to an extensive quantification, as if they were ontologically related to two different essences. The problem with all forms of codification, either qualitative or quantitative, either analog and transducive or digital and translative, is only their tendency to reduce difference to convertibility. This homogenization can take either a continuous form (such as the conversion of a variable impulse or momentum of light by analog technology) or a discrete one (the conversion of matter into information bits by the digital).

We understand now that what is critical in a numerical code like that of the digital is the purpose to flatten out the differential of its own numerical idea, or to hide it behind improbable qualities: for example, in the hyperrealistic aims of digital cinema, the technology, with its special effects, becomes a way to homogenize the qualitative difference between organic and cinematic perception, converting one into the other, whereas in the more sensationalist aims of the cinematographic industry these effects are used to bring forth a whole range of new, improbable kinetic qualities. A

totally different logic emerges, on the other hand, when the digital affirms its own, inconvertible difference and brings to the fore, without qualitative "excuses," the cut as an idea, a mathematical or numerical idea, in itself.

Rather than submitting the digitalization of the dance to the isolation of particular qualitative traits or of particular movement forms, in *Il s'agit* (and in the whole *Trilogie Stroboscopique*), it is the flatness of mathematical rules that defines the times and spaces of the movements perceived. It is not the idea of a spatial form or a qualitative time that pushes to appear in the image, but a mathematical operation in itself (the stroboscope as a systematic alternation of frames), which is what abstractly allows a presentation of multiple instances of time at the same time, and of multiple segments of space in the same space: a movement beyond spatiotemporal limitations. The infinity of numbers, in other words, is perceived and imagined through the digital cut.

A peculiar numerical idea finds, for example, its realization in *Il s'agit*. A frame-by-frame stroboscopic alternation of two sequences produces a generative syncopation of the dance. *Difference in itself* is flattened and reduced to the *difference between* two entities, in such a way that it becomes possible to empirically determine it as the opposition between a One and a not-One, sequence 1 and sequence 2, but also man and mannequin, on and off, 0 and 1.[18] The infinitesimally precise cutting of movement into a predictable binary grid is nevertheless accompanied by a simultaneous ranging of the mind into an infinity of repetitions and recombinations: an actual, technical dissection operated by the video-editing software corresponds to the opening of an unlimited mental field. As an effect of this endless alternation, beginnings and ends seem to disappear in imagination: there is no choreographic causality here, no qualitative amplification of movement, not even the simple flexing of a joint. Is the body really moving? Or is the technology moving it with its numbers?

The same technique (and the same idea) appears, in germ, in Martin Arnold's analog video remakes of Hollywood film shots, such as *Pièce touchée* (1989) and *Passage à l'acte* (1993), two works in which the frame-by-frame structural logic is realized through the use of an analog optical printer. Reminiscent of rap music techniques such as sampling and of bodily phenomena such as stuttering or limping, the mechanical ballets of the characters in the two videos apply a numerical and syncopated logic that shows up the mathematical structure of space and time. The game of producing new movements and meanings from a numerical structure is introduced, for example, at the beginning of *Pièce touchée*, where "we see two frames repeated over and over, showing a motionless woman in an

armchair. After longer observation, one might notice that one of her fingers is rendered out of focus. As a third and fourth frame are added, the finger starts to move and the spectator is inclined to attribute a certain meaning to it. We see a 'trembling' finger; which ultimately becomes a 'beating' finger. Movement enters the picture, meaning is seen."[19]

The logic is purely *mathematical* and binary: starting from frame x, you go forward to frame $x + 1$, and back again through frame x to $x - 1$. But here, the continuous stepping forward and backward still recalls a familiarity of habitual movements, only interrupted by ticlike twitchings that do not aspire to produce any real difference in the conceptualization of movement itself. In a different way, in the digital logic of De Bemels's videos, actual movements drift into the background, almost totally disappearing behind the numerical idea and its generation of a more abstract dance.

Digi-strain

In De Bemels's *Au quart de tour* (2004, dancer Bruno Marin), three different shots of the same action are filmed by two cameras on the same tripod, using the same traveling, panoramic, and zooming motions but different lights: six shots in total. Each of the six shots is alternated at the rate of one frame per second, which means that only one frame is taken from the first sequence, one from the second, one from the third, and so on. . . . On one hand, in the actual shooting, a man is simply swinging his arms against a black background; but the image of someone running in the dark appears as the final effect of this stroboscopic technique.

In De Bemels's videos, the quantification operated by the software often generates movement sequences endowed with incredibly fast or slow speeds: a frenetic mannequin in *Il s'agit*, a runner in *Au quart de tour*, and a man and a woman alternating in *Light Body Corpuscles*. But the digitally constructed velocity of these bodily displacements does not correspond to the virtuality implicit in the rhythmic experience of those same movements. The superposition of all the possible microarticulations that a body can activate is what gives us the infinite virtuality of its movement. Rhythm, in other words, or the microscopic variation of a linear trajectory, is marked by the emerging of imperceptible critical moments of change. From dance as "digital," the observable and controllable performance of a body disciplined by a cadenced sequence of steps, to the rhythm of dance as "lived," a series of unpredictable and imperceptible changes undergone by the same body.

Figure 4
Bruno Marin in *Au quart de tour* (dir. Antonin De Bemels, 2004).

The concrete actualization of this virtuality happens, then, through the intervention of particular systems of capture, enclosing the unlimited openness of potential into the space of possibilistic limits: even the most visceral feeling, such as that of rhythm, is nevertheless felt thanks to an anatomical apparatus without which it could not appear. Both the algorithmic probabilities of the digital and the organic system of human perception bend the virtuality of rhythm toward specific directions and durations, one toward extreme discreteness, the other toward the emerging of a whole figure and its displacement. The issue is therefore not so much the inaccessibility of the virtually infinite to human or digital perception, but rather the necessity of giving the right importance to these different limitations.

Limits seem to have two poles, which may be distinguished according to their technical production. One proceeds by proposing a sensational effect in which the too small directly comes to coincide with a perceptual excess: an excess of scale that, in relation to the limits both of human perception

and of the digital microscope, is already proper to matter in its molecular composition; matter is always too small for both humans and computers. The other notion becomes a speculative possibility to conceive the limit in its relation with the *too many* and the *too fast*.[20] Bill Viola explains this phenomenon well: "The spectrum of electromagnetic energy vibrations that make up the universe at large far exceeds the narrow bandwidth, or 'window,' open to us through our sensory receptors. As philosophers through the ages have stated, the human senses can thus be considered 'limiters' to the total amount of energy bombarding our beings, preventing the individual from being overwhelmed by the tremendous volume of information existing at each and every instant."[21] The spectral limitation operated by sense perception occurs as a particular quantification: an impossible number of vibrations becomes one color.

In order to define qualitative (or chromatic) difference, Deleuze also proposes the very interesting notion of a variation in the unit of measure.[22] The question thus becomes one of quantity: How many vibrations can you perceive, count, or distinguish simultaneously? How many measure units (and colors)? From this point of view, imagination appears as the only faculty that, according to Deleuze, can deal with what overcomes the senses, which is not the contingently too small, the too much, or the too many of a single occasion but, on the contrary, the "mathematical sublime."[23] This sublime is like the infinity of all of nature's quantities, the impossible virtuality forcing all (human and technical) faculties to face their own limit and reach their nth power, or to "transcendentalize" themselves: imagination brought to face its limit.[24] The aesthetic question posed to technology therefore finds its true counterpart in a philosophical reflection on the significance of technology's (and our own) limits.

We started this chapter with the idea of a quantitability of movement, the nature of which is to be a susceptibility for quantification. The number (or the bit), in contrast, is necessarily an actualization or a cut of this potential—what Deleuze defines as "coupure."[25] It operates a selection between what undergoes actualization (the actual counted numbers) and what remains virtual (all the potential numbers implicit between them). Feeling the limit point, the cut, or the bending of computational infinity by the finitude of numbers or bits, is what Whitehead would define as the feeling of a "strain."[26] According to Whitehead, all mathematical and geometrical facts are in fact attached to a particular kind of feeling that does not require a human or even an organic sensitivity in order to manifest itself: a mathematical strain-feeling does not necessarily involve consciousness, and is

also independent from "that approach to consciousness which we associate with life."[27] The strain feeling, in other words, is the oscillating passage between the limited extensive dimension of an event and the computation of infinity.

This strain feeling is imagined in a very peculiar way in De Bemels's videos, in which all the effects are a consequence of cutting, counting, and computing operations: "montrage" becomes *comptage*. In *Au quart de tour*, for example, De Bemels experiments with the quantitative limitations of the perceptual system. Considering the cinematic decomposition of movement into 24 frames per second, the succession of 12 or even 10 images would be already enough to recreate an illusion of continuity, whereas more than 30 would be too much for the brain to assimilate. The video's alternation of 6 (slightly) different frames 4 times per second therefore challenges the brain in its habitual limitations: the numerical composition of the image corresponds to the idea of recreating movement from an excessive number of cut frames, and of recomposing a complete body from a combination of too many fragments. Thinking the limit point between wholeness and decomposition, feeling the bending of infinity by the finitude of a countable number, is precisely what Whitehead would define as the experience of a strain, or more specifically here, a *digi-strain*.

The idea to perceive and imag(in)e infinity is like an infinitely repeatable thought that can only be experienced in its limited actualizations.[28] Before the advent of the digital, a raindrop or a water drop, for example, was seen by Viola as the conveyor of an infinitely discrete imaging of the world: his video *Migration* (1976) visualizes a journey through progressive changes in scale, from the figure of a man sitting in front of a dripping tube, to the magnified reflection of his image in the water drop. In this way, the video highlights the concepts of image *wholeness* and *detail* through electronic video techniques. Considered as the acuity of an image, detail is literally related to the number of photoreceptors in a given surface area of the retina; in audiovisual terms, it is the image *resolution*, a measure of the number of picture elements in a horizontal or vertical direction of the video frame. Unlike the limited image appearing on the retina or on television, reality is infinitely resolvable into myriad simultaneous details. It is in this sense that the virtual becomes an impossible, imperceptible totality forcing sensibility and imagination to face their own limits.[29] And it is in this sense that technical and perceptual limits become, in Viola's as well as in De Bemels's mediatic psychedelias, doorways to infinity: it is only when coupled with the mind that media, all media, "can offer us sight beyond the range of our everyday consciousness."[30]

Di-fractals

We can now repropose the situation presented at the beginning of this chapter, looking at De Bemels's video *Light Body Corpuscles* again and trying to reevaluate the question we already asked about the relation between the numerical nature of the image and its affects. In this image, ethereal light particles dance against a black background. Gradually, the particles grow and become human body parts. The outlines of two whole figures begin to emerge: a man and a woman convulsively alternate on the screen, until they suddenly fuse into one, still body. For the whole duration of the sequence, our perception is deceived and confused: How many dancers can we distinguish in the dark? One, a couple, an infinity? And how many angles/positions/frames have been really used?

The question appears here under a different light: numbers seem to have acquired a different value, especially when they bring imagination face to face with its own limit, or its own infinite potential. We have seen how

Figure 5
Melanie Munt and Ugo Dehaes in *Light Body Corpuscles* (dir. Antonin De Bemels, 2005).

every perceived image is the actualization of only one among a myriad of potentials, but the totality of all potentials can never be known. In the same sense, in De Bemels, a "mathematical-spiritual" conception of montage is produced, oscillating between the accuracy of the calculations and a more abstractly sensible (or nonsensible) effect: the whole that will never be totally known.[31]

The line of numerical connection between the frames, "an abstract line acting [not simply on the nerves or brain but] directly upon the soul," reflects, with its interruptions or cuts, a sort of cubist synthetic recomposition of movement according to a purely mathematical feeling.[32] As a precursor of this procedure, we can think how already in Fernand Léger and Dudley Murphy's video *Ballet mécanique* (1924) a nonnarrative exploration of cubist perspective through rapid cuts and recompositions gave to the emerging line of movement a precise, discrete definition. In the same way, cubist painting expresses the forces of variation of a single movement, paradoxically retaining the profound indetermination of chiaroscuro in the sharp-cut neatness of its segmented sections. In this sense, we recognize in Léger's and Murphy's work the *digital* specificity of a cubism that, similarly to De Bemels's technique, juxtaposes a large number of layers, fragments, and parts, adding and subtracting frames in order to obtain fragmented, discrete lines. As a result, the viewer is never able to actually see the totality of all the movements that are superimposed in the technical processing of the video: in *Ballet mécanique*, ever larger amounts of elements are included, bottles, triangles, reflections of the camera in a swinging sphere, gears, chrome machine (or kitchen) hardware, and shop mannequin parts, in a way that challenges perception but also imagination. There cannot be a totality behind the cuts, but there certainly is more than can be perceived or imagined. At the same time, we have reached the total unrecognizability of the movement: no linear or qualitative unfolding identifies the motion, everything is reduced to repeatable units and to their mathematical relation (the division of over 300 shots in 15 minutes of silent film, in Léger and Murphy; the addition or juxtaposition of 1 visible + 3 invisible frames, in De Bemels).

Translating this numerical conceptualization of dance into scientific terms, we can use Mandelbrot's theory of fractals to understand the geometric composition of De Bemels's *Light Body Corpuscles* not as a *simple* numerical line but as something that is *more than a surface and less than a volume*: a presence of infinite possible points in finite discreteness.[33] The image of the cubist broken line thus becomes like a *fractal sponge*, allowing us to see the double perceptual geometry built around the digital bit: a

geometry of simultaneously discrete and turbulent behaviors, one in which the combinations between the digital units overlap with the infinite variations, or with the infinitely variable curvatures of the bits, the lines, and the planes, *in thought*. The fractalization realized in the image is in fact peculiarly led by the binary logic of the digital, a fractalization that we could more specifically define as *di-fractal*: the image starts to fluctuate, from one body to the other, from one face to the other, and then from fold to fold, the digital collage enveloping a spongy, cavernous world. More than a question of determining a point in-between two points, it is a matter of always adding a further bifurcation, transforming every binary break into the locus of a new curvature, like in a maze, a meander, or a labyrinth. Movement becomes a dual vortex. It is the vortical shift between the two identities of the hermaphrodite, but also the quick motion of Janus, the double-faced God always looking in two opposite directions, the principle of a composite body executing the same sequence of movements but in different spatiotemporal dimensions: while the body is double, each figure (male and female) also shows two sides (left and right) alternatively.

We can conclude by saying that digital videochoreography cannot simply be seen and heard as an object of aesthetic perception in which, as argued by Brian Massumi, "the digital is sandwiched between an analog disappearance into code . . . and an analog appearance out of code."[34] Differently from this definition, the coding itself seems to have acquired important consequences that cannot be limited to the sphere of sensation but take on a wider imaginative field. What digital videochoreography brings to light is a *cutable* nature of movement in thought that is like a presupposition, a necessary correlate through which human and technological perception both realize their samplings. It is only in this sense that we can bring the cut back to a *cutability* that is the object of a purely mathematical (rather than organic) intuition. This cutability is in fact the corollary for any abstract choreographability of movement, the thinking machine or conceptual logic of any technological and choreographic system.

The Image, between Sensation and Imagination

Every concept or idea is always registered in the body as a sensation. In "The Evolutionary Alchemy of Reason," Massumi talks about sensation as an excessive dimension of the body infolding, and doubling, physical perception.[35] On the same level of bodily abstraction, it can be added, we also find thought: an unfolding of possibilities that is always interconnected with sensation. Sensation and thought, in other words, constitute

an abstract continuum. We can now understand the criticism that usually runs through the analysis of digital choreography, as well as of many other digital images: the abstract continuum of sensation and thought (and, consequently, *aesthetics*) is often intuitively associated with ideas of continuity, of analog self-variation, rather than with the discreteness of digital sampling.

And yet sensation can be associated with an analog entity only when it is opposed to the cerebral discontinuity of thought, and only when it is conceived as a specifically muscular, tactile, or visceral feeling. But in fact we should remember that the virtual continuum of sensation and thought is certainly not the equivalent of what we physically perceive as an actual continuity. In the same way, the physicotechnical apparatus of videochoreography cannot be simply reduced to the qualities emerging from it.

Now, it seems that the digital composition of videochoreography takes dance (or choreography as the thought of dance) toward an abstract imaginative dimension based on combinations of pure numbers. This is why the technical break between the three different technologies of analog cinema and electronic and digital video does not seem fundamental in the speculative evolution of the genre. By contrast, what seems fundamental is the distinction between different kinds of sensation and image logics (or nexus) with their corresponding concepts. In the digital logic, the dancing body is not sensed in the continuity of its motions but in their cut; this body is not recognized through causal perceptions or qualitative sensations, but is only mathematically thought. Dance is dehumanized, deformed, dequalified, and finally imagined as a relation between numbers. The dance image, in this sense, becomes a numerical nexus possibly transduced into the figurations of a moving and dancing body.

There are many possible transformations, almost imperceptible passages, and also combinations between causal, presentational, and numerical nexus. It cannot be said that one is more important than the other, whether more beautiful or more profound. All that can be said is that the organic continuity of a dance step does not give us its quality, which in its turn does not give us its numerical composition. The causal nexus of the first short films reconstitutes the dance in its empirical form, in an extrinsic relation of before and after, even though alternated or inverted. In electronic video (and modern cinema), by contrast, the qualitative image presents us with a pure image of time, and the dance subordinates itself to temporal and physical forces. In the same way, we can summarize the constitution of a numerical nexus in videochoreography, and the new numerical feelings that it implies or initiates. What characterizes the numerical nexus as

specifically digital is in fact the strain created by the algorithmic combinations of the software: a limitless-limit relation, a limitation of the infinity of computational thought by the specific finitude of the algorithms. It is the way in which the numbers (or bits) of the digital are felt, and also feel each other. We can in this sense conclude this discussion by arguing that our way to relate to the digital videochoreographic image is by going through both its affectivity and its definition, which are both numerical.

But the specific *points* of a dance are not totally lost in this numerical world: what is lost is the recognizability and the quality, and what remains is the cubist composability of the movement. In this way, digital video gives us a continuum that is no longer a continuous line of modulable qualities and forms, but the extensive continuum of all possible structural and mathematical relations between them: a germinal choreographability. It is therefore true that digital videochoreography shows a much stronger proximity to the first dance films than to many electronic dance videos: Loie Fuller's divisible flow, as a magnetic wave already anticipating and attracting the cuts of De Bemels's digital videodance.

II Remembering the Dance: Mov-objects

Having introduced the intuitive logic of the digital cut, we need to finally clarify the nature of the cut, and thus the very possibility of cutting movement. The essence of a cut is to determine a discontinuity in flow. By cutting movement into images, the faculty of imagination reveals an objective and discontinuous nature: as a tendency toward definition, it determines the appearance of beginnings and ends, of imagined objects, in the field of perception. Memory, on the other hand, is the faculty that makes us retain a particular object beyond the duration of its physical perception, preserving the cut image (and its idea) beyond the field from which it was cut, in other words allowing us to grasp it as an object in itself.

For the moment, therefore, we will define memory as the transformation of the cut into abstract object. As Deleuze reminds us, there is nevertheless a paradox of memory: it maintains the images abstracted by the imagination as infinitely *repeatable*, but this repeatability is accompanied by a change: we remember the same thing again and again, but our relation to it is different each time it returns.[1] In fact, in order to reconstitute the particular object as distinct, memory has to be a future extension of the imagination.[2] But the correlation between imagination and memory does not affirm itself without differentiation and separation, as the example borrowed by Deleuze from Bergson makes evident: "Four o'clock strikes . . . each stroke, each disturbance or excitation, is logically independent of the others, *mens momentanea*. However, quite apart from any memory or distinct calculation, we contract these into an internal . . . impression within this living present or *passive synthesis* which is duration. Then we restore them in an auxiliary space, a derived time in which we may reproduce them, reflect on them or count them like so many quantifiable external-impressions."[3] Imagination is the compression and cutting-out of the strokes in one perceptual impression; memory (very importantly associated by Deleuze with the intellect and calculation) gives them back their objectivity, making them appear in a different, divisible form. Memory is a repetition of the imagined, but

each time with a change: a change that is of the relation, more than of the remembering subject and remembered object in themselves. There is, in fact, a difference between empirical memory, which is always inseparable from imagination and still perceives the remembered object, and transcendental or pure memory, a memory that is only the abstract faculty of "remembering" a different relation between the object and the subject.

The repeatability or reproduction of movement as an object is emphasized by technologies of motion capture: from the imageability of movement to its preservability. Take, for example, *Hand-Drawn Spaces* (1998–2009), a performance realized by choreographer Merce Cunningham in collaboration with Marc Downie, Shelley Eshkar, and Paul Kaiser, the multimedia artists of the Openended Group. A series of colorful hand-drawn silhouettes dances on three black screens, respectively positioned to the viewer's back, left, and right. The only content viewers can initially give to the experience of the image is that of an actual perception: the empirical is that which is given to the senses; in other words, colors, shapes, and their displacements. But then we note that the dancing figures seem to be moving across the three different screens that surround us, as if they were traveling in and out of the projected image: the dancers are not only actually perceived as performing on screen, but they are also simultaneously thought as existing and moving in a wider, virtual area. This virtual area is memory: the image perceived on the screen continues its virtual life in the abstract space of remembrance. The actual perception is that of a group of colorful silhouettes dancing on the confined space of a screen, but the dance retains a virtual life as the impression of a movement that has already happened and yet is still happening across the screens.

But what exactly is this virtuality? All moving or dancing bodies, either digital or alive, either perceived or remembered, possess their own *virtual twin*, a sort of infinite extension with infinite possibilities that can only be thought as a concept and simultaneously felt as a sensation, rather than perceived as a geo-anatomical entity or a physical law. It is only by getting its feet back on the solid ground of the actual that the body acquires a position and physically learns its own limits. Following Deleuze's own definition, a pure memory is a virtual twin. Can a motion-captured body dancing on the screen also be thought as virtual? If we look again at the electronic dancers of *Hand-Drawn Spaces*, the dancing bodies are not there anymore: they are simply memories; furthermore, the elusive blurring of their contours and the lack of a solid ground (or stage) for their performance gives us the immediate impression of an indeterminate potential, an impossibility to precisely metricize or delimit the heights of their jumps, the durations

of their spins, the ratios of the relation between their wingspans and their elevations, their movements apparently melting and shading in the black void of an imaginary thought. In fact, a closer look at the actual composition of the image reveals its internal constitution as the result of exact metric calculations and of precise design processes: the hand-drawn dancers are actually trapped into the Cartesian net of a piece of digital animation software. The memory has been empirically programmed.

Performance/installations such as *Hand-Drawn Spaces* or *Biped* (1999), also realized by the Openended Group in collaboration with Cunningham, "took motion captured movement from Cunningham dancers and used it to drive hand-drawn, digitally animated sketchlike figures in a 3D landscape. . . . As discontinuous segments lasting from fifteen seconds to four minutes, Kaiser and Eshkar's motion-captured bodies materialized in a multiplicity of visual forms such as dots, sticks, lines, and Duchamp-inspired cubist forms suggesting early chronophotographic forms."[4] Recording the dancers' gestures through an apparatus of magnetic sensors attached to the key joints of the body and to infrared cameras, digital motion capture allows a representation of dance steps as patterns of points in space, simultaneously transforming movements into a series of *information objects*, numerical data to be reconverted, for instance, into 3D files.

In motion capture and animation software, what we have thought as the infinite virtuality of movement thus becomes visualized as a series of algorithmic paths traced by points, the points in turn resulting from the calculation of parameters and their relations. The program only seems able to remember and manipulate movement's limited physical possibilities, rather than its infinite potential: for the computer, infinity becomes a number, or a string of numerical data expressed in binary code. But is this string of data, the points and lines remembered by the technology, really ontologically different from a virtual body? Or can the digital variables preserved and manipulated by the program (as variations based on relations that remain constant in the computer's algorithm), stand for what Deleuze defines as the virtual "variety" of ideas or, as he also defines it, a variation of relations themselves, which is ultimately for him the object of a transcendental (rather than empirical) memory?[5]

Before moving on to the discussion of remembered movement, it is important to remind ourselves of how the transformation of perceived movement into a dance image relates to its imagination, and also, more importantly, of how thought intervenes in this process. If we wanted to define this intervention by following Deleuze's and Whitehead's terminologies, we could say that thought is that which derealizes and virtualizes perception, or the

ingression of ideas in perception, and that which transforms a sensation into an image. But what is the continuing role of thought, when an image becomes memory? And can this virtual role have any kind of relation with the rational capture and calculation of data at the basis of technological preservation? Can a virtual body be countable? This part of the book will try to deal with these questions, by exploring several examples of motion capture as ways to remember a dance, or to differentiate and repeat it through time.

What a Dancing Body Can Do (Desubjectifying the Motion)

By underlining the importance of organic physicality in the live performance, many phenomenological critiques of motion capture have often highlighted the problematic use of numerical technologies to register the embodied experience of the dancer, considering the technical apparatus as a simple recorder of the performative event and its throbbing aliveness. In these readings, the notion of a body-subject is often maintained as a constant background presupposition, like a perceptual and performative point of reference whose spatial and temporal awareness is strangely disembodied and desubjectified in the cyber realm.[6] Disembodiment and desubjectification are in fact key when thinking and defining the virtual. Instead of phenomenologically describing motion capture as an event experienced from a subjective point of view, and instead of addressing issues such as the relation between the bodily self and the technological other, or corporeal notions of bodily confines, questions on the status of the captured objects, and on the relation between technological preservation (or notational repetition) and transcendental memory as change, need to be asked.

One of the main limits of motion capture technologies has also been discussed by Erin Manning, this time from a radical empirical perspective, and with particular reference to its incapacity to reflect the desubjectified (virtual, or incorporeal), rather than subjectively embodied, dimension of movement: the technology as incapable of going beyond the predefined perimeter of already actualized human gestures.[7] Adopting Bergson's immanent philosophical approach, Manning defines movement in its intensity and incipience, rather than its quantifiable execution: without being reducible to a physical displacement from A to B, movement *already* happens when and where the gesture is an *almost* articulated form, and the body is *not* an individual performing subject *yet*, but "a sensing body in movement . . . that is involved in a reciprocal reaching-toward that in-gathers the world."[8]

At the same time, all reciprocal relations between bodies are to be intended as potential: perception, for example, is like a mirror whose strength reflects

the potential action (or affection) of one body upon another, and vice versa.[9] Bergson's conceptualization of movement and perception as open circuits continuously sinking into a field of half-actualized relations or suspended states allows us to expand the phenomenological concept of an enclosed subjective displacement into a virtual, incipient dimension of relationality. "In dance," this dimension "is felt as the virtual momentum of a movement's taking form before we actually move . . . the pulsion toward directionality [that] activates the force of a movement in its incipiency. It does not necessarily foretell where a movement will go."[10] In the encounter between movement and philosophical immanence, dance becomes a matter of relational intensity and potential, rather than of individual intentions and power.

When a movement is motion-captured, Manning argues, digital technology breaks its virtual wholeness, dissecting its potential relational web and mapping it into bits of numerical data. In order for the mapping to work and for the capturing system to be able to read the motion, a specific (and very limited or simplified) kind of gesture is required, a linear, clearly traceable displacement replicating a sort of gestural conformity to the software, diminishing what a body can really do. For Manning, the unmappable virtuality of a movement's preacceleration, or the virtual tendency of the body toward movement, toward relation, is what allows a displacement to take place and form. At the same time, relation is also what allows memory to be generated, for example, in rehearsal, during which it appears not as "a recurrence of the same," but as "difference embodied through movement": remembering the relation and its potential changes as recollecting the future. On the other hand, a visible, already actualized movement is all that is necessary for software detection, usually a displacement of a limb or of the whole body across space; the virtual double or twin of the gesture is left out of the picture. Taking these arguments as challenging questions posed to the philosophical reading of motion-captured dance, *Moving without a Body* will try to refasten the virtual intensity of movement and the relational nature of memory with the numerical character of digital technology, associating the interest of what a body can do (while dancing) to the exploration of what a technology can do (while capturing): does numerical memory have a virtual side?

What a Technology Can Really Do (Reobjectifying the Potential)

Aspiring "to give us the dance minus the dancer," technologies of motion capture cut the continuity of performed movement into a few structural

elements (points-lines corresponding to gestures and steps, bodily align-ments, speeds and rhythms), abstracting movement from the body and transforming it into numerical data.[11] The aim of the following pages is to argue that it is exactly their numerical nature that transforms motion-captured data patterns into what will be defined as *mov-objects*: virtual movement objects different from physical perceptions, to be differently actualized in the memory of innumerable repetitions.[12]

Indeed, the first two necessary and critical tasks emerging here are of an ontological nature: (1) desubjectifying movement, in order to bring to the fore its virtuality as a distributed, shifting relational potential (a movement that is sensed as much as it is empirically performed/perceived/remem-bered), as Manning does; and (2) reobjectifying this potential into an infin-ity of potentially countable objects, in order to reconcile the digital with the virtual, by defining the latter as an infinite series of computable, and infinitely relatable, ideal steps. These desubjectified mov-objects will then be reconciled with the possibility of remembering the movement as dance, a possibility in which simple memory (or repetition of the countable) is coupled with difference, a difference in the relation of the steps, deriving from the belonging of the repeated objects to the virtual field of thought. It is in the coupling of difference with repetition (or in the change that always haunts the counting) that the dance appears.

But why, and especially how, objects? In the history of philosophical thought, it is possible to distinguish two different sorts of anti-Cartesian (anti-subjective) ontologies: the Bergsonian concepts of a continuous tem-poral duration and a continuous bodily relationality, and the Whitehead-ian concept of "objectification" (or the process of becoming an object).[13] Objects are usually thought of in terms of their impossibly static, inertly cold, and discretely isolated persistence. The definition of mov-objects given here is aimed at reconfiguring these properties at three different lev-els. First, mov-objects do not block but constitute the virtuality and poten-tial for change of every dance; in this sense, the best philosophical parallel to be explored here is with Whitehead's concept of the eternal object. For Whitehead, eternal objects are "Pure Potentials for the Specific Determina-tion of Fact, or Forms of Definiteness."[14] They reveal how a new creation never occurs from nothing, or from the indefinite totality of chaos, but always from the indeterminate predefinition of a form, a virtual, eternal object (or an idea) implicit in the very materiality of experience and not simply reducible to conscious mentality. In the same way, mov-objects can be considered eternal movement objects, or the remembered ideas of move-ment, and compose the abstract potential for definition that subsists and

returns in the memory of all movements, while continuously varying in their relations.[15] It is therefore possible to rethink the static character of digital mov-objects in a virtual way. As an example, we could mention the codified nature of motion-captured movement data libraries as ideas continuously returning in many dances, together with their infinitely downloadable, reusable potential.

Second, rather than confirming the basic ontological aporia between movement as a material experience and its abstraction into cold, rational figures of the mind (or of the software), the concept of movement and choreographic ideas as mov-objects builds a connecting bridge between the empirical dimension of movement and the abstractness of the mind. Numbers, points, and lines in fact always result from the spatiotemporal thickness of events, from which they are abstracted, abstractly experienced (or experienced as abstractions) through a rational operation. This abstract operation is the rationality that allows recollection: a mind is always rationally thinking, while a body is moving, perceiving, or remembering. Rationality, in this sense, coincides with the same operation that Whitehead defines as "extensive abstraction," a process through which events can be thought, and therefore remembered, as surfaces, lines, or points, by virtue of their own capacity to become surfaces, lines, or points (rather than just by virtue of an intellectual operation performed by technology or the human brain).[16]

Once again, the parallel with the notion of eternal objects is more than evident, resonating with Whitehead's formulation of the concept as a way to express *how* the constitution of any actual entity is analyzable into phases, spatiotemporal sections or regions of experience from which abstract surfaces, lines, and points logically derive. Cold processes of abstraction and rational analysis lose their purely limiting and limited aspect and become the synonyms of a different, parallel virtual experience of the body-mind. Memory is comprised out of this experience, through which the process of rational abstraction gives place to an abstract image that repeats but is different from that of imagined perception. The returning ideal image of a movement can appear and be repeated as a pattern of points: memory as rational. The best example from the field of digital design here would be the *spline*, a polynomial curve or a fractal surface (a digital region) interpolated with control points aimed at the drawing of a smooth shape.

Third, the definition of these remembered movement ideas as rational objects is not to be interpreted as an attempt to emphasize the discrete rather than the continuous nature of movement's virtuality: rather, ideas are to be paradoxically considered the basis of all processes of continuous

relation *and* discrete individuation. Mov-objects are always relational *and* individual. The main example, in this case, will be the relational nature of parametric design. By transforming dance into a series of precise parametric objects (or data) in constant relation, motion capture software can allow, for example, the pirouette to always be perceivable and thinkable as a pirouette, a discernible individuation to be actualized in different ways (or styles). At the same time, the movement parameters of a pirouette (torque, jerk, center of gravity, center of mass, hip and ankle movements, etc.) are revealed by the software as connected to each other in such a way that a change affecting one of them corresponds to a change throughout the whole system (or the whole gesture).

It is important here to reiterate that the redefinition and distribution of movement into a series of virtual, rational, and relational objects is intended first and foremost as a way to desubjectify it and distinguish it from its mere organic or phenomenal embodiment. Mov-objects do not belong to any body-mind (and certainly not to that of a computer or a choreographer), as they constitute the virtual ideas that cross all bodies, algorithmically guiding or weaving the structure of every movement as dance. The description of choreographic memories (or data, splines, parameters) as algorithmic repetitions of mov-objects thus can be seen simply as a way to connect the fields of technology and choreography with philosophy, and also to reconnect different spaces and times, linking, for example, the pre-Socratic atomist conception of turbulence (Lucretius's "clinamen," difference appearing in nature as a deviation in the fall of the atoms), to the most recent explorations in parametric design: movement as formed of an inextricable repetition of ideal objects, a crowd of subliminal atoms with an ability to swerve away and deviate from their linear path. Mov-objects as the swerving atoms of choreographic memory.

10 Can Objects Be Preserved?

Singularities

Memory is a form of thought, a mental faculty that in its purity, according to Deleuze, directly links reminiscence to the realm of forgetting: that which can only be remembered (but not perceived, for example) is the object of a transcendental memory, and can never be the object of empirical remembrance.[1] Empirical memory is inextricably linked to perception, but transcendental memory is a way to define the work of remembrance as pure. Several systems of dance notation (i.e., analytical records of the dancer's body movements in relation to space and time) have for a long time been operating as forms of codification and remembrance. But it is a historically acquired fact that all notation techniques are afflicted by an essential form of forgetting.

Already in the Renaissance, alphabetical codes were adopted in order to spell out a dance sequence: in the line "R 9 p p de de de p re re re," for example, each letter corresponds to a step ("R" for *reverence*, a formal bow, or "p" for *passo*, a forward step followed by a closing of the other foot).[2] The extensive repeatability and reproducibility of motion implicit in these old notation systems as well as in modern systems such as Labanotation, seems to stand in diametrical opposition to a simple fact: movement is an always intensive, undescribable and therefore unrepeatable experience. Defining movement as an indivisible and unrepeatable continuity indicates that one step is always in relation not only to the following one, but to a multiplicity of potential steps not actually taken. It is this particular relation of the step to its intensive potential that constitutes movement's rhythm: the in-between of movement continuously folding into a centrifugal vortex or a spiral. Impossible to repeat.

The simple act of walking already shows this impossibility. At every step, the walking body goes into a fall (law of gravity), simultaneously managing

to regain its equilibrium and fly forward (escape force): "At every step you ground and orient yourself, using gravity to propel you along your habit-ridden line of daily actions."[3] You can certainly remember how to walk, and even note down the steps on a piece of paper. But midstep, a spiraling hiatus of virtual suspension or an unrepresentable swerve appears. The operation of cutting a step thus reveals its fundamentally paradoxical nature, because each and every step will always be inextricably connected to a series of intensively infinite and infinitely relatable potentials: between falling and walking, ground and air, left and right, how can you really delimit and describe, remember, the real form of your step?

Already in Plato's dialogues, the explanation and description of forms is framed in terms of their essences, of those geometrically characterized essences (for example, the perfect essence of a sphere) that act as ideal metaphysical entities. In classical ballet, *arabesque* can be defined, for instance, as a precise and ideal form: "a line emanating from the hip, at least 45 degrees from the floor, defined by the foot in relation to the hip and going up there to 180 degrees for a 'penchée.'"[4] The problem with this conceptual definition of form is that the difference of each particular, concrete *arabesque* becomes reduced to its resemblance to a general, repeatable concept of the perfect *arabesque* (a reduction of concrete materiality to the imitation of an abstract form).

The essentialist explanation of form is also relatable to the notion of a natural (rather than conceptual) repetition: in this sense, a danced form such as that of the *arabesque* becomes explainable through the return of some immutable physical principles, such as gravity and torque; these principles shape and limit the body's *arabesque*, allowing for a series of variations while maintaining the limitation of the form, in the same way in which a river always remains the same river throughout the flowing transformations of its water.[5] Repetition thus becomes the rigid heritage of nature: in the universal grid of physical and anatomical possibilities, the capacity to create formal novelty can only be generated by a rational bending or challenging of the law (the virtuosity of a gravity-defying *arabesque*, an opposition of rational calculation to natural force). This time, the difference of a rationally produced new form is diametrically opposed to the repetitiveness of nature: the body remembers gravity and escape. The result is that both conceptual and physical explanations define difference as simply resembling repetition (when the body resembles the concept) or as opposed to repetition (when reason, or calculation of the mind, is opposed to the body and its natural laws). The fundamental question that remains unanswered is how to explain difference *and* repetition, what persists *and* what mutates

in the form of a step, or how to preserve immanent patterns of being *and* becoming, of nature *and* reason, in dance.

According to Manuel De Landa, differential geometry is the intensive science that allows Deleuze to explain form as an immanent tendency (such as the tendency of water to change shape and become ice or steam at certain critical points of temperature): form as the attractor (rather than the physical law or concept) regulating the behavior of material systems.[6] These formal attractors can be distinguished into *singular* (in the sense of rare and remarkable points) and *ordinary*: whereas nothing remarkable happens, De Landa argues, at 99 degrees centigrade (or 98, 97, 96 degrees), something special happens at 100 degrees, when water becomes steam. Singularities have nothing to do with signification, but only with significance: any critical point makes a difference when reached.[7]

It is only in this sense that repetition can acquire a more positive, rhythmic nature: not as "cadence repetition" of the same (the same concept, the same physical pattern), but as a "rhythm repetition" of problematic singularities, or points of differentiation where something new appears.[8] Cadence repetition, or imitation, could for example be associated with the relation between a concept of the *arabesque* (as given in dance notation) and a resembling imitation (as performed in dance rehearsals): repetition in this sense only acquires a regulatory, ordering role, allowing the correction and perfection of a movement. On the other hand, every repetition has to become a productive return of difference, in order to be rhythmic: "It is the difference that is rhythmic, not the repetition, which nevertheless produces it: productive repetition has nothing to do with reproductive meter."[9] In other words, what is really repeated, or returns, is the singularity of ideas, such as the idea of a rotating ankle as the singular or problematic point that always stays the same in all *arabesques*, while always making a difference in every *arabesque*. Every time a remarkable or distinctive point of a body (for example, the ankle as an abstract point of the notation's score) combines with, or relates to, that of another body (for example, the dancer's ankle as a concrete anatomical point), a difference is generated: from one gesture to the other, difference is carried not alongside imitation but throughout a progressive repetition of singularities. This is memory, or what makes of the repeating body a remembering mind. Rather than being physically contingent and external to the abstract concept, or rather than being conceptually programmed and external to the physical body, the difference of a dance form becomes internal to an idea.

For Deleuze, the profundity of actual qualities and quantities (for example, rigidity and softness of the limbs, or the amplitude of an *arabesque*)

differentiates itself (but is always immanently coexisting with) the superficiality of ideas (the idea of a rotating ankle, or a form in the mind manifesting itself as a specific configuration of the physical body).[10] With a different terminology but a similar ontological operation, Whitehead describes the transcendental creativity (transcending, for instance, the law of physical gravity or the rules of choreographic perfection) that objectifies (or actualizes) an idea: actual movements are attracted or drawn by tendencies or movements to come.[11] At the same time, these tendencies become persistencies, or movements-come, when remembered.

But how are they remembered? In Whitehead's words, eternal objects do not have a preexisting subject, but neither are they separated from the material dimension of experience. Whitehead defines this experiential relation as the combination of a "conceptual" and a "physical" feeling, while William Forsythe describes it as an "intelligent sensation." A choreographic idea or a movement-come can be, for example, the idea of *arabesque* or *épaulement*, the latter conceptually indicating a precise relationship between the head, the hand, and the foot, and the consequent turnings and counterturnings or countertwistings; and, at the same time, *épaulement* as a "sensation in the neck."[12] Only when this tendency toward a feeling of the *épaulement* is "satisfied," or when the formal aim is accomplished as sensation and thought, do concrete subjects (dancers) and objects (dance steps) emerge to empirical memory.[13]

When the mnemonic occasion terminates, the individuality of the *arabesque* or of the *épaulement* as accomplished steps, taken beyond their processual character, becomes in fact immortal, or *eternal*, in the sense that it becomes the potential object for another occasion of experience (for example, another memory of the dance): a mov-object. The step abstracted from its performative concrescence is like the outcome separated from the process, and therefore a virtual idea without actuality, a universal form of coordination. The step, as Whitehead would say, "never really is" and is always perishing, at the same time becoming an objectification beyond itself: an immanent transcendent object.[14]

In the same way, Forsythe defines ballet as an art both "physically engaging and intellectually challenging,"[15] a code or a universal mathematics, "a matching of lines and forms in space" as the abstract objects that continually generate difference. The conception of memory as a repetition and difference of transcendent mov-objects is clearly illustrated by Forsythe's particular approach to the choreographic score, and by the way in which he conceives the mnemonic repetitions and reactualizations of the dancers in relation to it. First of all, it should be noted how his

idea of choreography is an analytical one: his investigations of ballet are in fact always aimed at analyzing its spatiotemporal system.[16] Mov-objects appear in Forsythe's analytical choreographies as patterns of points, lines, or forms in space. More specifically, Forsythe's mov-objects derive from Rudolf Laban's description of the body's "kinesphere" as a crystal form, an immutable three-dimensional geometry generated from the constant limits (degrees of freedom) of the outstretched bodily limbs, and marking 27 spatial points that tilt and rotate with every movement.[17] The kinespheric movement cube surrounds the body to the front and back, right and left, top and bottom, always remaining in a fixed relationship to it, a sort of portable metric grid always traveling with it.

This schema is delineated "without stepping away from that place which is the point of support when standing on one foot."[18] At the same time, this fixed model rests on the stability of a central gravitational point in the body, a *sameness* from which movement emanates and through which all movement axes pass: from here, the model "unfolds into a virtually infinite number of possible planes delineated by the axes that transverse the body at that center point."[19] Using Laban's kinesphere, each different gesture can be *Cartesianly* codified according to the same axial coordinates: movement becomes a varying repetition of a series of basic returning units.

Forsythe's innovative adaptations of Laban's kinespheric model (such as in *Die Befragung des Robert Scott*, 1986, a dance based on the idea of "losing your point of orientation") develop from the following questions: What if a movement does not emanate from the center? What if there are more than one centers? What if movement emanated from a line or a plane and not simply a point? Movement is generated from any bodily point, rather than coming from legs and arms around the trunk. Unlike the classical ideal of ballet so clearly imagined, for example, by Heinrich von Kleist, the center of movement in Forsythe's dance does not originate from the body's center of gravity in an ordinary way, and thus the ideal of the classical dancer as a puppet breaks down. A new way of moving appears, one in which the origin of the movement (or, in Kleist's terms, the "soul") positions itself not in the body's center but, for example, in the elbow, which becomes the center of gravity, resonating with other bodily parts that, in turn, instantiate new movements and form new centers.[20] Playing with singularities, rather than being directed by rules, Forsythe's dancers are indeed more than puppets, constantly making decisions within balletic structures, and constantly reinventing them.

In this sense, Forsythe's nonabsolutist choreographic scores seem to ask: Is it possible with *this* velocity to accomplish *that* particular combination

of points?[21] What returns in the scores are always points and lines as problematic ideas, rather than already experienced physical facts or ideal concepts of perfection. Using a redefined kinespheric physics of multiple singular points as a spatial framework, Forsythe employs a series of movement algorithms to think dance as a sort of "regenerative system": it is, in other words, as if his dancers were remembering each dance by drawing formulas and equations through points and lines, in order to solve a complex movement problematic (or to execute a choreographic algorithm) and to reconstruct the dance. To find a performative solution, dancers rapidly scroll through a list of possible mov-objects: "When the force of gravity throws them into another configuration, for example, they have to analyze themselves and their current state in relation to the entire piece."[22] Dancing the choreographic score of *AlienAction* (1992) is, for example, described by Forsythe as like navigating levels on the computer: one can't just move directly sideways to the desired destination; one has to go down to a different floor, cross over, and move back up. What is thus remembered by the dancers is not only the dance as an accomplished product, but also, as Forsythe reminds us, the shifting knowledge of how to produce it: the dance performance as an operating system.

Forsythe's complex conception of choreographic notation is clearly represented in the interactive CD-ROM *Improvisation Technologies*, created for him by the Center for Art and Media Technology (ZKM) in Karlsruhe (2000). In this work, "by superimposing computer renderings of the drawn lines and shapes over video recordings of him performing them, [Forsythe] could show his mental visualizations as clearly as his physical movements."[23]

In the notational videos of *Improvisation Technologies*, a line is, for example, established with a simple gesture or by making a crumbling gesture; it is drawn with little hops or by rubbing it on the floor; it is composed by making little dots or by moving between them. These simple but sophisticated definitions echo ancient notational systems and their capacity to abstract dance into a series of elements, points, or basic shapes: according to the choreographer, "You could look at your fingerprints, or a three-dimensional object, and understand how it functioned as a two-dimensional plan. Then you physically retranslate it back into a three-dimensional event."[24] In fact, what differentiates this model from old notation is the possibility of creating innumerable transformations by the repetition of a basic position or key frame, or by ever-changing variations on themes (such as in his choreography *Limb's Theorem*, 1990). The basic positions and key frames, points and lines, appearing on the screen are thus the abstract objects of mnemonic repetition, always returning with a difference. Memory becomes able to

Figure 6
William Forsythe in *Improvisation Technologies* (CD-ROM by the ZKM, 2000).

retain the potential for swerve that is implicit in the objects; it becomes change. The *abstractability* and *describability* of dance as a system of mov-objects open to change is also at the basis of Forsythe's project of a movement database, in which movement is split and stored as a library of 135 basic chunks, or virtual singularities of movement, and whose most recent version is represented by the Motion Bank.[25]

11 Can Objects Change?

Calculus

More than 100 years before the production of Forysthe's CD-ROM, various apparatuses of movement tracking were already attempting to mechanically record the physical complexity and continuity of motion. In 1873, Étienne-Jules Marey's experiments with chronophotography realized a first form of visual capture of the pulses of a galloping horse.[1] Marey considered the motion-captured body an animate machine whose motion is subject to the same universal forces (and laws) that are applicable to any moving object (animate or inanimate).[2] His experiments combined different techniques: a series of successive camera exposures and shots used to capture different key points of motion, together with a series of electric and pneumatic sensors and with pressure chambers distributed on the moving body.[3] At the same time, these studies allowed the scientist to formalize movement's forces into physical principles, nurturing the illusion of a possible mathematical prediction, an attempt to find comprehensive solutions to physical problems, through the deployment of laws or axioms. But more than for its functional efficacy, Marey's formulation of movement laws appears today as particularly relevant for its capacity to abstract the concreteness of motion into irreducible formulas.

Today, movement is digitally recorded as a set of data, or kinematic information, obtained from the position, rotation, and acceleration of various sensors placed on the body's joints.[4] Many of these motion capture systems are often connected to specific animation software in which the captured data are *cleaned* (filtered of all noise) and given a *skin* (i.e., a graphic body). But despite its very sophisticated achievements, computer animation is often still considered haunted by an awkward and somehow syncopated aspect and by a lack of fluidity, an aspect directly relatable to the discrete

nature of the digital, but also already appearing with the discrete cuts of chronophotography. In the 1980s, computer animators started to focus on software solutions to this problem—for example, by interpolating a set of keyframes in the syncopated in-betweens of the captured motion, in order to make the movement appear more fluidly real. Marey's own research has significantly contributed to these adjustments, and his formulas are still being integrated in the underlying algorithms of computer animation programs.[5] Nevertheless, even the most sophisticated of software remains inevitably trapped in the same infinitesimal maze, with further in-between micromotions always being interpolatable, without ever reaching the ultimate goal of a totally continuous motion. We should not forget that the insolubility of a problem is often the indicator of a false, or badly posed, question: in this instance, might the software's incapacity be the indicator of a different potential? Rather than concentrating on a possible imitation of organic fluidity, the main interest of movement's technological capture could perhaps lie in mathematization itself.

Motion capture indeed reveals how the mnemonic preservation of a movement first of all depends on a rational operation (in this case, a mathematical calculation) performed by the mind in order to transform the image into an abstractly repeatable object. In this sense, analog and digital motion capture represent two very different forms of movement mathematization. Marey's experiments point toward a particular comprehension of movement, one that can be generally associated to the mathematical formulation of *differential calculus*. Originating from the atomist conception of the "clinamen" (as already seen, a declination of atoms in their free fall), the *differential* (as the object of calculus) is an indefinite and undetermined incident, an angle of deviation that indicates the function of a mathematical curvature, or the inflection point of a curve. In this mathematico-philosophical concept, atomist physics encounters modern mathematics: as Michel Serres puts it, reality can therefore be conceived not as a sum of infinitely small things, but as being comprised of a great number of subdivided events, angles, or curves.[6]

In the nineteenth century, Marey's chronophotographic experiments and physical formulas about the rotation of a falling cat acted as an important source of inspiration for the modern formulation of differential calculus.[7] According to this principle, knowing the successive positions of the moving body at successive short intervals of time, it becomes possible to calculate the change of speed (the curvature of the path or the inflection of the fold) at each of these points.[8] At the same time, the ontological implications of calculus lead to a philosophical conceptualization that is

fundamental for radical empiricism: the concept of point of view as an emerging, rather than preexisting, condition of experience.

Being among the first philosophers to equate experience with a mathematical process, Leibniz defined the soul as an autonomous individual substance (a "monad") whose point of view appears as a progressive restriction or compression of matter's elasticity into one particular position, or focus (subjective perception, but also the differential focus of a camera's shutter, as seen in part I, or the receptivity of a motion-capturing sensor). From this compression, reality starts to take form, while the subjective soul makes its appearance as "what remains in point of view, what occupies point of view, and without which point of view would not be."[9] Having lost its primacy as a predetermined source of experience, subjectivity becomes a compressive operation that can recognize and define (or conceptualize itself) as a subject (a "sufficient reason" for experience to develop itself) only after including an event as its predicate.

As a philosopher-mathematician, Leibniz associated the compressive experiential event of the subjective monad/soul to three mathematical operations: the creation of the infinite series of prime numbers (for example, the counting of 1, 3, 5, 7 steps . . .); the conception of an infinite combinatory logic of wholes and parts ($4 = 2 \times 2$ or 8:2, a step always composed of microsteps); and the definition of qualities in their continuous change. The latter was expressed as a form of differential calculus, i.e., the calculation of the limit between two series that are always convergent and that infinitely tend toward a limit (such as velocity and slowness).[10] Nothing predeterminedly human seems to characterize Leibniz's theory of the calculating soul: an experiencing subjectivity only emerges as the aftereffect of a process of internalization (a *folding*) reaching its most complex level. The Leibnizian concept of calculus thus seems to work as an indispensable philosophico-scientific precursor for more contemporary definitions of subjectivity in machinic terms, in which what constitutes a subject is only the effect of an assemblage, a fold in the flows, an event generated by the contraction/dilatation of matter and the calculation of potentials (as is also the case with Whitehead's notion of the "superject").[11] In this sense, Marey's chronophotographic apparatus could be seen as a proto-subjective machine, endowed with its own operational logic and point of view.

As a contemporary metamorphosis of this machinic subjectivity, Character Studio, the animation software devised by Eshkar and Amkraut for the design of Bill T. Jones's performance/installation *Ghostcatching* (1999) and other motion-captured dances, manages to calculate and remember the rhythms and patterns of gait-shifting across bodies, discontinuously

recreating the differential of how a walk turns into a run or a canter into a gallop.[12] The software, in other words, complements the motion capture's sensitivity by calculating acceleration and gravity, the complex dependencies between all parts of the anatomy, multiple joint rotations and limb extensions moving simultaneously at different rates and intensities. This allows a recalculation of center of gravity and the adjustment of movement balance in the animated figures. The software, in other words, becomes a Leibnizian calculating monad, a machine with its own operational logic.

Topology

According to Gregory Chaitin, there are things that no computer can calculate: incomputable events, or infinities that are like the black holes of any algorithmic machine.[13] The essential idea formulated by Chaitin is that, given a set of objects (such as numbers) generated one by one by a machine, and given an algorithm or a computer program for the realization of this operation (such as a computation), the computed algorithmic series will in fact always be dominated by incalculability, or a true endless, infinite quality.[14] It therefore becomes possible to think two different kinds of infinity: not only an uncountable infinity, the infinitely many transcendental numbers existing in each numerical interval (as already seen with the continuity of infinitesimals, and with the necessarily oblivious nature of memory), but also a denumerable infinity, or an infinite series of discrete, countable mathematical objects.

The first kind of infinity (continuous infinity) has been the ontological object of scientific theories essentially focusing on how, starting from the calculus of a mathematical differential, we arrive at a real multiplicity: topology, for example, is the study of the continuous transformations, foldings, and curves generated by inflection points, as transformations happening between homologous forms (the doughnut and the cup).[15] Topology, in other words, is the vision of the non-Euclidean, abstract structures that *continue*, or subsist, as the invariants of all transformational events. This scientific method is often generically considered an analog form of mathematical expression, whose main assumption is that transformations and differences are continuous and can never be exactly calculated (as a computer program would, for example).[16]

The apparent linearity of a movement—such as the simple gesture of raising an arm—would be visualized for example by the topologist's eye as a series of continuous microscopic contractions and dilatations, fluidifications and solidifications, of the body. From this point of view, modern and contemporary dance are often considered topological forms in which space

and time can no longer be disconnected. In fact, thinking movement topo-
logically does not imply any distinction between particular choreographic
forms—for example, of contemporary dance as a more fluid improvisation
opposed to the Euclidean rigidity of classical ballet. Rather than simply con-
centrating on the corporeal and cultural actualizations of a performance, or
on the way in which it falls into actual definitions of classical or contempo-
rary, pure or hybrid, the topologist forgets the specificity of different move-
ments, and underlines the capacity of all gestures for being continuously
imitated and changed, repeated and differentiated (by the same body at
different time and space locations, by two different bodies, by two different
cultures, but also by a moving body and a remembering mind).

In fact, the topological notion of continuity specifically refers to what
is shared between two objects or moments, what is invariant or, in other
words, what does not change and returns, in the passage from one to the
other.[17] It is, in other words, a way in which we can conceive the repeti-
tions of memory as continuous with perception. From a topological point
of view, difference only appears by rhythmically interrupting the repeti-
tion and continuation of the same, and by constituting a contiguity, or a
discontinuity, between past-present objects and their forms.[18] How do we
therefore deal with the ontological aporia of topology (also defined as *Leib-
niz's labyrinth*), with its fundamental oscillation between the continuities
of material facts and the necessity of reducing them to abstract mappable
points of discontinuous differentiation?

In the field of dance, the science of topology clearly reveals its main
paradox: even in the continuous deformation of two bodies performing
the same movement, raising an arm is always perceivable, rememberable,
and thinkable as the gesture of raising an arm, a discernible, measurable,
and even technologically mappable discontinuity to be realized in differ-
ent ways: a continuous discontinuity.[19] There are different ways in which
the dancing body can actually perform a movement. The angular nature of
Merce Cunningham's dances, for example, is like a development of straight
lines and angles in the body's skeleton, whereas Bill T. Jones's choreogra-
phies are characterized by "the undulation and quivering of liquid muscle,"
the dance "rippling in waves through his body."[20] Nevertheless, various
immutable continuities, or permanences, are distinguishable between the
two styles. In its different actualizations, a pirouette is, for instance, always
characterized by the balance and impetus of the turning body. In all cho-
reographic styles, these two features are obtained anatomically, thanks to
the deployment of particular bodily techniques: *spotting*, the technique
used to avoid dizziness while turning, prescribes that the head stays facing
one direction and the eyes focus on a particular visible point (the *spot*),

while the body turns; when it can no longer maintain its position, the head turns instantaneously in the direction of the turn, coming around to the original spot or to a new spot—depending on whether it is a full turn (360 degrees) or a half turn (180 degrees).[21] Head and body rotations are then synchronized in order to acquire the same average rotational velocity.

The impetus of a pirouette, on the other hand, is achieved by setting up a *torque* through pressure of a foot on the floor, which is released as a spin.[22] All different pirouettes depend on the isolation of these two main topological points, a spotting point and a torque point, which constitute the main topological invariants of the pirouette. At this point, we must reiterate the implicit contradiction between the function of point-spotting and the topological vision outlined before, of a fluid and uninterrupted continuity of movement as a sum of microscopic gestural articulations imbricated into each other, where it is practically impossible to isolate any precise point.

Before being identified with precise spatial and temporal locations, spotting and torque points are ideal topological invariants of a turn, which subsist while varying in the degrees and rates, position and geometric development, of both Cunningham's and Jones's turns. As inflection points, they are the genetic elements of the curvature: the point where the head makes a turn is an idea that allows Jones's and Cunningham's movements to be differentiated, a quantitative differential *given in* and not *imposable on* movement, that appears more as an unpredictable moment of change than as a predeterminable and fully formed concept of the understanding.[23] In Deleuze's philosophy, the definition of an idea is in fact a direct philosophical transposition from differential geometry, the study of continuous topological transformations at a local, or infinitesimal, level.[24] Differential geometry, in other words, calculates the infinitesimal inflection points that continuously generate the curves of topological deformations, at the same time offering an explanation for their morphological differences.[25] In the same way, we have seen how, for Deleuze, the appearance of an idea is a differential that generates the infinite folds and curves of movements and thoughts. Spotting and torque are also the main topological differentials that accompany the repetition of pirouettes in memory, while at the same time making of them a different event at each recollection. Movement is remembered as a sum or a multiplication of these points: not a homogeneous and immutable flow, but a heterogeneous and shifting patchwork of potential points of change.

Memory, in other words, undertakes a different reconstruction of the same movement, starting from its differentials. Between the perceivable beginning and ending points of a turn (the head starting in A and ending

in B), but also between all the points appearing between A and B, more and more infinitesimal and infinitely divisible points of variation can spring: the interval contains an infinity of potentials. It is the reason why you can never be totally precise in remembering a performed step: memory only selects a limited number of points and then utilizes them in order to reconstruct the motion. But many other points could have been chosen, many other forms could have been realized. And it is also the reason why digital calculations can never achieve a precise reconstitution of a step in its infinite potential. The topological paradox of memory between continuities and points, or between empirical reality and transcendental abstraction, thus becomes a fall into the vagaries of the infinitesimal, the abyss of intercalary series of points that are never the last: as if motion could really be stuck in Zeno's paradox, as if memory could really be the return of that which continues.

Mereotopology

Differently from Deleuze's differential theory of ideas, Whitehead's mathematical and philosophical mereotopology builds a connecting bridge between the empirical continuity of movement and the abstract, atomistic, serial differentiation of points.[26] The definition of what a mereotopology is derives from the juxtaposition between *mereology* and *topology*: whereas mereology is the formal theory of wholes and parts, its topological component allows it to study the relations between objects (the parts) in space. We can therefore define mereotopology as a mereology that studies not only the wholes/parts but the boundaries and interiors of wholes, the relations of contact and connectedness between wholes and parts, and topological concepts such as surface, point, neighborhood, etc.[27] The main conceptual components of every mereotopology are therefore two: *parthood* (or mereological overlap), and *wholeness* (or topological connection). Whitehead's mereotopology is a model of physical space in which the basic entities are regions (volumes, lumps, spheres) rather than points, actual regions determined by a continuity of potential cuts.[28] This system can also be defined as a topology of physical space from a region-based perspective, in which the main primitive relation between two regions is *to be in contact*: $C(x,y)$, which means *x is in contact with y*, *x is connected to y*, or *x is a part of y*. This continuity is not explained by the concept of infinitesimals or of convergence of two parallel infinite lines, but by regions of actual and potential relation, infinite divisibilities of actual occasions that are external to each other in their spatiotemporal dimensions. In this sense, what can be phenomenally

observed are not points but events (such as a specific movement of the arms in *port de bras*, or a bending of knees in *plié*) whose duration is always a slice, a region, or a section with a temporal and spatial thickness of its own. It is, in other words, as if every section contained a series of concentric sections, in a continuous relation of sections within sections within sections, all in contact with each other and degenerating or touching in a discreet (rather than infinitesimal) point. The point is to be rationally deduced as a logical and ideal limit of exact precision: the topological point of variation, when and where the knees and the elbows bend, or the head turns and the foot presses against the floor.[29] The actual spatiotemporal regions of events become in this way rationally thinkable as patterns of points.

What is at stake in this theory is neither the imposition of an external field of Cartesian points nor the internal dissolution of space-time into infinite infinitesimals, but a degeneration of smaller and smaller events up to their limit point, the object of an intuitively rational operation of the body-mind. Every region or entity can be associated to a point, and every relation can be considered a relation between points: it is by virtue of this conception of countable and atomic regions that mereotopology is often considered a sort of precursor of digital or computable topology, allowing for the application of topological notions to computer science.[30] The mereotopological schema is in fact also defined as a *point-free* topology, in the sense that the infinite curvability of space (points as infinitesimals) is transformed into a precise and infinite discreteness corresponding to the possibility of a computation that would not be realizable according to the logic of infinitesimal points.

This conceptualization does not simply reduce choreography to a transcendental grid. In fact, the mereotopological (or discrete/topological) theory of countable regions developed in Whitehead's notion of the extensive continuum is an experiential category: a category immanent to experience and deriving from its actualized forms. Adopting a sort of double cosmology, the philosopher explains how reason is never to be considered a transcendental intellectualizing process, but always as experientially coexisting with feeling. Two different kinds of feeling respectively correspond to the "mental" and the "physical" poles of every experienced event, physical feelings being moved, guided, or directed by an implicit focus, a conceptual feeling associated with a form that is aimed at (such as the idea of a point, or a set of related points). "Every occasion of experience is dipolar. It is mental experience integrated with physical experience. Mental experience is the converse of bodily experience. It is the experience of forms of definiteness in respect to their disconnection from any particular physical

experience, but with abstract evaluation of what they *can* contribute to such experience. Consciousness is no necessary element in mental experience. The lowest form of mental experience is blind urge towards a *form of experience*, that is to say, an urge towards a *form for* realization."[31]

The idea of a pirouette, for example, is first of all an ideal region or a relation between points, between a spotting of the head and a foot torque, as one of the eternal objects that populate the schema of a body's physical possibilities as an extensive continuum. The pirouette's form of definiteness is here to be intended not as a phenomenon obeying physical laws, but as the problematic posed by an idea, or a rational tendency toward a definite form.

The choreographies previously analyzed clearly presuppose a general, ideal scheme of gestural regions as point-line patterns, transforming the dance into an objective datum of conceptual discernment always coupled to the vague and complex multiplicity of its sensations.[32] In the *Hand-Drawn Spaces* installation, as well as in most of Cunningham's other choreographies, foot work appears as the main component of the performance, and the position and movement of the arms only emerge as added, independent elements, creating a complex polyrhythm in the dancers' bodies, with legs and arms moving at their own respective velocities. Little pirouettes are performed by the dancers together with little elastic hops. At the same time, the precise spatiotemporal regions traced by hops, jumps, and pirouettes are alternated with classic balletic positions. The choreography unfolds and deforms the classical gestures of ballet, depriving them of their narrative symbolism and reducing them to their bare (and adaptable) structure.

The definition of movement as an ideal mov-object highlights how the abstract form of the gesture possesses the virtuality but also the invariancy of an idea. In Bill T. Jones's *Ghostcatching*, the idea of the turn returns. Here, the movement is highlighted in its continuity, and the dancers' quick pirouettes are elastically incorporated into the kinetic whole of the dance. The motion is fluid and plastic enough to reveal the bobbles and undulations of muscles as the body moves. At the same time, what can appear as a simple continuity of gestures and turns is in fact characterized by a repetition of sections performed in an endless loop.[33] Despite their apparent differences, both Cunningham's and Jones's pirouettes mirror an internal quantitative differentiation between microturns (of the head, arms, feet, etc.), all connectively related as subsets of a turn, together with a qualitative differentiation between the turns themselves. The idea of the pirouette becomes the analytical unit of a movement variation, an infinitely actualizable universal that is ideally the same but is physically and culturally deformed in the divergent movements of both choreographers.

Figure 7
Still 2 from *Ghostcatching* (by Bill T. Jones, Paul Kaiser, and Shelley Eshkar, 1999).

At this point, we should not forget that digital technology, and in particular the motion capture software used for both installations, works by remembering motion as mathematical points rather than as regions or thick events: the movement is first of all captured, or mapped, as points in space-time. For the realization of *Hand-Drawn Spaces* and *Ghostcatching*, for example, Paul Kaiser and Shelley Eshkar used the topological figure of the *spline*, a curve "described mathematically by connecting a series of points. . . . [In the making of *Ghostcatching*], [s]plines were the foundation for the more sculptural objects that made up the hand-drawn anatomy: a ribcage was built from spirals, a pelvis from a knot. And splines had a big advantage over drawn lines, for they could deform with motion, and so were well suited to animation."[34]

The anatomy of the moving body is in fact already woven as a series of splined constraints and dependencies between points. These splines form slices of spatiotemporal duration: when a shoulder shrugs, the corresponding arm and hand move with it (forward kinematics); if a finger lifts up, the elbow and shoulder joints rotate in turn, lifting the fore- and upper arm with them (inverse kinematics). From this point of view, what the digital mapping shows is not simply isolated points but a proliferation of possible connections, or bodily regions, from which the virtual idea of a point can be made to logically derive. From the anatomical (default) links already at work in a moving body, it goes for example to links of proximity (physical closeness of two points at a given moment of time), and to the *cat's cradle* link, in which body parts are linked by direct or complementary relation, or to the occlusive connection, the alignment of two points in the *z* axis of depth and in a field of view at a moment of time, where if one dot passes over another in a given camera angle, both are connected.[35] Movement is thus captured as a series of mov-objects, or movable spatiotemporal regions of interconnected points.

Many of these connections are often unperceived, as the objects of an apparent synthesis that is in fact the result of an analytical perspective exercised by the machine, in which the resensing of the body's movement, or its realistic reanimation, or remembrance, gives way to a more creative analytical operation. The real logic of the machine corresponds thus first of all with the cutting and recombination of durations (as the first motion capture photograms by Muybridge and Marey already showed very well), and only after a logical deductive operation, with the reduction of these to logical computational limits, points, or binary units. Motion capture technology is therefore no longer an example of how the human body magically animates a digital puppet, or inscribes itself in a flowing stream of data; neither projecting nor recognizing movements, the digital machine works by rationally abstracting dance as an infinitely countable object, and preserving its virtual discontinuities in time.

Generative

William Forsythe's choreography *One Flat Thing, reproduced* premiered at the Bockenheimer Depot, Frankfurt, in 2000; *Synchronous Objects for One Flat Thing, reproduced* is the website created by the Forsythe Company in collaboration with Ohio State University's Department of Dance and its Advanced Computing Center for the Arts and Design (ACCAD), as a means to visualize the performance choreographic data "in new ways."[1] In this project, choreographic memory has become deeper: it aspires "to show how a piece develops from the inside, how it functions, how it's put together," rather than just its form.[2]

The online platform was realized by using several mapping technologies; image processing, computer vision, 3D computer graphics, and interactive online algorithms were then deployed to explore the mapped data, and to systematically formalize the components of the choreographic system. For instance, the performance *cueing* system, described by Forsythe as "an internal clock of aural or visual signals given and received by the dancers to trigger and organize the dance event," was mapped as a score of interconnected points in 3D space.[3]

This, and many other abstract diagrams of dance information (concerning cueings but also alignments, i.e., the directionalities of corresponding flows, body and movement analogous shapes, related timings, etc.), were translated into algorithms that could determine results and effects in other performative modalities or fields (such as the modeling and milling of a fabricated architectural object by a machine instructed to follow the shape of a particular motion).[4] In short, the main aim of the whole project was to compress the performative complexity of the dance, intended as an intricate contrapuntal composition of movement patterns, into a number of discrete objects (charts, maps, scores, and then animations, graphics,

Figure 8

Cue Visualizer (from *Synchronous Objects*, created by William Forsythe, Norah Zuniga Shaw, and Maria Palazzi, 2009). The Cue Visualizer is an interactive tool with which users can view the cue system, over time, in William Forsythe's piece *One Flat Thing, reproduced.*

computer applications) that could reanimate the complexity elsewhere. The objects were meant to act as vectorial operators, transferring the relationality of the dance to different fields, from dance notation to music or architecture, statistics, or geography.

For its interdisciplinary openness, the *Synchronous Objects* website has been extensively described as a creative resource to explore space, movement, and the movement-space composition in fields parallel to dance: in other words, as a *generative* tool.[5] This definition cannot be properly valued without taking into account the technical and conceptual specificities of generative design. Based on repetitive processes performed on a routine basis, generative design is made up of constantly recurring elements and automated operations of a program leading to final unexpected results. Modeled along scientific concepts such as those of self-organization, swarm systems, evolution, and emergence, this digital procedure transfers the creativity of matter to digital algorithmic processes, allowing

a redefinition of the designed artifact in more dynamic terms, and shifting the focus from object to process, and to the generation of novelty, diversity, and complexity from simple basic units (or algorithmic rules).[6] The software, in other words, is left free to automatically run and generate its own complex results, while the designer only needs to keep control over the initial parameters, a control consisting in the specification of general models with a variety of possible outcomes. The resonance of this method with Forsythe's own choreographic technique (his peculiar way to realize choreographic ideas), and particularly with the creative methodological and conceptual aims of the *Synchronous Objects* website, seems obvious: to use choreographic data and ideas as initial models to "catalyze new creativity" and generate "a myriad of other manifestations of structure."[7] Furthermore, the technology is generative not simply from a conceptual perspective, but also in technical terms: for example, in relation to the design of some generative objects, in which a few parametric changes can create different results.

Generative processes allow designers to visualize the sequential transformations of an object in time and space. When transferred to the context of digital programming, this particular methodology raises a main skeptical criticism, comprehensibly due to the necessity (and incapacity) of the *fake* generative algorithm to imitate the true emergent qualities and transformations of nature. Constrained by an unnatural imposition to bend its numerical and discrete mode of working to the law of continuous organic evolution, the software loses its peculiarities, only gaining, in exchange, pure condemnation. It is important at this point to note that an object (be it natural, technical, or digital) is never the result of a linear algorithmic process of growth from simple elements or rules, but always emerges from a multiplicity of relations between algorithmically mutating parameters, variables that are always already complex and complexly related to each other: shifting relations between sets of variables, are what truly determines the transformation of a form.

We can therefore understand and highlight the conceptual significance of a technical distinction such as that between the generative and the *parametric*: if the generative algorithm is a method that allows the generation of complex forms and structures based on simple component rules or variables, then by programming the relations between these mathematical variables parametric design allows a manipulation of multiple scales, from part to whole, while acknowledging the co-working of many algorithmic levels and the complexity of each level or step.[8] It will therefore be useful to test a possible relation between *Synchronous Objects* and a parametric, rather than

a simply generative, logic, in order to understand whether the mapping of movement performed in the online platform appears versatile enough to remember the multiple parameters, variable relationships, and complex proportions that compose each single choreographed step. Technology, in other words, will need to be reconsidered in the full range of its logic process and not simply reduced to the unique aspect of its preprogrammed structure; it will need to be valued for what it allows to think (and remember), rather than just for what it is thought to be.

Parametric

Movement is a relational process, as bodily gestures and steps can never be isolated but are always related to each other: Forsythe's choreographic technique reveals this relationality very well, underlining the complexity of bodily coordination in many ways, and paradoxically using the isolation and extreme articulation of the head, neck, hips, torso, and limbs in order to create relational chains of response in the moving body of the dancer. These chains are instantiated by nodes, or "potential physical points of contact: chest, arm, stomach, shoulder, breast. William Forsythe calls this cz, the connection between two limbs where 'the pressure of one limb on the other gives the alterations in the skeletal mechanic.'"[9]

In other words, the basic functional unit of Forsythe's choreography is always already a relation between points. The reason for defining Forsythe's choreographic instructions as movement algorithms is now evident, as this parallel resides precisely in the relational nature of the algorithm, a coded and limited set of instructions that only becomes active in its relation with other coded sets. As a string of information that behaves very similarly to a virus, an algorithm is always part of an environment, the 0/1 binary becoming the particular relation through which instructions do not only develop consecutively but transversally enter in contact with each other. If, in the software, a parameter is a variable to which other variables are related through a series of parametric equations, it follows that the linear algorithmic calculation is always inserted into a field of simultaneous calculations, or algorithmic relationships: the main focus of the design process is not the setting up of a shape, but rather the rules of interplay that govern the process itself. According to Meredith, "It is possible to imagine the advent of design methods based on codified geometrical operations proliferating and interacting to achieve a higher level of complex order": in this logic, differentiation would emerge from the setup of coherent operations in the field of a whole algorithmic ecology.[10]

An important objection at this point comes to mind: the ontological basis of the digital corresponds very clearly to an epistemological framework that instantiates itself in the logic of the code (linear causality, one programmed step after another), and then in the visualization of discrete, separated points of alignment (geometric mapping).[11] Every new occurrence is the result of a previous operation, incorporated in a repetitive (rather than generative or parametric) linearity. How can novelty emerge from this tight chain?

On one hand, it is of course fundamental to acknowledge the event of qualitative novelty emerging through the perceptual process of data visualization, a process that constitutes an important moment of presentational emergence: the images appearing on the *Synchronous Objects* interface do not imitate or represent anything, but present us with something already new. On the other hand, the analysis of the coding and programming of the website according to the mere notion of algorithmic linearity needs to be replaced by a concept of the digital as a nonlinear, complex environment.[12] By adopting this definition, we see how, even though *Synchronous Objects* was not designed with the use of specific parametric technologies, parametric complexity becomes here a working conceptual technology. Operating a numerical structuring (or *scaffolding*) of the data, the site works like a choreographic databank whose entities are relations rather than simple objects: sets of variables—for example, cueing and alignment, the density of movement or its form—are considered in their reciprocal and transversal (or synchronous) interlocking, and the dance itself becomes a set of parametric algorithms to be differently rechoreographed.

And yet the choreographic relations illustrated by the *Synchronous Objects* project do not seem to correspond to any relationality in the technicality of the software. Despite its synchronic (rather than diachronic) and its parametric (rather than generative) aspect, the platform seems to retain a sort of stubborn digital quality, like a rigid discrete structure or grid that molds the dance but is always necessarily missing the relational quality involved in its analog unfolding. At this point, the discussion would seem to have reached an end (a gridlock), with the insurmountable discreteness of digital technology once again imposing itself. And once again we will suggest dismissing the analog/digital opposition and abandoning the idea of computers as another evolutionary type, another kind of entity incessantly competing with organic bodies in potential capacity. We will thus take a step back, and consider the particular hardware/software combination of the *Synchronous Objects* tracking system as enveloping an original form of relationality.

Figure 9
Movement Density (from *Synchronous Objects*, created by William Forsythe, Norah Zuniga Shaw, and Maria Palazzi, 2009). This diagram from the process of creating the movement density object in *Synchronous Objects* was realized with collaboration from geographers Ola Ahlqvist and Hyowon Ban. It shows dancer pathways in space and uses a common geographic visualization technique to explore where the dancers spend most of their time over the full length of the piece.

The New

For Erin Manning, an object, every object, is a "not-quite-form" that cannot be separated from its milieu. As a consequence, "There is no succession in the metric sense. To act is to activate as much as to actualize, to make felt the schism between the virtual folds of duration and the actual openings of the now in its quality of passage. On its way."[13] Following Manning's concept of process as nonobjectifiable passage, it is also possible to think change without, or beyond, any thing changing. This affirmation echoes Whitehead's own idea that "the notion of an actual entity as the unchanging subject of change" needs to be completely abandoned.[14] In Manning's reading, the proposition to do without subjects (and objects) of change is reflected as a suggestion to activate the immutability of being (object) by replacing it with the movements of becoming (relation): "It is out of relation that the solitary is crafted, not the other way around: relation is what an object, a subject is made of."[15]

It is nevertheless possible to read the same concept differently, and to give to the unchanging abstraction of objects another ontological sense. In

this reading, objects do not persist as subjects of change but certainly exist, before perishing; process, for Whitehead, is a succession of atomic, objective occasions. It is in fact never experientially possible, but always speculatively allowed, in Whitehead's philosophical system, to subdivide an event into the actual occasions that compose it: dancing human bodies, tables, and also dance cues, velocity alignments, steps, and themes that constitute the performance as its own monadic atoms. What makes this Whiteheadian analytical, or atomistic, approach particularly interesting, is that the occasions always reconcile their irredeemably discrete actuality with two resonant levels of potential: the "pure potential" of ideas, and a "real potential," the potential of each actual occasion to become the objective datum of another actual occasion, or to relate to it.

Not unlike what happens to the dance of *One Flat Thing, reproduced* on the *Synchronous Objects* website, an event for Whitehead always becomes objectified into a set of data, a series of "units of historic fact" (such as the points mapped in the scores), or of "pulsations" (0s and 1s), transmitted from occasion to occasion.[16] The data are composed by what has been in the past, but also by what might have been, and what might be: a dance step, a graphic 3D form, a piece of furniture. The data are always actual, and their specific potential is always real (a set of real possibilities, rather than a virtuality). Following the logic of causal efficacy, the pulsed transmission of data in a linear fashion, from past to present to future, characterizes, for instance, the working of the digital algorithm as habitual and diachronic, restricted to a physical and compulsory level (the physical nature of the program). The computer operates in the same repetitive fashion as physical, inorganic, inert matter.

We now find ourselves in the position of asking the same question that Steven Shaviro asks, namely, "How can the future avoid being predetermined by the past or by the relentless chain of causes and effects? How is it possible, in the world described for us by physical science [and computer science], for anything genuinely New to emerge?"[17] In Shaviro's reading of Whitehead, the appearance of the new takes the form of a *glitch*, an interruption of the continuous relational chain between past and future, the moment when past data are valued and particular ideas are selected in an occasion of experience, in order to determine what the future occasion will be. For Manning, this cut coincides, for example, with the moment when cues are rehearsed, as relations that remain open to interpretation toward a shifting manifold in movement. The dance is thus renewed each time by the different interpretation of the relations and the iterations of the dancing, each iteration an experience of the now of the movement's

occasion. This means that the dance's virtuality is only perceivable live, as a landscape of infinite relational reconfigurations. From this point of view, despite its complexity, the *Synchronous Objects* website cannot fully map the choreography, because no representation can "attend to the durational force of the push-pull" that makes the dance come to expression.[18]

It is not an aim of this discussion to determine the essential nature of the novelty-bringing cut (be it material, organic, or human): as quantum physics has shown, atomic particles are already able to interrupt the flow and take their own paths. What is important, rather, is to identify the cut with a break in which pure (rather than real) potentials, new forms of definiteness for a relation (rather than new relations), start to function as principles of individuation for an upcoming occasion. The conceptual novelty of every event is, in other words, simply the novelty of the definiteness, "the making-definite of something that was already existing in the 'inherited data' but not with that particular definition (i.e., something that was merely a real potential)."[19] One of these principles of definiteness, or ideas, is identifiable with quality (for instance, color: red as redness, a qualifying idea preceding its own actualization). As Whitehead explained at length, the linearity and vagueness of perception (perception corresponding to a vague bodily inheritance from the past) changes with the ingression of a precise determinant factor under the form of a new eternal object (such as the quality of red). At the same time, it is always possible to conceive the same differentiating determinant in quantitative terms: red as an infinitely actualizable quantity, or an infinity of quantitative potentials.[20] Thanks to a different quantitative or qualitative idea, a relation can take a different form.

In the causal relationality of a Forsythe dance, in which (as in every other movement) one step is inextricably linked to the other and each step is potentially linkable to all others, the intricate vagueness of the dance data is more precisely defined by choreography, through the selection of a particular eternal object such as *counterpoint* (a way to find agreement or rhythm in movement, without necessarily requiring unison or unity). It is the undetermined precision of counterpoint as an idea realizable in many different ways (a form rather than a precise relation) that allows the experience of movement to become *this or that*, eliminating other potential forms of relationality: a choreographic thought not necessarily preexisting and imposed but immanent to the occasion, preceding the appearance of the dancer/choreographer distinction. But the list of ideas (or pure potentials) can be infinite, including not only qualities (red, counterpoint) but also such things as numbers (oneness, twoness, threeness, or square roots), ideas

bringing forth the definite arithmetical character of an occasion, or ways in which the occasion can be cut and reglued from the totality of actual preexisting data.

Ideas, therefore, can also be numbers. The real question is not who, or what, is capable of such appetition (organic yes, computerized no; live yes, mediated no), but how, and in what form, this abstract process can be thought. The question, in short, is not who decides the particular logic to be adopted, but the fact that ideas can indeed take innumerable forms and necessarily intervene in all forms of process, qualitative or quantitative alike. Novelty, in other words, is the very form of process, because in every process the following instance will necessarily be different from the previous one, if only for its following position. It is also important to highlight how, for Whitehead, the function of ideas in process always remains one of simplification, rather than of complexification: ideas retain in fact a pure, detached character, or a capacity for relations at a distance, that distinguishes them from the entangled relationality of real physical potentials. An idea, from this point of view, can also be thought as a digital algorithm.

If, in Forsythe's choreography, the idea of counterpoint appears as a structural form of dialogue, a rhythm of alternation coinciding with the pure and definite potentiality of an eternal object, this idea is also conceivable as a mathematical potentiality. We can now go back to the choreographic website and its synchronous objects. Here, ideas literally become digital mov-objects: sets of 0s and 1s, or sets of instructions, to execute preexisting algorithms of movement mapping. The idea, in other words, takes the form of a specific algorithmic or choreographic object. Counterpoint, for instance, becomes the idea of alignment. Conceivable as a mathematical pattern in space-time (and simultaneously as a set of 0s and 1s), the contrapuntal quality of alignment transforms the map of performative data into a definite occasion with a precise individual construction in form and timing (such as the actual Alignment Annotations object).[21]

The selection of the idea, or in other words "deciding which alignments to mark," is a fundamental decisional process: "Originally," Norah Zuniga Shaw says, "we marked hundreds more alignments than the ones you see in the final version. As we learned to read the dance, we made better decisions about which alignments were most significant in relation to others and would best help to elucidate the dance's structure."[22] Different mov-objects correspond to different new ways of mapping and remembering the same phenomenon of alignment: lines and shaded circles, shaded geometric figures, anticipatory arcs filled with colors and animated lines, or lines drawn on a frame-by-frame basis, colorful moving bars.[23] At the same time, each

Figure 10
Alignment Annotations (from *Synchronous Objects*, created by William Forsythe, Norah Zuniga Shaw, and Maria Palazzi, 2009). Still from annotated video illustrating alignments, the way in which William Forsythe designs relationships in space and time.

of these modalities constitutes a different algorithmic operation, or a different software coding to be selected, a coding that will always be applicable to other platforms (such as those of graphic or video game design). The algorithmic idea of a relation.

Rationally Remembering

At this point, we are clearly on a different dimension from that of the live performance event, and it is important to bear this in mind. The technological transposition of the dance and the quantification and collection of data becomes here a way to keep a trace of the ordered, clear, and diagrammatic potentials of movement (the annotation of the alignments as short instances of synchronization between the dancers, the annotation of the cues by which the cueing system of the dance unfolds in a rapidly shifting network of relationships, and the indexing of the movement themes that serve as building blocks of the motion). What is remembered is the shifting extensive, algorithmic structure of the dance more than its qualitative nuances, bringing to light organization and order as parallel aspects of creation. The capacity to retain the organic, or living, sensations of movement

(as different from readable understandability and its related feelings) is certainly not the technology's main strength, and perhaps this is not what we should look for in its manifestations. Instead, the computer activates a memory more associated with the extensive aspects of the performance: alignment, cues, the order of the themes as ideas. What remains, in other words, in this pure mathematical transcendence is the infinite divisibility of choreography into clear, autonomous patterns-structures doubled by an infinite possibility of reactualization by each structural object: the theme of a dance can become a dance of graphic shapes, a 3D object, or a diagram, and allow an abstract rethinking of the choreography (a pure memory realizing itself, even without the intervention of the physicality of a body). Without transforming the choreographic composition into a sort of Platonic realm of transcendental mathematical ideals hylomorphically imposed on the movement material, it is important to reiterate the simultaneity of the qualitative and quantitative nature of ideas flowing into the performance, ideas always working in tight relation with an actualized dimension of shapes, timings, and directions.

In attempting to take the digital closer to the notion of the virtual (or motion capture to pure memory), we have ended up by realigning the virtuality of movement to the digital, as a particular way of remembering according to notions of extensive divisibility and compression. In order for this operation to be accomplished, the virtual is to be conceived no longer as a complex infinity of relations, but instead as a final simple idea whose complexity consists of its infinite possibilities of actualization. The final simple idea can correspond to a quality *or* a quantity, a color *or* a number, a sense datum *or* a digital datum; its relational potential does not derive from its complexity but from its capacity to select, simplify, or compress, the event of dance: only what is simple can be remembered and simultaneously change.

III Thinking the Dance: Compu-sitions

In "The Image of Thought," Deleuze affirms that thought, as an "autonomous thinking function," is there to grasp that which can only be thought, the "*cogitandum* or *noeteon*, the Essence."[1] What this Essence is, and how to manage to think it, or even to just think something, is the main question the philosopher shares with Antonin Artaud, for him one of the greatest, and most troubled, of thinkers. Being without an image, having even abandoned the remembered singularities of memory, pure thought becomes a way to create thinking itself; because, together with Artaud, Deleuze "knows that the problem is not to direct or methodically apply a thought which preexists in principle and in nature, but to bring into being that which does not yet exist (there is no other work, all the rest is arbitrary, mere decoration). To think is to create—there is no other creation."[2]

There is a second type of definition that Deleuze also gives to the creative nature of pure thought: when equating film directors to thinkers, he introduces the concept of creation as a junctional/disjunctional activity (in the same way as cinema is a junction/disjunction of image and voice).[3] Pure thought, in the latter instance, becomes the composition of a chaos, the creation of an order of combinations that, as he often reminds us, is balanced enough to stand throughout time. What differentiates modern cinema from the mere succession of frames allowed by the technical perception of the cinematographic machine is the emergence of a pure thought in the form of montage: thinking with moving images, cutting out images in the real and offering them to memory, directors create original combinations, something that had never been seen before. With these principles in mind, it is now possible to shift the focus to the faculty of thinking movement as a dance, or the capacity to create movement as something new, a faculty of which choreography (intended as the creative process of joining movements together and of planning changes of speed and direction through a detailed script) constitutes an interesting example.

The possibility of giving precise instructions about a movement's coordinated points, and precise calculations of its degrees, is certainly a matters of philosophical discussion, at least as much as these can be objects of performative experimentation. But what choreographic theories and analyses such as Laban's have already made clear is how the continuous flow of movement can be defined by a series of points and positions that can greatly vary in the precision of their coordinates but are nevertheless there (0 degrees: rest position; 180 degrees: hand at shoulder level). In a choreographic script, the distribution of these spatial distinctions of position (A-B as departure and arrival points of a movement) is also often associated with the function of numbers as quantitative meter, in which the A-B distinction can, for example, directly correspond to a basic counting schema on a sequential milieu (A-B, A-B, 1-2, 1-2).[4] Selecting and arranging series of movement points, choreography in-forms the body about its possibilities in space.

Despite the limited nature of this possibilistic movement field (which characterizes, for example, the choreography of classical ballet), choreography could nevertheless be conceived by Merce Cunningham as an "open space": every choreographic structure is, for him, a "space in time" in which anything can happen.[5] It is indeed a particular conception of choreography as emerging process, one very different from that of ballet, that is at play in Cunningham's work; and yet in this conception, numbers and mathematical calculations still play a crucial role: for example, in his spatialized conception of the steps as numerical elements to be arranged on a grid; in the extreme calculated precision of those steps as performed by his dancers; as well as in the famous adoption of combinatorial compositional techniques (such as coin tossing and the *I Ching*) based on chance. In the open space of choreography, according to Cunningham, "time can be an awful lot of bother with the ordinary pinch-penny counting that has to go on with it, but if one can think of the structure as a space of time, in which anything can happen in any sequence of movement event, and any length of stillness can take place, then the counting is an aid towards freedom rather than a discipline towards mechanization."[6] And it is not *by chance* that these numerical techniques have found, since Cunningham's first encounter with the computer screen, a digital counterpart.

Often digitalized in all its different phases (from composition to capture and editing), contemporary choreography inserts movement in a technological field whose consistency relies on a world of numbers (or more precisely, of binary numerical algorithms). Composition, as pure thought, now becomes purely numerical. But how can all this counting become an

aid toward freedom? The relation between choreography and numbers, or the numerical aspect of the choreographic creation as pure, or free, movement thought, will be of particular interest in the following pages. In this part of the book, attention will therefore be devoted to Cunningham's choreographic composition as a process that can be defined as digital even before its transference into the field of computer software. Choreographic composition as a form of *computation*: a computational/compositional (or *compu/sitional*) process, a way to creatively think the dance with numbers. This concept will aim at highlighting the numerical virtuality characterizing both the mathematics of choreography and technology.

Figure 11
The *I Ching*.

Numbering Numbers

Deleuze and Guattari define the number intended as a counting and measuring tool as a "numbered number," an instrument of organization used by the human subject "to gain mastery over matter," to control the dynamics of its own movement and inscribe them onto a measurable spatiotemporal framework: a number, in this sense, is linked to "metric magnitudes."[7] The metric relation between body and space subordinates number to space and its geometric segmentation. The numerical coding of movement is also related to the physics of gravity, the principle of material codification that transforms every spatial displacement into a reproduction of Newton's laws and of their parallel, laminar and lamellar model of speed measurement (falling as measurable linear acceleration). Measurement as a form of numerical codification is, in other words, made possible by a conception of movement inextricably linked to (and weighed down by) geometry and physics.

But, from Deleuze and Guattari's point of view, the metric aspect of motor phenomena hides something: a dropped body does not simply have a measurable velocity, but also develops an infinitely decreasing slowness; in the same way, movement cannot be reduced to biunivocal relations between two spatial points A and B (falling as an increase in speed, from a minimum in A to a maximum in B), but is composed of reciprocal relations (also falling as a decrease in slowness, from a maximum in A to a minimum in B). Rather than fixed positional points, A and B become critical moments at which a change occurs in the slowness-speed relation. Every movement trajectory appears thus as infinitely punctuated by an uncountable multiplicity of such singularities. These singular moments correspond to what the two philosophers consider "numbering numbers," distributive, nomadic numbers autonomous from both space and matter:

The *Numbering Number*, in other words, autonomous, arithmetic organization. . . . These numbers appear as soon as one distributes something in space, instead of dividing up space or distributing space itself. The number becomes a subject. The independence of the number in relation to space is a result not of abstraction but of the concrete nature of smooth space, which is occupied without itself being counted. The number is no longer a means of counting or measuring but of moving: it is the number itself that moves through smooth space. . . . The more independent space is from a metrics, the more independent the number is from space. . . . The number is the mobile occupant, the movable (*meuble*) in smooth space, as opposed to the geometry of the immovable (*immeuble*) in striated space. . . . The numbering number is rhythmic, not harmonic. It is not related to cadence or measure [but to an] *order of displacement*.[8]

Notions of "counting" and "dividing up" space are replaced by a concept of "distribution": numbers distribute themselves autonomously; they appear as subjects, rather than preexisting as tools. Numbering numbers are therefore impossible to count, if not retrospectively; movement is related to a notion of rhythm as the uncountable.

It is at this point important to clarify that Deleuze and Guattari's concept of the numbering number, as the philosophers highlight, is not a result of abstraction: mathematics, in other words, does not detach itself from geometry or physics, but points toward a different, qualitative conception of these disciplines. In the final instance, it is more to a philosophical conception of number that the notion refers, a concept of number that, differently from scientific functions, does not capture the infinite virtuality of thought into any still frame, nor does it pose any limits to the chaos of matter.[9] Moving particles or bodies are scientifically calculable in their position and speed, even if approximately, but only under the condition of falling into an actual grid of coordinates and trajectories; or, in other words, into a scientific plane of reference. It is to this plane that the philosophers refer when they define numbers as "numbered," one of the main examples of which is Cantor's definition of number as a "set" (or a mathematical matter of fact): numbers and numerical functions do not only represent but constitute matters of fact, in which virtuality becomes real potential.[10] Differently from these functions, philosophical concepts such as that of the "numbering number" constitute the incorporeal events of thought. It is only by transforming mathematical functions into concepts that Deleuze and Guattari can restore to them all the openness and creativity of ideas.[11]

As a philosophical concept, the numbering number allows Deleuze and Guattari to create a particular notion of movement. In this notion, the qualities of a movement receive a sort of ontological privilege over its quantities, and its form or behavior (the *curve*) precedes the possibility of its numerical calculation: the numbering number is an infinitesimal that cannot and is not to be counted, but only followed.[12] This notion makes the possibility of precise calculation disappear, or rather become something else, something not detached from but immanent to the moving body, and yet something that "belongs to mathematics, even at the very moment when it finds its sense in the revelation of a dialectic which points beyond mathematics."[13]

This *something* is defined by Deleuze and Guattari as distribution, a concept that clearly resonates (if it does not directly derive from) Poincaré's "qualitative theory of differential equations."[14] Counting becomes distribution, or a sort of nonconscious counting operated by the body in the very

act of moving. The body distributes itself in space, it becomes numbers. The crucial event highlighted by Deleuze and Guattari's terminology is the fact that, rather than having a moving subject measuring its own relation to movement and space through numbers, it is the number that now becomes a subject, through the becoming-number of the moving body. In its spatial occupation, or distribution of itself in space, the moving body spreads itself, drawing a kinetic and dynamic diagram of speeds, of accelerations and decelerations, forces that cannot be numerically measured but can only be followed.[15]

The combinatorial nature of the distributed body does not identify it with a statistic element (or a statistic aggregate of preexisting units with preexisting properties, as in the anatomical composition) but with a fractal complexity: each arithmetic unit is always also an assemblage of heterogeneous fractal (or fractional) distribution, and each bodily gestural unit is always an assemblage of microgestures. Immeasurable multiplicities or molecular packs of micromovements (rather than a whole body) appear in infinitesimal numbers that generate reciprocal relations of becoming rather than binary relations between states. Rather than a measurement and definition of space from point to point, the rhythmic distribution of the body happens as a qualitative variation in-between points.

Deleuze and Guattari's definition of number as the subject of qualitative distribution, rather than the tool of quantitative measurement, therefore outlines a different conception of movement as distributed between parts and not directed by any central point (or conscious thought). Movement, in other words, as something that occurs *in* the body (rather than being performed *by* it). The thought of movement is not separated from movement itself and situated in a different point, or temporally delayed, but coincides with it in the very moment of a motor sensation. This simultaneity of body/mind only appears in the distribution of thought-motion in the body, when thought and action coincide in their bodily spreading or delocalization.

An example of this qualitative delocalized distribution (as different from conscious gravitational displacement from point to point) can be found in the dancing of certain West African rituals, where the movement is kept in the body, which vibrates and is tended, and where the motion never abandons the body and does not distinguish between a center (torso, but also mind) and periphery (limbs).[16] Here, the condition of the dancing body following the drum beat as a sonic guide for its movements is changed by the entrance into an ecstatic state of sensations in which only rhythmic (or qualitative) differences are felt.

The same phenomenon can even apply to a gravity-oriented form of dance such as classical ballet. Despite the obvious differences, what is finally reached in both tribal dance and ballet is a sort of pure *kinesis*, a going beyond one's self and perceptions, while moving. In his treatise "On the Puppet Theater," Heinrich von Kleist defines the centered movement of puppets, and the puppeteer's continuous play with gravity, as a relation of the arithmetic unit with its logarithms.[17] Despite the anatomically centered nature of this movement, Kleist transfers this play to a "spiritual" realm where the "light" puppets are able to overcome all gravity and do not even need to be guided by a central subject (the puppeteer) anymore (logarithms become autonomous). In the human body of the ballet dancer, the same autonomous condition can coincide with what Kleist defines as the perfect centering of thought and action beyond conscience and reflection, which is a centralization of movement in the body as much as it is a decentralization and distribution of its thought, beyond gravity and weight and beyond the direction of a dominating brain. The consciousness of movement as originating from one's own body and aiming at one particular point is in this sense accompanied by the continuous motion of an infinite, uncountable number of autonomous bodies/puppets/logarithms: every movement is made of little simultaneous but autonomous movements, as in a fractal composition that achieves perfect final unification. For this reason, counting and measuring, geometry and physics, are not tenable: the intense indiscernibility of movements makes numbers sink into the infinite, or the infinitesimal. For Deleuze and Guattari, only an infinitesimal concept of number can express the event of movement, by giving a certain consistency to its microscopic virtuality.

The Abstractness of Relation

Deleuze and Guattari's concept of the numbering number shows how a dancing body can become an emerging phenomenon, or a molecular pack, of qualitative sensations. Incorporating this Spinozist point of view, André Lepecki talks about "stillness" as the exhaustion of contemporary theatrical dance: after the frenetic contortions of modern dance (from Martha Graham's to Mary Wigman's performances), stillness becomes today, according to Lepecki, able to occupy the stage space for an undetermined amount of time, full as it is of infinite, intensive, microscopic motions and sensations.[1] The critic finds significant examples of a qualitatively charged stillness in the work of artists such as Bruce Nauman, Xavier Le Roy, Trisha Brown, and William Pope.L, all of whom, in the aftermath of the Gulf War and until the present day, have chosen to react to the petrifying effect of such events by affirming the impossibility for dancers to move any longer, and therefore to subjugate themselves to the kinetic imperative of mobility proposed by contemporary capitalist regimes. Stuck between perpetual motion and the infinitesimal intensity of the "still act," what the contemporary dancing body described by Lepecki ultimately needs is a structure that can prevent it not only from remaining in a state of constant agitation, but also from falling, like Zeno's Achilles, into the abyss of the infinitesimal.

In both its frenetic and still forms, the modern and contemporary dancing body has frequently focused on a principle of connectedness characterizing almost all performative levels: between movement and stillness; between stage and street; between art and life. As Roger Copeland says, Merce Cunningham's style represents a difference in this landscape: "If there was any sort of connectedness to be found in this work, it was not the tactile, sensory massage variety"; for example, a connection at a distance, rather than an indiscernible closeness, distinguishes the relations between

his dancers on stage.[2] At the same time, opposing themselves to the vague approximations and confusions of many modern performances, the movements of his dancers help to restore equilibrium on the stage with "the lucidity of line and shape."[3]

Together with distance and clarity, another important trait of Cunningham's work is its peculiar relation to space. The audience's attention is not conquered through the use of perspective (a "magnet to the eye," a vanishing point that lures the gaze involuntarily upstage): "watching a Cunningham piece, one tends to scan left and right, rather than zooming in on a single point set in deep space."[4] The classical conception of the stage seen through a frontal perspective is replaced by a more complex conceptualization of all the different mathematical points of the scene as having equal value. Because the points lose their reciprocal relations of correspondence and hierarchy, movement can be constant, and innumerable simultaneous transformations can be generated everywhere all the time: "As you're not referring one sequence to another you can constantly shift everything, the movement can be continuous, and numerous transformations can be imagined. You still can have people dancing the same phrase together, but they can also dance different phrases at the same time, different phrases divided in different ways, in two, three, five, eight or whatever."[5]

Two, three, five, eight, or whatever: Cunningham's choreographic method implies the creation of different movements in different rhythms and, therefore, a multiplication of possibilities and a complexification of the whole performance. In order to compose this complexity, chance techniques such as the *I Ching* allow the choreographer to decide what movements to be performed and where, or the number of people performing them, avoiding every subjective or emotional intervention in the compositional process. The use of chance procedures thus transforms the mobility of the dancers on stage into a sort of play with its own playground and rules. According to José Gil, an important consequence "of incorporating chance into dance is particularly interesting: the break it produces in the traditional frame (or code) governing corporeal possibilities, and how that opens the body out to other previously unexplored movements. This implies yet another break, this time with the traditional 'models' governing the co-ordination of movements. These models, used in ballet as well as in the school of Doris Humphrey, always presupposed an organic image of the body as a finished whole. 'That was surely one of the reasons I began to use random methods in choreography, to break the patterns of personal remembered physical co-ordinations,' says Cunningham."[6] Here, mathematical operations reveal their full potential: the idiosyncratic phrases chosen by

chance go against bodily natural actions and even beyond human thought, instead following simple mathematical rules.[7]

It is in this sense that, as the choreographer stated, counting stops being a simple form of measurement, and becomes a free, creative way of grouping bodies and movements according to abstract ideas. Unlike that of Deleuze and Guattari, Whitehead's conception of mathematics possesses a conceptual correspondence to this choreographic style, a conception that does not assign numbers to the limited realm of matters of fact (numbered numbers) but already ascribes them the status of ideal, eternal objects independent from the physical nature of concrete things: it assigns them, in other words, a virtuality of their own.

"For example," Whitehead argues, "we think of the number 'five' as applying to appropriate groups of any entities whatsoever—to five fishes, five children, five apples, five days. Thus in considering the relations of the number 'five' to the number 'three,' we are thinking of two groups of things, one with five members and the other with three members. But we are entirely abstracting from any consideration of any particular entities, or even of any particular sorts of entities, which go to make up the membership of either of the two groups. We are merely thinking of those relationships between those two groups which are entirely independent of the individual essences of any of the members of either group."[8] Number is an abstract grouping property to be applied to different physical elements (for example, to the duration of a space of time or, as John Cage defines it, a "time-length," a number of temporal units, seconds or minutes, which can indicate the muscular memory of a movement as executed or the duration of sonic temporalities).[9] Abstraction, for Whitehead, is objectification; that is, the activity of abstraction from our experiences produces ideal objects. In this process, we "put aside our immediate sensations" and recognize that "what is left is composed of our general ideas of the abstract formal properties of things . . . the abstract mathematical ideas."[10]

Coming back to Cunningham's choreographic thought, it is easy to see its direct generation from a simple creative idea that cannot but be numerical: Cage described this thought as "a study of numbers with which I find it congenial to begin a musical composition." Even evocative aesthetic objects such as "the fullness and stillness of a summer day" become countable sections and numerical situations. Executing a numerical idea, each dancer becomes in turn numbered as a point in space, as in a game of chess: "The dancer is at a given point in the dancing area. That point in space and or that particular moment in time concurrently is the center for him and he stays or moves to the next point to the next center. . . . So, from moment

to moment and from point to point, the dancers move . . . separately."[11] It is an interest in the separate, reciprocally distant "each thing-ness" of steps (as experienced actualities of movement and as abstract connections of points in space) that leads the choreographer to the use of chance methods to find the continuities and combinations of a dance. "In dance, it is the simple fact of a jump being a jump, and the further fact of what shape the jump takes. This attention given the jump eliminates the necessity to feel that the meaning of dancing lies in everything but the dancing, and further eliminates cause-and-effect worry as to what movement should follow what movement, frees one's feelings about continuity, and makes it clear that each act of life can be its own history: past, present and future, and can be so regarded, which helps to break the chains that too often follow dancers' feet around."[12] Continuities and combinations are thus reduced to their bare numerical nature.

More specifically, this technique involves an elaborate assignment of numbers to the movements, to the division and duration of their time, and to the spaces in which they appear. From these numbers, various series of charts are obtained. Tossing coins or using the *I Ching* allows then a random selection of movements, times, and spaces from the charts. Out of this system, a determined randomness appears. The same numerical (rather than organic) criterion applies to the disorganization of the moving body, in which, as noted by Gil, the center of balance (torso or spine) becomes an autonomous mobile force. Movements are disarticulated from one another, since they no longer have to logically relate to a fixed body part, and are decomposed into multiplicities, in which the limbs do not have to follow any particular rule in aligning themselves to other limbs, in order to achieve a sense of balance: any part of the body can enter into composition with several mobile axes. Divergent series of movement arise thus at the same instant: a series of gestures disconnected from another series of gestures in the same body; the series of a dancer's gestures in relation to those of another dancer; the music series and that of danced gestures. But, Gil asks, if pure movement ends up appearing as a kind of serial exercise, where does its aesthetic value lie?

Gil's answer to this question begins by highlighting how, very importantly, Cunningham empties the stage space of all semiotic elements, stripping away all representative and emotional elements and keeping only the pure "grammar" of movement. Body awareness commands consciousness. But this answer does not yet provide a criterion for establishing why these choreographies should be considered as possessing any particular aesthetic equilibrium. What is it that, to use Deleuze and Guattari's words again,

allows Cunningham's performances to differentiate themselves, and stand on their own feet?

For Deleuze and Guattari, the capacity of a work of art to sustain itself is based on the aesthetic composition of blocs of sensation.[13] These blocs do not simply coincide with mixtures of matters and materials (for example, blocs of color, or blocs of sound), although they are inextricably linked to them. To become a sensation, a color perception needs to become a more abstract, evanescent entity: the *redness* of a red, the *metallicness* of a metallic sound, taken in themselves. One of the examples given by the philosophers is that of musical compositions in which the quality of the sound becomes the main object of composition. In dance, from this point of view, it is fluidity, or the capacity of a danced movement to distribute itself in space, and to form a qualitative continuity with the environments and actions of life, that would constitute a compositional element. This qualitative conception finds some of its main expressions in performances such as those by Fred Astaire or Gene Kelly, whose value resides, according to Deleuze, not so much in the impeccable meter of the steps, but in the capacity to respond to the quality of the street, the pavement, and all the surrounding objects.[14] It is a technique that also resonates with the style of a modern choreographer such as Alwin Nikolais, whose practice of filling the stage with obstacles and objects was meant to develop the dancers' own awareness of the qualitative physicality of their own movements in space.

Here, in short, it is matter itself that, by making its qualities emerge, dictates its own composition. This dehumanized or desubjectified conception of aesthetic composition undermines the power of the artist-creator, and assigns to matter the task of overcoming itself, such as when metal, leather, and wood weave with the winds to create blocs of sensation in Edgard Varèse's music, or when sensation itself is redefined by noise and the raw quality of sound, in John Cage.[15] But it should not be forgotten that another, different compositional criterion is in fact also at play in Cage's technique, one that goes hand in hand with the qualitative exploration of sound. This criterion assigns all compositional decisions to an external, detached element that is able to simultaneously overcome both the (conscious or unconscious) subjectivity of the author (or executor), and the physicality of matter. This external element is represented by the hexametric combinations of the *I Ching*, in which the structuring capacity of numbers emerges in its most abstract potential.

In the same way, not in line with modern (or modernist) conceptions of dance, Cunningham weaves a numerical grid to sustain and, at the same

time, as he himself affirms, to free his dancers. But free them from what? Bergson's empiricism has taught us how all movements are continuous with one another. Accordingly, as all movement (and stillness) is also simultaneously a dance, it still remains to be understood how something new, something unexpected, can emerge from the continuum.[16] At the same time, the aliveness of this emerging novelty would need to work in combination with a particular criterion or structure, in order for it to be defined as dance. Without this structure, a dancer's body and movements, as Cunningham affirms, would literally dissolve.

This structuring possibility needs to appear outside of the predetermined decisions and thinking habits of the choreographer's mind, but also outside of the motor routines of the dancing body, both being still too entangled with the chaos of the world. In order to structure chaos, an external decisional entity has to be let in: in Cunningham's example, this function is fulfilled by the possibilistic options of the *I Ching*. The structure derives from numbers, from a numerical definition of all the possible elements and relations (for example, legs and torso directions, velocities, tempo and movement phrases, all numbered, as in the choreography of *Torse*, 1976), and from their possibilistic combination by chance. In this limited compositional field, autonomous decisions start to be taken by numbers themselves. It is indeed a Platonic conception of creative formation that emerges here, one in which a transcendental dimension of composition intervenes and combines itself with the qualitative dimension of matter. But it certainly is a Platonism without moral implications, one in which every judgment according to the beautiful, or the just, is replaced by the decisional force of chance, and one in which the two dimensions of matter and numbers coexist as two parallel aesthetic fields: the quantitative order of numbers in this sense intervenes on a movement material (the gestures and steps), interacting with its qualities and formations.

It is not a purely qualitative conception of the idea that is therefore at play, one in which the qualities of matter determine their own order, but a quantitative one, in which numbers intervene to order a set of preexisting elements. To reposition ideas in a field of numbers is to acknowledge the importance of an external, neutral intervention into the realm of art: it is for this reason that Cage, and his collaborator Cunningham, are often considered among the precursors of software-based composition in art. And we can find in Whitehead's philosophy the abstract principle coinciding with this external entity (which we will define here as *software*) of creative composition: it is the notion of "relation," which he defines as an "abstraction from contrast."

In Whitehead's words, "A complex entity with . . . individual definiteness, arising out of determinateness of eternal objects, will be termed a 'contrast.' A contrast cannot be abstracted from the contrasted relata."[17] In order to exemplify this notion, Whitehead recurs to a chromatic case: the contrast between blue and red, which "cannot be repeated as *that* contrast between any other pair of colours, or any pair of sounds, or between a colour and a sound."[18] Being only the contrast between those two colors and nothing else, a contrast (always *that* contrast) is different from the relation that can be abstracted from it: "A relation can be found in many contrasts" (for example, between different colors or sounds), as it is *only* what relates the contrasted objects. In this sense, we can see how relations possess the necessary *indifference* to go not only beyond the human subject, but also beyond the artistic, in art.

Artists such as Jackson Pollock, Arnold Schoenberg, and Martha Graham had in fact already desubjectified pictorial, musical, and choreographic composition, respectively, by giving them a *raison d'être* based on the expression of subconscious, archaic, and primeval feelings. Something different occurs when Mark Rothko, Edgard Varèse, and Helen Tamiris make the qualities of color, sound, and movement emerge in all their aesthetic value. And yet, even in its most material forms, what these examples do not reveal is how art can be composed by the intervention of something existing outside and beyond its own sphere, even outside and beyond its own materiality.

From this point of view, it is possible to amplify Deleuze and Guattari's concept of sensation into a more abstract compositional principle, one less tightly linked to the essence of the matter in question. In Whitehead's theory, this software element is represented by the abstract relation of numbers that become autonomous from art, from philosophy, from body and mind, a principle shared, for example, by different artistic works such as Gerhard Richter's *Farben* paintings, Pierre Boulez's Third Piano Sonata, and John Cage and Merce Cunningham's collaborations.

The very nature and concept of the *diagram* has therefore changed: from a composition of sensations, it has now become "a purely quantitative regime and functions as a schema of data collection and registration."[19] Be it color chips or dance steps, the data transform the plane of composition into an abstract space of operational processes where coherence and confusion, structured possibilism and chance, coexist in "a structure of permutation that could vary its own quantitative arrangements in . . . different presentational constellations."[20] In the same way, eternal objects, in Whitehead's philosophy, are indeed conceivable as potential relations of extensive connection between atoms or regions of the world.

The Rhythm of Counting

Cunningham's contemporary classicism (or *software ballet*) also reveals the full potential of its compositional principle in the unusual relation that links choreographic and sound scores. Rather than by expressive or representational correspondences, the sonic and visual elements participating in Cunningham's performances are only associated by a common compositional process based on numbers: chance as the main generative method shared by the two composers. As examples of "wild disorder embedded in stable structure," the dance performances are accompanied by an unpredictable combination of sounds that are not in an expressive or prechoreographed relation with the steps.[21] Furthermore, the sound score is only heard in the last rehearsal or in the first performance, and suddenly appears to the ears of the dancers as a veritable assault on their orientation and balance capacities. It is therefore important to consider this compositional technique in relation to its embodied results on stage. According to Carolyn Brown, a previous member of the Cunningham Dance Company, "Usually we would hear the music and feel the lighting in the first performance. I will not pretend that this is not extremely difficult for the dancers. Loudness, especially unexpected loudness, affects the inner ear, the seat of balance, of equilibrium. Continual loudness can make one irritable, nauseous, even faint."[22]

With the music-choreography disassociation increasing, and the dancers' unsupported time span expanding, a need for balance and consistency arises. Instead of the direct music-dance accompaniment, Cunningham's choreography asks the dancer to reach a condition of resistance to external stimuli and of exclusive immersion into the performance of movement, to find that consistency in movement itself. As the music was composed in a parallel nonrelation to the dance, the dancers would balance and time themselves, and the duration of their steps, by counting. By counting, the numbered dancers literally manage to stand.

We have already seen how Cunningham attributes to numbers, and counting, the peculiar role of liberating the aesthetic composition from its subjective and material anchorages. The same liberating function now returns, this time as a veritable anchorage for the dancers' distraught and precarious balance. We have also seen how Deleuze and Guattari's notion of the numbering number made counting correspond to a simple metric routine, or a trap. We are therefore, at this point, in need of expanding this concept. Whitehead's philosophico-scientific theorizations appear once again as possible ways out from this contradiction.[23]

Far from indicating an ontological stasis in Whitehead's mathematical conception (compared, for example, to his process philosophy), his simple, straightforward conception of counting and numbers is at the basis of a very abstract and yet dynamic notion. This notion relates to and also informs the concept of *nexus*: a set of actual occasions "in the unity of their reciprocal relatedness," or in other words an "event"; for example, a movement as a series or a set of steps.[24] A nexus is in fact always analyzable through a sequential mathematical model, or by counting: 1, 2, 3 . . . steps. But a closer reading of this concept reveals that if, on one hand, steps are extensively disposed, from A to B, or from 1 to 2, on the other hand, from point 1 to point 2, a simple step unfolds into a potential spiral. Point 2 becomes the mark of a change, as if the idea of *twoness* (different from *oneness* for the simple fact of coming after) was attracting the unraveling of the step. The body in position 2 will always be different from its past experience: the image of what will have happened in point 2 or, in Whitehead's vocabulary, the point-object of an idea (twoness), is what attracts and constitutes change, the becoming of a step-object as the unfolding of an actual occasion of experience.

This acting backward of the future point (or the idea) gives to the moving event its rhythm: it is like the complexity inherent in an apparently simple continuity, or the differentiation of a linear movement. *From 1 to 2* is, in other words, differentiated and complexified by the parallel sequence, *from 2 to 1*. In this reverberation between the "atomized quanta of extension" involved in the realization of a step, it is possible to grasp the rhythmic sense of time as a pushing and pulling in all directions.[25] As Whitehead shows, in order to perceive time, we have to abandon the idea of a pure succession and feel the irreversible relation between fixed past and derivative future. It is this intricate relationality between the concreteness of the past and the virtuality of the future that characterizes Whitehead's conception of numerical difference, or what it means to count. In this conception, the very process of counting always follows an abstract idea, a metric always possesses its own rhythm. Dancing while counting, you are after the eachthingness of steps as numerical ideas.

It is very evident how the combinations delineated by Cunningham's choreographic compositions derive from numerical ideas, in which the *I Ching* acts as a sort of software, or an idea generator. A very clear example of this numerical conception is the idea of root in the choreography *Root of an Unfocus* (1944): here, as Copeland explains, the root refers not to any deep emotional core from which the dance would derive, but to the numerical concept of square root that governs the whole time structure.[26] The

performance has in fact three sections, with three different time lengths (90 seconds, 180 seconds, 60 seconds), and the tempo of each section varies as well (starting from an original phrase of eight beats, ten beats, and six beats, respectively). The division into discrete units, their combination into square roots, and the counting of these roots by the dancers, is fundamental. By counting, the dancers do not simply measure the space and time metrically, but literally cling to the virtual structures woven around these ideas. This makes of the dancers composers, as well as executors of the movements: in the same way in which the choreographer appears as the executor of the *I Ching*'s numerical ideas by composing them with a set of possible steps, dancers compose the choreographic ideas by weaving their own anatomical possibilities around them.

The Detachment of Technology

Cunningham's use of the LifeForms and DanceForms software has determined an extension of his compu-sitional procedure, allowing both himself and the dancers to discover how to make possible the impossible or the unthought: on the computer screen, body parts selection, their number, and the types of movements to be performed by them, can all be decided by chance. In 1968, Cunningham had already imagined the conception of a digital technology that could allow the representation of 3D figures on a computer screen. Twenty years later, the LifeForms software has provided a pragmatic reply to the choreographer's hypothetical vision, allowing him to create choreography by mixing, matching, and blending (as well as copying and pasting) preexisting or newly created phrases and sequences of movement.

On the computer screen, a series of algorithms visualized as odd little 3D bodies without organs, bones, or muscles move and float in a sort of vacuum space-time with no gravitational or chronological restrictions, stimulating and suggesting all sorts of unexpected and unimagined motions. The software simply ignores habitual kinetic parameters such as those of gravity, allowing a series of bounce and squish motions to be performed beyond all space responsiveness. Pure algorithmic relations between points, embedded with constraints and rules, produce a sort of mathematical dance that the human body will be asked to reproduce, in one way or another. The digital *dispositif* appears here in its capacity to multiply the possibilities of gestural creation, allowing the choreographer to search and find new movements, and the dancers to perform them: when movement sequences created on the screen become physically impossible, dancers can work to discover new

ways of realizing them, while the choreographer can discover new ways to think or find connections and new imaginative possibilities.

In *Software Studies*, Matthew Fuller reminds us of the literal definition of *software*, when he echoes the words of John Tukey, the writer-mathematician who introduced the term: a set of mathematical and logical instructions for electronic calculators.[27] Software, in other words, is the combination of data and programs that constitute the instructions of a computer (or a data processing system). As a conceptual and intangible (rather than physical) entity, software possesses what Fuller defines as a sort of "self-sufficiency," or mathematical abstraction. It is this abstraction, in Fuller's words, that "allows (in much the same way as it allows a programmer to think he or she is working on the formulation of a particularly interesting and chewy algorithm when working at another scale, perhaps more determining, on an insurance program to more finely exclude the poor from social services) a certain distance from social or cultural norms."[28]

Whereas the application of this abstraction becomes an ethical aberration of social indifference toward the concrete effects of programming, the sphere of artistic composition allows the same indifference to acquire a positive creative value. It is in this abstract space that, as Fuller insists, "things can be done in software that don't require much dependence on other factors. The range of articulation software allows due to the nature of the joints it forms with other layers of reality means that this freedom (that of a closed world), while somewhat paralyzing, has also guaranteed it a space for profound and unfinishable imagination."[29] Would this not be a somehow relevant definition for choreographic software, especially as it is used by Cunningham?

It is important to clarify that the aim of this discussion is not to humanize technology or to make it alive by thinking it as a locus of autonomous subjective tendencies, desires, or beliefs (as Adrian Mackenzie does, for example, in his analysis of the scripting language R) but, to the contrary, to reattribute to the field of human-computer interaction (or, for us, the field of choreography-software collaboration) the abstract character of numerical processes.[30] Echoing Fuller's words, we can thus reiterate the question: "How are we to develop the capacity for unleashing the unexpected upon software and the certainties which form it?"[31]

In Cunningham's computer-assisted choreographies, it is exactly the abstraction and dehumanization of the software that seems to continuously push the body across thresholds. Already a characteristic of his choreographic technique from the 1970s (see, for example, *Torse*, in which the dancers are driven to master footwork and legwork of an incredible

difficulty, or the complex solos in *Fractions*, a video-choreographic collaboration with Charles Atlas, 1977), the achievement of unexpected complexity is strongly accentuated by the use of the software, with which the choreographer pushes his dancers to new extremes of upper- and lower-body coordination. This complexity is the result of a neat separation between the autonomous working of the software (a machine of chance procedures) and the physical consideration of the dancers' anatomy. The software, in other words, is not humanized by Cunningham; to the contrary, it is the body of the dancer that becomes *softwareized*.

In Cunningham's computerized choreographies (such as *Trackers*, 1991; *Beach Birds for Camera*, 1992; *Ocean*, 1994; *Enter*, *CRWDSPCR*, 1996; and the motion-captured performance *Biped*, 1999), the quality of the movements changes from his previous choreographic tendencies: footwork becomes the main component of the performance, and the position and movement of the arms appears as an added element. Arm movements are in fact only added secondarily and without any relation to the dance, creating a complex polyrhythm in the dancers' bodies, with legs and arms moving at their own respective velocity. Head and torso movements appear then at another stage of choreographic composition, again without any relation to what is happening to the legs and arms: the result is an idiosyncratic, unnatural, and difficult march. Deriving from the particular configuration of the computer screen and from the positioning of the dancing models on it (a positioning that highlights leg movements while making the arms somehow peripheral), this automatically acquired stylistic aspect gives the performance an awkward effect, exercising an affective impact on the performers' style. By isolating all the different elements of the performance as autonomous components of an assemblage, and by transforming the human dancer into one of these components, Cunningham reverses the usual process of humanization of the dance stage: this time, it is the human body that goes toward the inorganic working of the technical machine. This inverted relation indicates not only the idiosyncratic adaptation of the script by the human body, but also an anorganic becoming of both body and technology as they are animated by new abstract modalities.

More specifically, the creation of movement sequences by the software starts from key positions utilized by the computer to calculate and visualize intermediate images in a particular sequence. In this way, the computer automatically creates a smooth movement in between two key positions. This interpolation happens as a mathematical function that calculates the missing values by using an average of the functional values at its disposal. With the resources provided by this algorithmic calculation, the digital

dancer can unrealistically jump at whatever height, and can fly and remain in the air; the possibilities of its energy, muscles, articulations, and ligaments are unlimited. In this sense, performance can be thought as obeying a mathematical, rather than merely physical, order: rather than reflecting the acquired habits of the trained dancing body and its possibilities, chance becomes a rigorous procedure to destroy them and obtain unforeseen results.

As Copeland argues, "Cunningham [i]s a Pygmalion in reverse, choreographing dances in which performers seem . . . to acquire the emotional reticence and palpable physicality of objects."[32] Cunningham's choreographic style can in fact be defined as anorganic and consistent with a kinetic order that rarely seems guided by a natural sense of flow or by anatomical logic.[33] This style is merely guided by an interest in the dancing body as a moving object with infinite mathematical combinations. Here, the algorithmic creations of the software bring forth new potentials and new stimuli to realize apparently impossible movements and idiosyncratic phrases that go against biological and anatomical possibilities, allowing the exploration and discovery of previously unknown capacities and the overcoming of past beliefs and ideas of both dancers and audience. The performer/audience space is thus intensified and animated by the surprise and wonder of an unexpected event: technology and chance suggesting to the dancers how to do what they can do. The particular relation between thought and numbers, or between choreographic composition and numerical techniques/technologies, appears thus as an original mode of creation, something that, as Deleuze pronounces for pure thought, did not exist before.

Algorithmic Connections

Dominated as it is by the automatism of software-based processes, the computer age is often viewed as a threat to cultural memory. This idea is at the origin of *Loops* (2001–2011), a motion capture and multimedia art project realized by Merce Cunninghm in collaboration with the OpenendedGroup. Originally commissioned by the MIT Media Lab for its "ID/Entity" show, this work was recreated in 2007 in triptych format installation, and its underlying code released as open-source.

More specifically, *Loops* is not a portrait of Cunningham's own body or figure, but of the movement of his hands. The portrait derives from a motion capture of his solo dance for hands and fingers, in which the joints "become nodes in a network that sets them into fluctuating relationships with one another."[1] The source for the soundtrack is Cunningham's own voice reading various diary entries that tell us about his first visit to New York in 1937, when he was seventeen years old. The intonation and rhythm of the voice are then transformed into an actualization of a piano score composed by John Cage. The score does not specify the notes to be played, but rather the desired relationships between elements such as voice intonation and the equivalent piano tones. These relationships are played out in a different way at each different execution of the work, as *Loops* is computed in real time via an AI program, and is therefore to be considered, in this sense, a live performance.

We can conceive *Loops* as comprised of a choreographic and a technological element: the dance of Cunningham's hands, and the digital artwork derived from their motion capture. Despite their two different physical actualizations (human hands, digital computer and screen), these two elements are linked by a common need for *preservation*, as both dance and computer art never repeat themselves. "As a dance," Paul Kaiser therefore

asks, can *Loops* "outlive . . . its sole performer? As a digital artwork, can it survive the rapid obsolescence of its hardware and software?"[2] The impossibility of foreseeing all future technological formats, computer models, etc., in fact indicates an intrinsic obsolescence that can only be solved by continuously adjusting the code in order to accommodate it to the continuous technical updates. In the end, how can you make both forms, choreographic and digital, last through time? Can a film or a videotape make their memory eternal?

Another important issue emerging in the work is the complexity of both choreographic and technological components, and their challenging of any form of preservation or capture (such as notation or flowchart). Given this complexity and unpreservability, the *Loops* project's own answer to the above questions would seem to be a definite no. Instead, for Kaiser, the alternative to the preservation of a fixed form becomes the creation of a "living will" for both choreography and software, a sort of living inheritance that can allow perpetuation while preserving the openness and changeability of the work as its most important features. This living will has been technically realized not simply by transforming *Loops* into an ever-changing and live work, but more importantly, by releasing both the choreography and the code as open-source. In this way, choreographic and technological memory become forms of creation.

The choreography of *Loops* has been completely opened up. Videos shot from different cameras can be watched, and the motion capture files can be studied; this means that the movement of Cunningham's hands can be analyzed, examined, and measured from different angles and distances, and at any velocity. The digital artwork has also been opened up, and viewers are not only able to watch the runtime version, but also to look at, rewrite, and change its source code. Open-source licensing intervenes not only as a way to constantly update the work, but also to add something more to it, to reanimate it in its superficial presentation as well as in its profound structure.

The inspirational framework at the basis of *Loops* clearly belongs to a conceptual background characterized by the interweaving of art and nature, the natural and the artificial, organic and material creation, in which the metaphor of reanimation by living will is totally realized: the cybernetic machine becomes a living body, endowed with its own generative potential. Another interesting concept related to the work is that of "cultural ecology": according to Kaiser, rather than being born and existing in isolated purity, every artwork *grows* in a cultural environment that nourishes it and makes it survive. Here the organic parallel becomes even more evident.

It is worth noting here that the term *ecology* has always had interesting echoes and repercussions in the field of media and cultural studies. As Matthew Fuller explains, the term can refer to an environment in which "parts no longer exist simply as discrete bits that stay separate," but instead "set in play a process of mutual stimulation that exceeds what they are as a set."[3] In this ecological sense, objects are clearly to be perceived as potential "processes" temporarily embodied as objects, dynamic passions, or capacities that find a moment of transient stoppage in the stability of an objective state. According to the theorist, it is this very condition of passing temporaneity and processuality that gives us the true meaning or conceptual reality of objects. And it is one of the powers of art to cross the dimensions of actuality and virtuality, to go from objects to concepts, unifying them in one single event. This processual vision is tightly coupled, in Fuller's notion, with an interest in the experienced materiality of objects, that is, in how they "can be sensed, made use of," and how they can make other things tangible in their qualities.[4] In fact, intrinsic dualistic tendencies seem to appear each time an object is required to strenuously fight in order to win for itself the desired definition of *organic*, even if only metaphorically, and be guaranteed a place in the sacred realm of the living. The same happens with assertions of useful concreteness as opposed to idle abstraction, in which an object such as software is asked to prove its usefulness as a tool allowing various processes of exchange, sharing, and communication between human beings.

On the other hand, it is possible to simultaneously pursue an investigation of the inert (im)materiality of objects and, in particular, of a specific choreographic and digital object such as *Loops*. From this point of view, reevaluating the open-source nature of the software in a conceptual sense will allow us to think a different kind of openness operating at a more abstract level, an immaterial level indifferent to its physical connections and concrete outcomes: an openness that is first of all simply due to the capacity of numerical algorithms to connect with each other. It is this form of numerical connectability that makes processes of human-machine-human interaction possible, as if numbers, or digital bits, were acting, with their own reciprocal connections, as attractors for the connection of human participants. Instead of the *more people, more ideas* equation that usually makes creativity a prerogative of human collectives, and instead of considering the survival of the artwork as a result of multiple collaborations between programmers and sharers, it is the work itself, intended as software or as a pure numerical idea, that attracts the processuality of the whole open-source movement, in which people become the tool for the actualization of an idea.

Algorithmic Complexity

The *Loops* project was realized through a digital environment called Field, an authoring program created by the OpenendedGroup to respond to the particular needs and limits of digital art.[5] In fact, the main guiding principles of the system are "embrace" and "extend." In other words, rather than make a personal, private code possible, what Field mainly achieves is the bridging and linking of different libraries, programming languages, and ways of doing things. And instead of asking artists to choose between data flow systems, graphical user interfaces, or textual programming, it brings it all together at the same time, through its programming language Python, a flexible language that makes the program intensely customizable through the constant modification of the relations (the glue) between interface objects and data. One of the most important characteristics of software, all software, is indeed its standard, that is, the process that allows software designed in different languages and for different operating systems to understand and exchange information reciprocally. In this sense, we can see how the concepts of open-source and free software actualize the main underlying idea of all executable code (i.e., unlimited exchange). Creative openness, once again, becomes a feature of digital algorithms connecting, and connectable, to each other. It is at this point necessary to discuss whether, and how, the combinatorial nature of digital algorithms can really be thought as conceptually infinite, and therefore creatively open, in itself. Or, in other words, can the virtual infinity of thought become an infinite combinatorics allowed by the universal standard of 0s and 1s?

All computer software simply counts according to a dual (or Boolean) logic, in which the operations are limited to those possible between a 0 and a 1. Pure mathematics was theorized by George Boole in 1847 as a mode of thought in which even numbers (intended as quantities or magnitudes) lost their significance in favor of more abstract and universal operations. A new algebra, known as Boolean algebra, or the algebra of sets, appeared. In this system, letters (x, y, z) were used to represent the objects of subsets of things (be they numbers, points, ideas, or actual entities). The signs \vee, \wedge, and \neg were used to indicate OR, AND, and NOT, respectively, as the possible operations of union or intersection between the members of a set. These operations also coincided with the set of all operations on the set $\{0,1\}$.

The basic element introduced by Boolean logic, the concept of x, y, or z as an abstract variable, is in fact also strongly present in Whitehead's thought. Discussing logical reasoning, Whitehead introduces the notion of a "proposition," or a combination of actual entities and their abstract

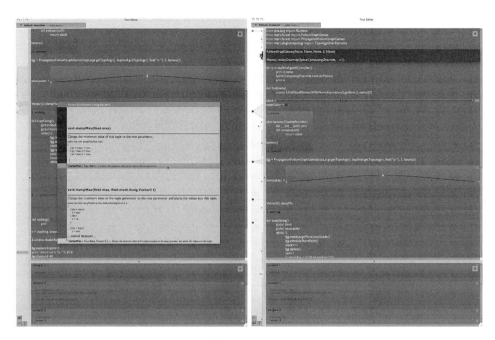

Figure 12
Field software screenshot (open-source software by the OpenendedGroup).

relations; in this context, the variable can be identified with a symbol that indicates "any" entity to which the proposition can be validly applied, so as to constitute a determinate proposition. This variable, though undetermined, sustains its identity throughout various successive arguments.[6] It is once again important to highlight the main property of the variable as that of indeterminacy, or its capacity to indicate an abstract *any* that at the same time gives to the proposition its determinateness. In this sense, the function of the variable is adopted by Whitehead as one of the best ways to describe "process." Indicating a general *any* (for example, *any* number in algebra), the variable does not indicate a particular quantity or quality, but only the possibility of having the same quantity or quality, the same number as valid in all consecutive operations of a particular process. The vagueness of *any* is thus combined with the definiteness of a particular persistent indication, but in abstraction from actual numbers. It is this precise abstraction, according to Whitehead, that transforms logic (and pure mathematics) into metaphysics. Barry Smith has also described very well this metaphysical passage of Whitehead's (and Husserl's) logic: "Variables, x, y, z, etc. will range over entities (particulars, individuals) in general. Here

the term 'entity' is to be understood as ranging over *realia* of all sorts. Our quantifiers are otherwise unrestricted, embracing, inter alia, my left foot and the interstellar vacuum, my present headache and the 3-dimensionally extended colour of this green glass cube. They embrace what is continuous or discontinuous, bounded or unbounded, connected or non-connected, and they embrace also volumes of space and intervals of time, as well as 3-dimensional material things and their parts and moments."[7] The first important element introduced by Boole's logical idea is therefore the universal abstraction operated by the symbol, even beyond number. The possibilities of actualization and connection in this abstract logical field are practically unlimited: infinite.

The possibility of reducing (or not) infinity to an infinite series of possibilities, that is, reducing it to a "pure" number, has been an issue of debate in philosophical discussions of all times. Hegelian dialectic already distinguished an actual or philosophical infinite from a bad or mathematical infinite.[8] According to Hegel, mathematicians rely on a concept of number to indicate the infinite as the greatest of all numbers (the infinite series), the indefinite or unlimited. The concept of a nonnumerical, philosophical, or actual infinite, on the other hand, was conceived by him in contradiction to the former. It is the limited or finite that, for Hegel, realizes an actual conceptual infinity, not as an infinitely open series, but as the uncountable units existing between the maximum and the minimum of a finite, limited actuality. Deriving from Hegel's own interpretation of Spinoza's ideas on infinity, this dialectical conception has been overcome by contemporary rereadings of Spinoza's work: rather than being thought in contradiction, the two aspects—the unlimited series and the actual infinity of the finite— are considered to be one and the same thing perceived from the respective points of view of the imagination, and of reason.

In Spinoza, both infinities, numerable and nonnumerable, in fact exist simultaneously. Their difference cannot be expressed in the form of an opposition or a contradiction, but rather as a difference between an inadequate and an adequate way of understanding the infinite, the main error of the imagination being that of taking for infinite something that is in fact finite. But it is the idea of infinity as the absolutely infinite continuity in the finite that indicates an adequate understanding of this relation. Counting to infinity becomes, from this point of view, an inadequate idea of the infinite or virtuality itself, mathematics being at the same time considered a limited way to represent this virtuality.

One point on which Spinoza might have agreed, at least to a certain extent, with both Deleuze and Whitehead is that mathematics is a field

endowed with infinite complexity, one in which new concepts and ideas, or new *non-self-evident axioms*, are constantly being created.[9] Differently from David Hilbert's view of mathematics as a determined and closed axiomatico-formal system, this infinite possibility of creation constitutes mathematics as an open field, an incomplete system whose truths can rarely be fully demonstrated.[10] What this means is that mathematics is full of facts that do not have redundancy, or cannot be reduced to any explanation because they are infinitely complex: every law or theory must in fact always be simpler than the data it tries to explain.

It was already Leibniz's problem, in the seventeenth century, to understand how to distinguish facts that follow some definite law, or can be explained by an axiom, from those without rule, chaotic and irreducible. In order to reduce logical problems such as chaos to the order of a systematic form, Leibniz tried to develop a universal algebra of logic, in which a set of universal symbols or ideograms would represent the small number of fundamental concepts that are really needed in thought to explain everything, and in which composite ideas would result as combinatorics of this alphabet. New discoveries would thus derive from the performance of routine operations on these symbols, and according to the rules of a logical calculus. The relation between this kind of combinatorics and the existence of complex irreducible facts is still a philosophical and mathematical problem of great importance today.

Interestingly for us, Leibniz also thought that everything can be represented as binary mathematical information: by building one of the first computing machines in history, and dealing through it with themes of complexity and causality, he was the first real predecessor of Gregory Chaitin and his "algorithmic theory of information," also known as the "theory of algorithmic complexity." In this theory, the whole physical world (even its complexity) is considered discrete and made of digital information, of 0s and 1s, while the continuum is only perceived as an illusion.[11]

Chaitin's algorithmic theory is, in short, like a software vision of science: every scientific system is considered a digital information program, a software that elaborates empirical observations and experimental data. The aim is to calculate the number of bits of the smallest software (or of the simplest existing scientific theory). In other words, the algorithmic theory tries to compress all the existing empirical data into the most concise algorithm. The simpler the theory (or the smaller the program), the better the capacity to understand. What Chaitin's theory really explores, therefore, is the possibility of measuring the complexity of a theory, or of a mathematical fact, through the number of bits of the smallest program required for its

calculation. By doing so, he tries to reduce complexity to binary units of information, and to formulate an algorithmic notion of complexity. Complexity, or the quantity of information about a particular set of facts, is transformed into a digital object.

A string of bits (or a set of facts) is considered irreducible (or *algorithmically casual, incompressible*) when its complexity is not reducible to a smaller program, but can only stay equal to its dimension in bits. This is to say that a fact is scientifically nonexplicable. In fact, according to Chaitin, we can never be sure that a given program is the smallest possible (or that a given theory is the most efficacious, or that a given set of facts is not explainable differently), because this is not mathematically calculable.[12] The impossibility of calculating whether a binary string or a program is the smallest possible, is defined by an incomputable number that Chaitin defines as Ω (Omega). The complexity of nature is thus considered a real number connecting virtual and actual planes, a potential incomputability embedded within all strings of countable bits. In this sense, Omega constitutes the incomputable virtuality of all computer programs.

Whereas, as we have seen, Deleuze's notion of the differential (the noncalculability of an idea) comes ontologically before the binarism of 0 and 1, Chaitin instead includes an element of unknowability in the very concept of digital computing and its sequences of binary strings. And whereas Deleuze's differential metaphysics defines the continual or topological deformations of movement and space, singularity for Chaitin becomes a discrete yet infinite, or continuous, number. Or, in Whiteheadian terms, it becomes an eternal object, a pure form or pattern, an infinite quantity intrinsic to any binary computation.[13]

According to Chaitin, basic mathematical axioms can be found by reducing facts to simpler and simpler explanations, until a level of self-evident axioms or postulates is reached. These axioms are like the atoms of thought, and cannot be proven through any simpler principles. All mathematical theories start from these axioms of logical irreducibility, from which more complex theorems are then deduced. At the same time, some mathematical facts do not belong to this category, and neither do they result from simpler principles; for example, Ω, an infinite string that is both irreducible and unprovable, appears as an inaccessible final number that shows the limits of reason and logic, and of counting itself. Chaitin's concept, in other words, reproposes the idea of a countable infinity.

The consequence of Chaitin's theory is that if, on one hand, software corresponds to the actual execution of preprogrammed automatic combinations, on the other hand its virtual dimension rests on a potential infinity

of combinations: once cut and translated into logical variables (such as 0 and 1), everything becomes connectable to everything else. This principle becomes clearly perceivable with open-source and free software, in which preprogramming gives place to unpredictable openness. More specifically, this is empirically achieved, for example, when the Field program allows the integration of graphical elements such as sliders or buttons into the text editor (equivalence between graphics and text); with the possibility of embedding other programming languages into the same document (including programming languages that execute inside other applications); or thanks to the capacity to build things visually in the canvas and then load them in other programs without having to recur to any user interface. What this graphic/text, or inter- and intralinguistic connectability shows, in other words, is a universal linkability between algorithmic objects.[14] Thus, what is important is not the actual step-by-step functioning of the computer, but the possibility of multiple transverse combinations.

It is worth noting here how Whitehead's definition of a pure potential also corresponds to a similar conception of infinity, identified as an imaginary, infinite series of eternal objects that are also expressible through the symbols (the variables and operations) of pure mathematics, ideas that determine the world as an atomic continuum. If virtuality is not a specific thing or trait but can take all possible forms according to how it is imagined, in Whitehead's way of imagining the virtual, ideas do not overlay or juxtapose themselves to the point of indiscernibility, but are actually what brings clarity of definition to the indiscernible and boundless nature of bodies. In the same way, Chaitin's mathematical symbol of Omega is an infinity made of discrete points (of 0s and 1s). Whitehead's theory thus encounters algorithmic complexity. In order to follow this encounter, it is, once again, important to think of algorithmic bits as having the capacity of interpolating and succeeding one another endlessly, in multiple ways, realizing a mathematical concept of infinity.

The computer's numeric way of arraying alternative states so that they can be sequenced into a set, step after step, is founded on the possibility of always adding a further step, a further number, not as an empty repetition of the same, but as the generator of a different virtuality, in which the latter does not coincide with self-varying deformation, but with the infinite addition of one more possibility. It is a metaphysical principle that gives us the key to a *computational faculty* taken beyond its actual technological application and reaching its nth level: digital technology becomes interesting, in this sense, only when asked to face the idea of computing the *incomputable*, or what can only be computed.

Binary Alternative

As a conclusion to these reflections on choreographic software, we would like to propose a binary concept of the virtual in its actualization. How does an abstract relation or an idea (such as that of countable infinity) provoke an actual occasion (such as a binary alternative)? Or, in Whitehead's words, how does it become this and not that contrast? Digital code is, inevitably, binary. In the Boolean logic moving the computations of digital machines, all the possible variables of a set are selected from a universal set defined as 1. At the same time, 0 is used to indicate the empty set, containing no element of the universal set (the null set). Each variable can thus be assigned a value of 0 or 1 (which generally indicate true or false, existing or nonexisting). Is this another possible contradiction with respect to the infinite creativity of the virtual?

Now, there is a way in which we can rethink the limitative aspect of this binary logic as being in fact an implicit character of all forms of thought (or, for Whitehead, of all conceptual feelings), therefore giving the exclusive polarity of the bits a more profound ontological foundation. According to Whitehead, the nature of every pulsation of actuality consists in an evaluative experience with respect to its actual data: what this means is that, first of all, all forms of process can be diagrammatically reduced to an operation of *keep* or *discard*. Experience does not have a simply continuous aspect but, as Whitehead states, at its most fundamental level is characterized by "the large-scale feeling . . . avoid it or maintain it."[15] Actual occasions of experience avoid or maintain each other. If, following this concept, we call *binary* the actual occasion's evaluation of data, it is possible to then recognize that this binary conceptual feeling characterizes the potential of ideas (and therefore the mind) more than the physicality of actual occasions (bodies). Again, in Whitehead's words, "An actual entity in the actual world of a subject *must* enter into the concrescence of that subject by *some* simple causal feeling, however vague, trivial, and submerged. Negative prehensions may eliminate its distinctive importance. But in some way, by some trace of causal feeling, the remote actual entity is prehended positively. In the case of an eternal object, there is no such necessity. In any given concrescence, it may be included positively by means of a conceptual feeling; but it may be excluded by a negative prehension. The actualities *have* to be felt, while the pure potentials *can* be dismissed. . . . A conceptual feeling is the feeling of an eternal object in respect to its general capacity as a determinant of character, including thereby its capacity of exclusiveness."[16] Whereas bodies can all in one way or another be considered as connected to each other,

ideas cannot. The clarity of each actual occasion of experience is precisely due to the fact that each movement, each perception, each thought, determines itself as only that movement, that perception, or that thought, often coexisting, but never confusing itself, with other occasions. Ideas are prehended or not.

We should not, of course, present this universal conceptual binarism of ideas as simply coinciding with the actual working of digital technology. But the case is similar to Whitehead's definition of process, in which the latter can simultaneously indicate a physical or a conceptual operation. For Whitehead, processes are of two kinds. The first is the self-constitution of an occasion, to the extent that it constitutes itself according to its final cause (or abstract idea).[17] In the second sense, process means the concrete determination of the present by the immediate past, intending, through this efficient causality, that the present also unfolds into the future. To analyze the occasion means to show under what transitional process multiple alien entities, coming from the past, are transformed into a unique present occasion. This also means that the two, physical and conceptual, operations are one and the same in each occasion, and that final causes act in accord with efficient ones. Digital technology, accordingly, works under the logic of a simultaneously efficient and final binary cause.

In *Loops*, for instance, we see how, thanks to an AI program, the ever-changing outcomes of each new running of the multimedia artwork derive from the preprogrammed steps of the software (actual process). At the same time, the articulation points that compose Cunningham's hands are in fact moved by a binary final cause or idea, which appears in the decision the points can take, about what other points to connect to. For example, the points can decide whether to connect with each other according to the predefined hierarchy of the hand, or not; to grab the closest point in space, or not; to connect with opposite points, or not. The points can also choose whether to lead or trail the motion, to cut corners, or to preserve imaginary physical momenta, and they can finally decide whether to send signals and noise to the colony of points, causing rapid shifts in it, or to lead to patches of agreement. Here, the *yes* or *no* logic translates into software and hardware operations: to reconstruct or not reconstruct movement, and to adopt or not adopt a special rendering style. Whereas this binary logic has often been considered essential to the software's fundamental lack of real intelligence, this same logic can be reread in light of Whitehead's principle of conceptual alternatives. And whereas the repetitive continuity of the digital appears limited to the predetermined nature of the software, the simple fact of its binary interruption and choice coincides with a conceptual feeling

that, we can conclude, is proper to the algorithms' way to experience each other.

In fact, the binary principle is not merely a prerogative of digital computing, but of all forms of process. In Whitehead's philosophy, every form of process, independently of its nature, can be divided into three main phases: a first responsive phase, a supplemental stage, and the satisfaction.[18] As an example, in the case of dance we can see how actual data are first of all physically prehended as a multiplicity for synthesis—multiple sensations of the bones, muscles, ligaments, joints— appearing simultaneously and unconsciously. In the supplemental phase, the multiple data (or the multiple feelings) are transformed into a unity of appreciation (through a unique conceptual feeling) that is a step. Then, in Whitehead's words, "The satisfaction is merely the culmination marking the evaporation of all indetermination; so that, in respect to all modes of feeling and to all entities in the universe, the satisfied actual entity embodies a determinate attitude of 'yes' or 'no'": a step is *this* and not *that* step.[19] For Whitehead, in fact, "the

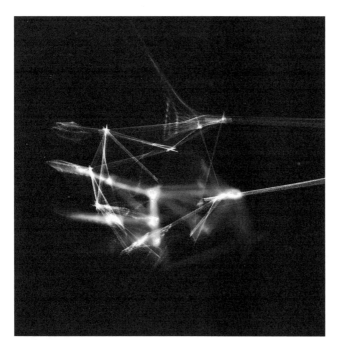

Figure 13
2D still from 3D version of *Loops* (movement and voice: Merce Cunningham; image and sound: OpenendedGroup [Marc Downie, Shelley Eshkar, Paul Kaiser], 2001–2011).

definiteness of the actual arises from the exclusiveness of eternal objects in their function as determinants. If the actual entity be *this*, then by the nature of the case it is not *that* or *that*. The fact of incompatible alternatives is the ultimate fact in virtue of which there is definite character."[20] A binary principle exists between incompatible alternatives, or more exactly between this *or* that, between this *and not* that.[21] It is simply the way in which the generality of all relations acquires the consistency of a particular contrast.

One of the clearest examples of this ideal alternative in the field of choreographic compu-sition is the logic behind Cunningham's *Loops*, a dance solo originally devised by the choreographer in 1971 as a performance to be exclusively executed by himself, and that he continued to dance in various forms until arthritis forced him to limit the execution to just his hands.[22] The original piece took different body parts and their variations one at a time (feet, head, trunk, leg, shoulder, etc.), in any order. The idea was to explore the maximum number of movement possibilities within the anatomical restrictions of each joint rotation. Despite the attempt at performing as many simultaneous movements as possible (for example, of hands and feet together), the performance is conceived as a step-by-step actualization of the concept of a binary choice. The duality that we have seen expressed by Whitehead's definition of conceptual feelings as evaluative forms according to which to *maintain or discard* an idea, manifests itself as the main principle guiding this choreography, under the form of a progressive list of automatic decisions between all the possible rotations of a limb: when rotating the right wrist clockwise, you cannot rotate it counterclockwise, and then vice versa. Rather than fluid continuity, the main idea at play here is the necessary alternative between motions.

We will call *radically digital* every choreographic compu-sition according to which, in one way or another, decisions are derived from binary evaluations. Whereas the coexistence of all possible and impossible moves is like the virtual field of movement, thinking movement in binary terms entails creative actualization, or the composition of ideas, according to a principle of alternatives. In this sense, we can say that Cunningham understood the essence of the digital, because he understood choreographic compu-sition from the vantage point of separate body parts, and practiced it under the conditions of this basic principle: each movement is only one single movement at a time, only this and not that movement (the each-thingness of each movement).

This criterion of exclusiveness is even more fully realized in the performance of the dance. The choreography of *Loops* is indeed very different

from those danced by the Cunningham Company, principally for its more intricate rhythm. The performance becomes a complex software program insofar as the synthesis of all the possible rotations is constituted as a weaving of simultaneous performances. It is easy to understand that the happening of ten movements simultaneously in the body means that the rhythm cannot follow the metric pattern of a beat. It is by reason of this complexity that Cunningham understood the choreography as only executable by his and not another body. *Loops* cannot be taught to anyone, because everyone's rhythm is different, and *this* particular rhythm could only be performed by Cunningham himself. The primary interest of the choreography therefore is that it situates the whole dance where it should be and in the way it should be, that is, in Cunningham's body as one, unique realization in the execution of a program. Of all possible dancers, he presents his own moving body as unique, as a "determinant of character, including thereby its capacity of exclusiveness."[23] When performing *Loops*, Cunningham himself became, in short, an eternal object, or an abstract idea.

A Germ of Conclusion: In Abstraction

Ideas, according to their nature, compose what we define as *the mind* in two different ways. The first way refers not merely to the transcendent realm of thought, but to that generative distribution of sensing, thinking, and moving that constitutes a body as simultaneously concrete and abstract. We do not move from one idea to another, by taking one step after the other, following a linear and predetermined plan. Ideas can only be felt and thought in the continuity of movement. In short, under the influence of ideas, thought becomes movement becomes feeling becomes thought, or a *bodymind*. Just think of the uneasy task of choreographing an improvisation, or of the ecstatic condition induced by tribal dances: no hiatus between body and mind, but only embodied ideas. Whitehead, however, makes an important point: if, at the limit, the thinking mind were conceivable as simply coincident with the sentient body, then there would not be any definite differentiation between bodies, and no definition of where a body begins and external nature ends.[1] A natural confusion of bodies: this is not all that dance as an art form does.

True and fascinating as it is, the indiscernibility of body and mind can only make sense when coupled to the other side of experience: that of their immanent distinction. In fact, unlike the exclusively embodied nature of emotions, ideas have two simultaneous but different sides. Ideas, therefore, must determine the mind in some other way. One must not confuse, in effect, physical feelings with conceptual feelings (or bodily mixtures with surface effects). The different nature of these two types of feeling (or of event) also takes us to the definition of another important difference between the objects felt, which can be distinguished as concepts (the "universals," or eternal objects) and individuals (the "particularities" of actual entities).[2] Being different in their objects and operations, how would the body and mind thus be able to fuse and confuse themselves, almost to the point of seeing their specificities dissolve into a reciprocal reflection? To

claim that one *is* or even *becomes* the other is not better than stating one as *superior* or *in control* of the other. None of these modalities accounts for and respects *both* their inseparability and their difference. In fact, it is not simply by reducing the mind to the body (following the same but inverted logic already adopted by Descartes when he reduced the body to the *cogitans* mind), that the anathema of dualism will be avoided. Bodily feelings, by themselves, suffice to make material relations (sensing a movement), but they cannot account for the origination of novelty that is proper of mental feelings, or the feelings of ideas (a movement is thought as dance).

But we are not talking of just any ideas here. As we have seen, the abstract nature of ideas can be exemplarily defined in the very abstractness of movement as an idea in itself, or an object without a body, a thought to be thought by analog and digital machines of all sorts. It is in cases of technologically perceived, preserved, and composed movements such as those thus far analyzed that the definite and abstract nature of ideas reveals itself, mobilizing the possibility of a body/movement abstraction: movement concepts to be thought separately from actual bodily movements. Simultaneous, but different. Immanent, but different. In their abstraction, movement ideas can occur *with* and *without* the body. And if indeed their actualization implies a body, the latter should be intended as a nonhuman, nonliving, immaterial one: for example, a digital image, or a thought.

No doubt, the outline of an abstract dimension of movement ideas could leave one thinking of a Platonic metaphysics simplistically adopted to counterbalance the phenomenology of dance and the conflation of reality with the privileged dimension of bodily events. As often noted, Plato is indeed an important reference in both Deleuze's and Whitehead's conceptions of the virtual. But recognizing how Platonic abstraction does not necessarily involve metaphysical dualism, we also recognize a radical difference between movements of the body and movements of the mind in their immanent relation. Taking the example of software, some commentators have noted how programming and digital design can easily become just another way to linger in the abstract recesses of the mind. This is partly true, and in this book abstraction indeed has been given more space than physicality. But the real (and problematic) issue, as clearly shown by Cunningham's digital choreographies, is not to eliminate abstraction tout court, or to solidify and reduce it to bodily sensations (even to the most fluid, ethereal ones); it is to know which abstract thoughts can attract and be attracted by certain bodily directions: for example, when a dancing body is shot by a camera, motion-captured, or choreographed on a screen. The

impasse of dualism would be implied, in these cases, by a theory of novelty as simply emerging from physical material forces.

Dismissing dualistic tendencies in favor of immanence, one of the threads that runs through the book—in tension with the assumption that the body-mind difference implies separation or predominance—finds in some examples of videochoreography, motion-captured dance, and choreographic software some of the main conceptualizations for a mobilization of thought-movement. Thinking here exceeds the subjective intellect, in the same way that the effects exceed their direct physical cause: following Deleuze, ideas must be thought as independent effects that have freed themselves from causes to become what Whitehead also defines as final causes in themselves. The subject who thinks (a dancer or a choreographer) is generated by thoughts. As such, ideas are idealized as differentials of thought, the unconscious of pure thought, toward a transcendental ungrounding of the very faculty of thought.

It is no longer a matter of rationally finding coordinates for movement or of precisely measuring it, but rather of literally cutting it up in thought, which amounts to a completely different thing. One main idea has emerged in our discussion: extreme disarticulation (the cutting of a continuity such as that of movement into discrete independent units) allows a proliferation of infinite possible relations. What can be philosophically salvaged from techniques of digital video editing, motion capture notation, choreographic software, after recognizing the technical limitations presupposed by these applications, is a movement concept as a mode of thinking movement that opens up some possibilities to wider potentials. Within technology's limited parameters and ways of working, there are ideas that are virtually infinite. This potential has been here pinpointed using the concepts of *choreo-nexus*, *mov-object*, and *compu-sition* to indicate the imaginative, mnemonic, and creative reflections of a movement idea that becomes digital, or discrete. In its negative connotation, choreographic thought aptly describes the regimentation of bodily potential by intellectual control. We thus find the link between, for example, metric (as a preestablished pattern) and control. But generally speaking, choreographic ideas denote the virtuality of thought in its relation to movement, the capacity of the mind to move and be moved, masked by technical and intellectual systems of various kinds. To think movement is to cut it in perception, to capture it in memory, to count and compose it, in thought. In abstraction.

The experiments of video-dance, notation, and software analyzed here have been useful ways of framing or demarcating the field of these choreographic faculties. Undoubtedly, they all include the potential of what we

have defined as the mind, as all audiovisual perception starts to *imagine* from a strain, all temporal preservation *remembers* regions of points and lines, and all creations are forms of *composition*. Actual applications (or, to use a definition found in both Deleuze and Whitehead, experienced "assemblages") envelop an abstract potential. But potential (as Whitehead often remarks) does not necessarily need to be exclusively equated with a concept of the infinite. We have already noted how each form of technology must be considered already possessing its own infinite reservoir of potential. But even the concept of infinity, or virtuality, a potent detonator since the days of the pre-Socratic clinamen, and especially after its systemization by Nietzsche and Deleuze, seems to have lost some of its urgency. One cannot simply continue detonating or hammering systems, if one does not want to end up with pure chaos.

In this sense, these applications can be seen, echoing Whitehead's language again, as technical "types" that, with their capacity for selection and emphasis, generate finite assemblages and make the flux of human movement thinkable (imaginable, rememberable, creatable) as dance. This capacity for limits is in a sense a property of the technology and also a potential of movement itself: a *mathematical mode of abstraction*. As Whitehead remarks, "We cannot understand the flux which constitutes our human experience unless we realize that it is raised above the futility of infinitude by various successive types of modes of emphasis which generate the active energy of a finite assemblage. The superstitious awe of infinitude has been the bane of philosophy. The infinite has no properties. All value has the gift of finitude which is the necessary condition for activity. Also activity means the origination of patterns of assemblage, and mathematics is the study of pattern."[3] Patterns and limits, when thought in combination with the infinite virtuality of ideas, are more interesting than virtuality in itself. The mind provides the limit, while keeping a glimmer open onto the infinite.

One example: the body. If the mind can be (and it has been) too easily accused of transcendental detachment, the definition of the body can easily become an excuse for physical predilection (the simple equation of thought and sensation), or, to put it another way, the organic realm of all that is moving and alive may be taken as an example of novelty, originality, potential. For there are two ways, as we have learned from Spinoza via Deleuze, to understand bodies: longitudinally, as made of material elements and components; and latitudinally, according to the sensations and affects they are capable of. However, in the Spinozan definition of a body's cartographic extension, its differential lines of individuation risk

remaining trapped within the confines of physically living matter, becoming the coordinates for a material organic art, or an art of the elements and affects. An art object fluidifying itself as a living body in the becoming of constant relations.

In its most efficacious readings (such as that of Deleuze), the materiality of the Spinozan definition is twisted into a dialectic of immanent abstraction, and the living body becomes a reservoir of potential, a source of affective becoming. But as emerging from Whitehead's frequent definitions, radical empiricism is as much a theory of concrete experiential evaluations as it is an abstraction from lived experience, or an experience of the abstract itself. It is to this reconciliation of the abstract and the concrete that most twentieth-century materialist philosophies and arts owe most of their innovations and potential. We do not call bodies only *real*, but also thoughts and ideas. And these are very different things.

What is certain is that the simple dialectical conflict of body and mind cannot contain the concept of the choreographic idea developed here, but neither can their absolute conflation. This concept helps us to know bodies and minds, and it tells us also how "each actuality is essentially bipolar, physical and mental, and the physical inheritance is essentially accompanied by a conceptual reaction partly conformed to it, and partly introductory of a relevant novel contrast, but always introducing emphasis, valuation, and purpose."[4] Hence, it is not for simple dialectical reasons that emphasis has been deliberately shifted here to ideas—and therefore to the abstractness of the mind—as that multiplicity without which pure empirical data would not receive any new form. Without ideas, "in the constitution of an actual entity . . . whatever component is red, might have been green; and whatever component is loved, might have been coldly esteemed. . . . The eternal objects are the pure potentials of the universe; and the actual entities differ from each other in their realization of potentials. [The] term 'idea' . . . means the determinate ingression of an eternal object into the actual entity in question."[5]

The problem with the Spinozan bodily cartography of elements and affects (or the continuum of lived experiences) when analyzing digital choreographic processes is that it usually comes at the expense of an equally important set of discontinuous abstract, ideal formations distributed across that experience, formations that are different from (or indifferent to) bodily affects themselves. How can this set speak out without falling back into dualism? One possible answer is by adding an abstract level of movement images, memories, and thoughts to the affective aesthetics of movement sensations. It is precisely the frequent exclusive accent on the physical

feelings, and the blind spot that this dogma produces with respect to conceptual feelings, that make it impossible to take a properly speculative non-dualistic perspective.

Creative determination transcends the occasion. As the transcendent abstractions of the occasional movement experience, concepts, or ideas, of movement establish novelty within the given: being equipped with mentality—with an abstract dimension responding to but also deflecting from concreteness—bodies become creative. Yet some readers may understand the movement idea, in its focused concern with an abstract dimension, as anti-aesthetic or, the preferable term, beyond aesthetics. For this reason, it is important to reiterate that dance, as it has been conceived here, is the effect of ideas in the mind. Too Cartesian to be art?

There is a key difference between an argument about the Cartesian harnessing and control of bodily passions by the rationality of the human mind (as expressed in anthropocentric notions of classical choreography and performative execution) on one hand, and the influential notion developed by choreographies such as those of Cunningham and Forsythe, of an abstract choreographic idea without the body, on the other hand. Whitehead says something very similar in relation to the Cartesian origin of his philosophy of the organism, distinguishing objects existing in reality from those existing in the mind. All mathematical objects (arithmetic, algebra, and logic) are grounded in mental operations as forms of pure process. It is, of course, a very different conception from that of Descartes, one in which the mind loses its private character and its total detachment from the world. But it is still a very different thing to creatively model and compose movement through abstract ideas (for example, numerical ideas) rather than physical ones. The creative force of these ideas lies in their abstraction and in their simultaneous capacity for weaving a dialogue with the moving body.

Where aesthetic and conceptual creation, abstract and technological mobilization, and performative desubjectification coincide, the appropriate term for such processes, following Whitehead but also Deleuze, may be that of choreographic ideas, or movement concepts. Movement is aesthetically animated when ideas define it, as they establish relations between singular points; it is animated when ideas activate it, in the sense that they give to the vagueness of sensations and impressions a certain vividness and order. In this sense, ideas of movement, or movements without a body, in, across, and throughout the dancer's body, make movement into a dance, or into an art.

One could easily assume that the substance of choreographic thought resides exclusively in the body. But is it possible for choreography, as Forsythe wonders, to generate autonomous expressions of its principles

without the body?[6] Forsythe's conception of choreography as a series of objects *without the body* appears as the potential generator of complex and controversial discussions. It was an aim of *Moving without a Body* to start from a very similar conceptualization. The new, reformulated question thus becomes: Is it possible for a choreographic image, object, or structure to possess a body of its own? This possibility acquires its most precise sense when we disentangle the very notion of *body* from that definition of "the body in motion," which, according to Forsythe, is still relegated to the domain of "raw sense." Here, the body starts to regain its mental consistency through choreography as a "physical model of thought." The objectification of this physical thinking comes to correspond to an almost unlimited array of potential embodiments (or potential divisions) of which the dancing human body is just one example. The body thus becomes the trace of an idea in the real world, "from nowhere to somewhere, not everywhere, and no longer exclusively within the bodies."[7]

At this point, we can paraphrase Forsythe's own question, and ask if choreography, in the era of its digitalization, has not come to a point of *ideal* change, in which the ideas that are traditionally seen as bound to a sentient, embodied expression are also able to exist in another intelligible (or, Whitehead would say, conceptual) state. In this technological/conceptual light, movement, it seems, becomes a matter of the mind at least as much as it remains an effect of the body.

Notes

Introduction

1. The definition of what an *online digital score* is and how it is obtained, can be found on the project's website: "The score creation process has an initial phase of **preparatory research** that normally includes the selection and possible adaptation of an existing dance to be the basis for the score. This initial phase also involves the determination of the most appropriate filming or recording technology for the particular score. The selected dance is eventually performed and recorded. This recorded material is taken into a **production phase** with digital designers and programmers who work closely with the choreographer to realize the final score result to be published on the web." Available at http://motionbank.org/en/scores-2/ (last accessed April 3, 2012).

2. See http://planettonyhawk.gamespy.com/ (last accessed April 3, 2012).

3. See http://www.bbc.co.uk/news/uk-scotland-glasgow-west-10659661 (last accessed April 3, 2012).

4. In this book, the processing of such abstractions is defined as *mind*. The view of particular entities as calculable units, separate extensions, or spatially and locatable points, is in fact what Alfred North Whitehead defines as *abstraction*: for the philosopher, the distinction between what is abstract (facts of the mind) and what is concrete (physical reality) is of fundamental importance, and failure to make this distinction amounts to a "fallacy of misplaced concreteness." As Whitehead argues, "Among the primary elements of nature as apprehended in our immediate experience, there is no element whatever which possesses this character of simple location. . . . I hold that by a process of constructive abstraction we can arrive at abstractions which are the simply located bits of material, and at other abstractions which are the minds included in the scientific scheme. Accordingly, the real error is an example of what I have termed: The Fallacy of Misplaced Concreteness." Alfred North Whitehead, *Science and the Modern World* (New York: Free Press, 1967), 58. From this point of view, the main question to be explored is to what extent digital technology can also be said to be a mind.

5. The definition of *code* adopted in this book will be given later in the text. For the moment, we will point out how this conception derives from Gilles Deleuze's distinction between analog and digital codes, and his definition of the digital from *digitum* (the counting finger). In his book on the painter Francis Bacon, Deleuze discusses abstract painting as a form of artistic expression in which chaos is eliminated, or reduced to its minimum, together with any form of tactile trace or manual craft: it is an ascetic art, an art of the spirit that goes beyond figuration, in order to reveal abstract forms. An art "without hands." These abstract forms, in their turn, belong to a purely optical space. Abstract painting, in this sense, elaborates a symbolic code on the basis of formal oppositions. It is this code that the philosopher defines as digital: the digits, here, are the units that group the terms of the opposition in a visible space. With its simple codified oppositions of vertical-white-activity and horizontal-black-inertia, Kandinski's art is mentioned as a primary example of this *code*: a conception of art based on binary choices. Gilles Deleuze, "The Diagram," in *Francis Bacon: The Logic of Sensation* (London: Continuum, 2005), 70–77. It is in this sense primarily that *Moving without a Body* conceives the digital.

6. In her book *The Absent Body*, Drew Leder discusses bodily absence as the disappearance of the physical body from subjective consciousness. In a quite different sense, *Moving without a Body* discusses the *absent body* as a passage into that dimension which has been extensively theorized, by contemporary cultural theorists, as the virtual: the body does not simply disappear from consciousness but from its own physical dimension. And differently from Leder's project of recombining the phenomenological interest and exploration of the body-subject with deconstruction and its notion of an inaccessible physicality, this book conceptualizes the simultaneity of bodily presence/absence as a relation between desubjectified matter and its powers of abstraction. The absent body, in short, is not the "anonymous body" (as Leder defines phenomena such as sleep or breathing, or the immaterialization of the body by digital technologies), but the incorporeal idea. According to Leder, it is a characteristic of the body to let itself be forgotten or fall into a nonperceived dimension. In this account, forgetting and disappearance are considered directly linked to philosophical tendencies such as Platonism and Cartesianism, which have always predominated in Western thought. A different, reverse version of these philosophies is given by *Moving without a Body*, in a time when their predominance no longer seems to be in place. Not the subjective experience of Platonism but its radical experience, in which the opposition between the anatomical body as a physical thing and the subjective body as a phenomenological experiencer is replaced by a notion of the virtual body. See Drew Leder, *The Absent Body* (Chicago: University of Chicago Press, 1990).

7. For a comprehensive account of this aspect, see the writings of theorist and practitioner Scott De La Hunta. Among his many writings, the article "Software for Dancers: Coding Forms," though written more than a decade ago, still constitutes a very useful resource. Available at http://www.sdela.dds.nl/sfd/scott.html (last accessed April 3, 2012).

8. The reference here is to the philosophical methodology actuated by Deleuze in relation to cinema. In particular, see "Preface to the French Edition," in Gilles Deleuze, *Cinema 1: The Movement-Image* (London: Continuum, 2005), xix–xx, where the philosopher explains how his two books (*Cinema 1* and *Cinema 2*) aim to present not a history of cinema but a discussion of images and signs, following philosophers Charles Sanders Peirce and Henri Bergson. In Deleuze's books, the concepts extrapolated from the work of these two thinkers are juxtaposed with some of the most important images in the history of cinema, of which they become "illustrations."

9. For a discussion on dance as a language (or a making of signs), and its relation to technology, see Kenneth King, *Writing in Motion: Body—Language—Technology* (Middletown, CT: Wesleyan University Press, 2003). For a phenomenological understanding and exploration of the dance/technology relation, see Susan Kozel, *Closer: Performance, Technologies, Phenomenology* (Cambridge, MA: MIT Press, 2007).

10. Kozel, *Closer*, xiv. Here, the body of the experiential subject is the *site of discovery*, and concepts and facts are mainly understood at a corporeal level, for the impact they have on how we concretely engage with them.

11. It is, in other words, a methodology in which both subjective and intersubjective experience predominate, as well as the need "to describe concrete, lived human life." Ibid., 5.

12. In the affirmation that "thought impacts experience just as experience impacts thought," we already see a clear distinction between the two. Ibid., 9. Perception and imagination, as well as thinking and doing, are always of the subject, or of the human body using technology. If phenomenology spans the differences between human and nonhuman, animal and machine, it always does so in physical, concrete, embodied, actual ways: embodied human perception is core. In a different way, *Moving without a Body* considers thought as an experience in itself.

13. The definition of choreography adopted here, as the composition of abstract movement patterns in thought, is in resonance with Merce Cunningham and John Cage's definition. In particular, as Jonathan Burrows specifies, one of their main ideas was to share "what they called a rhythmic structure, a pattern of empty bars of time which they would fill in with music and dance." Jonathan Burrows, *A Choreographer's Handbook* (London: Routledge, 2010), 152.

14. Kozel, *Closer*, xvii.

15. The phenomenological concept of an embodied mind is elaborated in Kozel's approach to performance and technology. For a nonphenomenological account of the bodily nature of sensations in relation to movement, dance and technology, see Erin Manning, *Relationscapes: Movement, Art, Philosophy* (Cambridge, MA: MIT Press, 2009).

16. Gilles Deleuze, *Difference and Repetition* (London: Continuum, 2002), 146.

17. Ibid., 141.

18. The definition of radical empiricism was given by William James, who explained:

Empiricism is known as the opposite of rationalism. Rationalism tends to emphasize universals and to make wholes prior to parts in the order of logic as well as in that of being. Empiricism, on the contrary, lays the explanatory stress upon the part, the element, the individual, and treats the whole as a collection and the universal as an abstraction. My description of things, accordingly, starts with the parts and makes of the whole a being of the second order. It is essentially a mosaic philosophy, a philosophy of plural facts, like that of Hume and his descendants, who refer these facts neither to Substances in which they inhere nor to an Absolute Mind that creates them as its objects. But it differs from the Humian type of empiricism in one particular which makes me add the epithet radical.

To be radical, an empiricism must neither admit into its constructions any element that is not directly experienced, nor exclude from them any element that is directly experienced. For such a philosophy, *the relations that connect experiences must themselves be experienced relations, and any kind of relation experienced must be accounted as "real" as anything else in the system.* Elements may indeed be redistributed, the original placing of things getting corrected, but a real place must be found for every kind of thing experienced, whether term or relation, in the final philosophic arrangement. (William James, *Essays in Radical Empiricism* [Lincoln: University of Nebraska Press, 1996], 39.)

In *Moving without a Body*, radical empiricism will be equated with Whitehead's philosophical system, defined by Michel Weber as "pancreativism," a "pragmatist metaphysics" in which actual and potential dimensions of experience coexist, as well as aspects such as atomism and continuity, liberty and determinism, duration and time. See Michel Weber, *Whitehead's Pancreativism: Jamesian Applications* (Frankfurt: Ontos Verlag, 2011), and Michel Weber, *Whitehead's Pancreativism: The Basics* (Frankfurt: Ontos Verlag, 2006). At the same time, these notions will also be associated with Gilles Deleuze's definition of "transcendental empiricism" as an empiricism of sensations. See Deleuze, *Difference and Repetition*, 56–57.

19. The reference here is to Spinoza's notion of "thought" as an attribute already proper to "substance" or matter.

20. For an account of Whitehead's relation with Platonism, see Alfred North Whitehead, *Process and Reality* (New York: Free Press, 1985), 43–44. As Deleuze also specifies: "The task of modern philosophy has been defined: to overturn Platonism. That this overturning should conserve many Platonic characteristics is not only inevitable but desirable. . . . The Idea is not yet the concept of an object which submits the world to the requirements of representation, but rather a brute presence which can be invoked in the world only in function of that which is not 'representable' in things." Deleuze, *Difference and Repetition*, 59. According to Deleuze, ideas are differ-

ent, in Plato, from Aristotle's "concepts." The Platonic Idea is to be intended as a quasi-cause (rather than a cause), an effect more similar to the Stoics' "phantasm": "For if bodies with their states, qualities, and quantities, assume all the characteristics of substance and cause, conversely, the characteristics of the Idea are relegated to the other side, that is to this impassive extra-Being which is sterile, inefficacious, and on the surface of things: *the ideational or the incorporeal can no longer be anything other than an 'effect.'*" Gilles Deleuze, *The Logic of Sense* (London: Continuum, 2004), 9–10. Being quasi-causal effects, rather than causes, ideas are indicative of a creative process that is not unidirectional (from idea in the mind to creation in matter). In both Whitehead and Deleuze, the ideal (or the radical, the transcendental) is in matter itself, and in relation with matter's physical forces.

21. Gregory Chaitin, *Meta Math! The Quest for Omega* (New York: Vintage, 2005), xiii.

22. See Brian Massumi, "Introduction: Concrete Is as Concrete Doesn't," in *Parables for the Virtual: Movement, Affect, Sensation* (Durham: Duke University Press, 2002), 1–21.

23. The definition of the virtual as infinite potential can be compared with Whitehead's notion of "pure," "abstract," or "general potentiality," that he also juxtaposes to that of the eternal objects.

24. Deleuze, *Difference and Repetition*, 209.

25. José Gil, *Metamorphoses of the Body* (Minneapolis: University of Minnesota Press,1998), 112.

26. Massumi, *Parables for the Virtual*, 137.

27. Whitehead, *Process and Reality*, 288. For a comprehensive account of extension, see Whitehead, "Extensive Connection," in *Process and Reality*, 294–301. The concept of extension as a Whiteheadian methodological perspective to conceive potential as an extensive continuum of discontinuous relations is very similar to the one deployed in Steve Goodman, *Sonic Warfare: Sound, Affect, and the Ecology of Fear* (Cambridge, MA: MIT Press, 2010). Identifying this potential discontinuity with vibrating matter, Goodman reminds us that, "One way or another, it is vibration, after all, that connects every separate entity in the cosmos, organic or nonorganic." Ibid., xiv. The discontinuous concept of vibration is nevertheless deployed by Goodman in a different way than the methodology adopted here, by analyzing the resonating encounter between body and sound from a perspective focused on the effects, or affects, provoked by the encounter at both physical and virtual levels. Abstraction, or the abstractive process of the mind, becomes thus incorporated to the account of how sound impacts the way an (individual or collective) body feels.

28. For Deleuze, the Whiteheadian definition of an experiential occasion deviates the philosophical discourse from the notion of the monadic subject as "automaton" to that of a subjective "machinism": machines are open and creative.

29. This prehensive collaboration does not need any sort of control or surveillance from the outside (as was the case with the monad's enclosed character, and with its need of a further divine presence); rather, it is the result of a material tendency toward aggregation. Highlighting this prehensive character of the actual occasion of experience, Deleuze traces a fundamental difference between the Leibnizian and the Whiteheadian philosophical methodologies: "For Whitehead it involves prehensions being directly connected to each other, either because they draw on others for data and form a world with them, or because they exclude others (negative prehensions), but always in the same universe in process. For Leibniz, to the contrary, monads exclude only universes that are incompossible with their world, and all those that exist express the same world without exclusion . . . they 'express one another' without harnessing each other. We might say that in the two instances monadic or prehensive units have neither doors nor windows. But for Leibniz, it is because the monads' being-for-the-world is submitted to a condition of closure, all compossible monads including a single and same world. Now for Whitehead, to the contrary, a condition of opening causes all prehension to be already the prehension of another prehension, either to control it or to exclude it. Prehension is naturally open, open onto the world, without having to pass through a window." Gilles Deleuze, *The Fold: Leibniz and the Baroque* (London: Continuum, 2006), 92.

30. Whitehead, *Process and Reality*, 96–97. See also Whitehead, "Coordinate Division," in *Process and Reality*, 283–293.

31. Kozel, *Closer*, xiv.

32. Gilles Deleuze and Félix Guattari, *What Is Philosophy?* (London: Verso, 2003), 123.

33. Deleuze and Guattari, "Functives and Concepts," in *What Is Philosophy?*, 117–134.

34. From Steven Shaviro's post "Fragment," in his blog The Pinocchio Theory, March 8, 2009, available at http://www.shaviro.com/Blog/?p=725 (last accessed April 3, 2012).

35. Shaviro's main project, in *Without Criteria*, derives from what he defines as a "philosophical fantasy" of the *what if*: trying to envision what the world would be (or would have been) if Whitehead had "set the agenda for postmodern thought" and had taken the place of Heidegger. See Steven Shaviro, "Preface: A Philosophical Fantasy," in *Without Criteria: Kant, Whitehead, Deleuze, and Aesthetics* (Cambridge, MA: MIT Press, 2009), ix–xvi. Again, this aim is very different from the one pursued here, in which Whitehead is instead considered one of the precursors of what is currently being thought and defined (in germ) by Maurizio Ferraris as "New Realism." For an exploration of this concept, see Maurizio Ferraris, *Manifesto del Nuovo Realismo* (Bari: Laterza, 2012).

36. One of these workshops is the *Notation Research Project*, a project based on the work of Emio Greco/PC, 2004. Information on the workshop is available at http://

insidemovementknowledge.net/context/background/capturing-intention (last accessed April 3, 2012).

37. Scott De La Hunta, ed., *Capturing Intention* (Amsterdam: Emio Greco/PC and the Amsterdam School of the Arts, 2007), 11.

38. Other approaches have focused on how the technological tool can allow viewers to manipulate and actively relate to interactive environments, and on the use of advanced motion capture technologies to create archives of movement. Examples of such practices are Thomas Hall and Mark Parry, STIR (information available at http://www.t01.co.uk/stir.html, last accessed April 3, 2012), the work of Silke Z./ resistdance (http://www.resistdance.de/resistdance/index.php/emotional_energy .html, last accessed April 3, 2012), the Whatever Dance Toolbox, of the company BADco, and also the experiments of Dr. Zhidong Xiao (Bournemouth University), to capture and archive the performances of the Beijing Opera.

39. For a clarification on the difference between extension and thought as two aspects of the same substance, see Gilles Deleuze, "On the Difference between the *Ethics* and a Morality," in *Spinoza: Practical Philosophy* (San Francisco: City Lights, 1988), 17–29. Also see Baruch Spinoza, "II. On the Nature and Origin of the Mind," in *Ethics* (New York: Penguin Classics, 2005), 31–67.

40. Whitehead, *Process and Reality*, 61.

41. The reference here is to Fedor Lopukhov's own definition of dance criticism, as mainly focused on the necessity to know what a movement feels like, in order to know and write about it. Fedor Lopukhov, *Writings on Ballet and Music* (Madison: University of Wisconsin Press, 2002), 151–152.

Part I

1. See Jürgen Schmidhuber's account of Konrad Zuse's theories, available at http:// www.idsia.ch/~juergen/computeruniverse.html (last accessed April 3, 2012).

2. The description of the *arabesque* comes from Carlo Blasis, quoted in Valerie Preston-Dunlop, *Dance Words* (Amsterdam: Harwood Academic Publishers, 1995), 309. Its definition as an ideal comes from Paul Kaiser and William Forsythe, "Dance Geometry," *Performance Research* 4, no. 2 (Summer 1999): 64–71.

3. Alfred North Whitehead, *Process and Reality* (New York: Free Press, 1985), 5.

4. Ibid.

5. See Karen Pearlman, "A Dance of Definitions," available at http://www.realtime arts.net/article/issue74/8164/ (last accessed March 23, 2012).

6. The transposition of dance into digital video seems to inevitably require a bridging of the gap, an affective activation of the numerical system by its *lived* experience:

technology is in fact *reanimated* many times, in the dancers' performance, in the choreographers' and videomakers' thoughts, and in the spectators' perceptions. Perception itself is therefore considered the bridging faculty, by bringing with itself a possibility of qualitative actualization for a pure numerical "nothingness." On the conception of the digital as numerical nothingness to be reanimated, see Brian Massumi, "On the Superiority of the Analog," in *Parables for the Virtual: Movement, Affect, Sensation* (Durham: Duke University Press, 2002), 133–143.

7. The perceptual illusions (or *hallucinations*) of a subject (*I see*, *I hear* movement) and the delirious (self)re-cognition of a thinking spectator (*I think* I recognize one or more dancing bodies, therefore I am) always presuppose an *I feel* "at an even deeper level, which gives hallucinations their object and thought delirium its content." Gilles Deleuze and Félix Guattari, *Anti-Oedipus: Capitalism and Schizophrenia* (London: Continuum, 2000), 18. Before thinking and counting, but also before seeing and hearing, there comes feeling. As Shaviro points out, "Deleuze and Guattari are writing in particular about the experiences of those people who are classified as mad; but their principle applies all the more to the collective hallucination and delirium that is cinema. It applies as well . . . to the newer media that have displaced film in the late twentieth and early twenty-first centuries." Steven Shaviro, "The Cinematic Body Redux," available at http://www.shaviro.com/Othertexts/Cinematic.pdf (last accessed March 23, 2012).

8. From the author's email correspondence with Shaviro.

9. In fact, Shaviro's approach goes much beyond the phenomenology of a performing body and a perceiving body connected and amplified through their technological extension, referring to an experiential plurality that poses the problem at a more complex level, redirecting the physical and subjective focus of phenomenology toward a different, and wider, critical trajectory.

10. Massumi, *Parables for the Virtual*, 16.

11. The definition of an "aesthetic cogito" derives from Brian Massumi, "Deleuze, Guattari and the Philosophy of Expression: Involutionary Afterword," available at http://www.anu.edu.au/hrc/first_and_last/works/crclintro.htm (last accessed March 23, 2012).

12. A numerical thinking-feeling, in other words, that delineates an experiential dimension beyond the rationalism of thought but also beyond the physicality of sensation. Luciana Parisi, "Abstract Spatium: Deleuze and Whitehead via Algorithmic Architecture," paper presented at Connect-Deleuze International Conference, University of Cologne, Germany, August 10–13, 2009. Nevertheless, Parisi's conception of this numerical feeling is different from the one proposed in this book, the main difference residing in her theorization of a totally autonomous sphere of abstract experience that does not need to be accompanied by any physical sensation in order to exist.

13. See Valentina Valentini, "Percorsi di ricerca" and "Teatro e nuovi media," in *Teatro in immagine. Eventi performativi e nuovi media* (Rome: Bulzoni Editore, 1987), 15–51.

Chapter 0

1. For this parallel, see Gilles Deleuze, *Cinema 1: The Movement-Image* (London: Continuum, 2005), and *Cinema 2: The Time-Image* (London: Continuum, 2005).

2. Deleuze, *Cinema 1*, 19.

3. Extensive studies of Loie Fuller's work can be found in Rhonda K. Garelick, *Electric Salome: Loie Fuller's Performance of Modernism* (Princeton: Princeton University Press, 2007); and in Ann Cooper Albright, *Traces of Light: Absence and Presence in the Work of Loie Fuller* (Middletown, CT: Wesleyan University Press, 2007).

4. For example, see Richard Nelson and Marcia Ewing Current, *Loie Fuller: Goddess of Light* (Boston: Northeastern University Press, 1997).

5. The definition of choreography adopted here has purposefully been made to coincide with Deleuze's notion of difference as "the only moment of presence and precision." Gilles Deleuze, *Difference and Repetition* (London: Continuum, 2002), 28.

6. Gilles Deleuze and Félix Guattari, *A Thousand Plateaus: Capitalism and Schizophrenia* (London: Continuum, 2002), 70.

7. Only after the full development of montage techniques will this simple hylomorphic action be complemented by the external agency of the director who, intervening in a godlike way, refines the rough perceptual function of the machine.

8. Deleuze and Guattari, *A Thousand Plateaus*, 407–410.

9. According to Deleuze and Guattari, Edmund Husserl was the first to conceptualize a materiality of changing qualities and of qualitative changes. Ibid.

10. See Gilles Deleuze, *Foucault* (Minneapolis: University of Minnesota Press, 1988), 45.

11. One may say, then, that the smallest operational unit of the cinematic configuration is not the frame but the *intensive degree*, the *intensive number*.

12. See Gilles Deleuze and Félix Guattari, "Percept, Affect, and Concept," in *What Is Philosophy?* (London: Verso, 2003), 163–200.

13. Deleuze, *Difference and Repetition*, 162.

14. For the concept of a "bloc of sensations," or a bloc of space-time, see Deleuze and Guattari, *What Is Philosophy?*, 164. The concept of a "locus" of contemporary occasions is such that any two of its members are contemporaries, and any occasion not belonging to it is in the past or in the future of some of its members. According to Whitehead, "A duration is a complete locus of actual occasions in 'unison of

becoming,' or in 'concrescent unison.'" Alfred North Whitehead, *Process and Reality* (New York: Free Press, 1985), 320.

15. In his short essay *The Principle of Relativity*, Whitehead proposes an original view on the subject of relativity, accepting the idea of an absolute contingency of physical phenomena, while at the same time acknowledging the necessity of a set of parameters or principles of spatiotemporal uniformity in order for this contingency to be creatively ordered. In the philosopher's words, electromagnetic and magnetic fields, or intensities and tensors of light, only constitute the material world lines, the impetus or paths of events as influenced by matter, and therefore only revealing a contingent level of appearance. The uniform appearance of multiple contrasting occasions will later on be defined by Whitehead as presentational immediacy. See Alfred North Whitehead, *The Principle of Relativity* (New York: Cosimo Classics, 2007).

16. Whitehead, *Process and Reality*, 29.

17. Whitehead, *The Principle of Relativity*, 114.

18. Whitehead, *Process and Reality*, 29–30.

19. On the history and conceptualization of different montage techniques as cinematic ways of thinking, see Deleuze, *Cinema 1* and *Cinema 2*.

20. Whitehead, *Process and Reality*, 18–20. The etymological origin of the prefix *choreo-* (as in choreography, choreutics, choreology) lies in the Greek *khoreia*, "dance."

21. Ibid., 81.

22. In Bergson's words, this temporal synthesis constitutes the duration of the present: "But there can be no question here of a mathematical instant. No doubt there is an ideal present—a pure conception, the indivisible limit which separates past from future. But the real, concrete, live present—that of which I speak when I speak of my present perception—that present necessarily occupies a duration. Where then is this duration placed? . . . Quite evidently . . . what I call 'my present' has one foot in my past and another in my future." Henri Bergson, *Matter and Memory* (Brooklyn: Zone Books, 2002), 137–138.

23. Following Bergson's philosophy of time, we understand the temporal compression of a multiplicity of moments (or occasions) as an incipient thought (or consciousness) emerging in the elastic duration or contraction of the present. Bodies are images, each body/image being more than a mere idealistic representation but less than an empirically determined and totally subjectified thing. The energetic modifications, tensions, and perturbations propagated throughout the universe cross bodies, which act and react reciprocally by linking all their facets at once. Bergson's radical immanence goes to the point of affirming that we cannot even say that bodies can simply be isolated as individuals acting and reacting reciprocally, because they are not separable from their own variations, movements, and relations. Ibid., 190.

24. Henri Bergson, "Of the Selection of Images for Conscious Presentation: What Our Body Means and Does," in *Matter and Memory*, 17–76.

25. Deleuze, *Cinema 2*, 58–61.

26. Whitehead, *Process and Reality*, 116.

27. Ibid., 61–65.

28. Ibid., 121–122.

29. Ibid., 67.

30. Ibid., 168.

31. Deleuze, *Cinema 2*, 7.

32. Ibid., 55–56.

33. The concepts of image as "crystal" and of "montrage" appear in Deleuze, ibid., 40 and 66–94. Deleuze borrows the concept of "montrage" from Robert Lapoujade.

34. See Maurizio Lazzarato, *Videofilosofia. La percezione del tempo nel Postfordismo* (Rome: Manifesto Libri, 1986), 7.

35. From a technical point of view, the ontology of electronic video, as a continuous scanning of electromagnetic points, is based on the idea of modulation: the same process of material image formation that was captured by the photographic frame and hidden behind the cinematographic mold, is now fully brought forward in the animated woof of electronic video. With modulation, the mold is put into variation, transformed at each moment of the operation (for example, through code grafts, as in the electronic image).

36. Other technical features of video are the manipulation of images (and perceptions) in real time through the continuous distortion of form, sound, and color, and the possibility to divide the screen in different sections with different images on them.

37. Deleuze, *Cinema 2*, 6.

38. Or, in *Body Electric #2* (2005, dancer Miriam King), the subjectivation does not happen at a mental but a corporeal level: the contractions and relaxations of muscles, nerves, joints, and the clockwork motions of the bones produce in the body a new dance that takes place between its folds. Pepe's video is available at http://www.davidepepe.com/ (last accessed March 23, 2012).

39. "Scrubbing" is a way of manipulating digital video that enables the user to manually deconstruct the continuity of a recorded sequence, by simply moving a cursor on a timeline. In a sort of audiovisual DJing, slight movements of the hand on the mouse can produce a subtle vibration of the frame, while large movements along two or more different sequences can create fast flickering effects and the

impression that multiple images are mixed together. This technique (which is usually used by editors to precisely locate in and out points of editing) is applied here to compose a new choreography by manipulating the recorded performance of the dancer.

40. This conceptual inference derives from a reading of Simondon's discussion on "substantial" and "hylomorphic" theories of individuation. Gilbert Simondon, *L'individuazione psichica e collettiva* (Rome: DeriveApprodi, 2001).

41. D. N. Rodowick, *The Virtual Life of Film* (Cambridge: Harvard University Press, 2007), 9.

42. For the concept of more-thanness, see Erin Manning, *Relationscapes: Movement, Art, Philosophy* (Cambridge, MA: MIT Press, 2009), 66. The "more-than" is also the subject of Erin Manning, *Always More Than One: Individuation's Dance* (Durham: Duke University Press, 2012).

43. Brian Massumi, *Parables for the Virtual: Movement, Affect, Sensation* (Durham: Duke University Press, 2002), 155.

44. Whitehead, *Process and Reality*, 56.

45. Ibid., 327.

46. Ibid.

47. For a detailed analysis of McLaren's *Pas de Deux*, see Manning, "Interlude: Animation's Dance," in *Relationscapes*, 113–118.

48. Ibid., 117.

Chapter 1

1. The definition of *digi-sign* used here is an adaptation of Deleuze's concept of "dici-sign." Gilles Deleuze, *Cinema 2: The Time-Image* (London: Continuum, 2005), 31.

2. A good example of perceptual design and control is given by contemporary advertising. On the preemptive nature of digital images, see Luciana Parisi and Steve Goodman, "Extensive Continuum: Towards a Rhythmic Anarchitecture," *Inflexions*, no. 2 (2009), available at http://www.inflexions.org/n2_parisigoodmanhtml.html (last accessed October 4, 2012).

3. Gilles Deleuze, "On Spinoza," available at http://deleuzelectures.blogspot .it/2007/02/on-spinoza.html (last accessed March 23, 2012).

4. Gilles Deleuze, *The Fold: Leibniz and the Baroque* (London: Continuum, 2006), 98.

5. For the notion of an obscure depth of perception, see Deleuze, "Perception in the Folds," in *The Fold*, 97–113.

6. For a discussion of this mathematical/philosophical parallel, see Gilles Deleuze, "Ideas and the Synthesis of Difference," in *Difference and Repetition* (London: Continuum, 2002), 168–221.

7. On the idea as differential of thought, see ibid.

8. In the differential calculus equation (dx/dy), the differential (d), a quantity that is rigorously calculable despite its inexactness, is quantitatively unimportant in relation to x and y, but exercises a fundamental function in determining their reciprocal relation and difference.

9. Deleuze, "Ideas and the Synthesis of Difference," 175.

10. Ibid., 171–172.

11. Steven Shaviro, "Kant, Deleuze and the Virtual," blog post in *The Pinocchio Theory*, available at http://www.shaviro.com/Blog/?p=577 (last accessed March 23, 2012).

12. Gilles Deleuze, *The Logic of Sense* (London: Continuum, 2004), 12.

13. Ibid., 8.

14. Alfred North Whitehead, *Process and Reality* (New York: Free Press, 1985), 327. As an example, we can think how all actual timbres, or tone colors of sound (bright, dull, wooden, metallic, etc.) presuppose a qualitative variability coupled to a systematic framework or an ultimate quantum system, a general and open scheme of possible quantitative relations or periodic vibrations of the sonic scale, that makes all comprehension (and compression) of sound possible.

15. Ibid., 43–46.

16. In Deleuze's words, the notion of "cut" grounds a new, static, and purely ideal definition of continuity, coinciding with modern mathematics, a continuity referred to as "the universal in number": the cut as the expression of an irrational number that precisely divides the series of rational numbers, at the same time making it into an ideal continuum. Deleuze, *Difference and Repetition*, 172.

17. The differential geometry of the Deleuzian idea as an inflection point continuously generating curves and folds appears different from Whitehead's mathematics of eternal objects and its capacity to combine the infinite qualitative continuity of the world with the atomized or *digital* seriality of individual occasions (quanta). Although the term "mereotopology" has been coined by Whitehead's successors in order to better define his geometrical theory, an explanation of the mereotopological schema can be already found in Whitehead, "The Theory of Extension," in *Process and Reality*, 281–333.

18. On difference as opposition, see Deleuze, *Difference and Repetition*, 50–51.

19. Scott MacDonald, *A Critical Cinema: Interviews with Independent Filmmakers* (Berkeley: University of California Press, 1998), vol. 3, 352.

20. In relation to this limit, human perception obeys an analytical and selective function: the infinitely repeated vibrations of light are, for example, captured and contracted into a unified image, trillions of external oscillations condensed, or filtered, into a millisecond color vision. From this point of view, Bergson defined the brain as a central telephonic operator: more than a center of conscious representation, the cerebral membrane appeared to him like a switchboard letting only a small amount of information pass through while delaying the rest. Henri Bergson, *Matter and Memory* (Brooklyn: Zone Books, 2002), 30.

21. Bill Viola, *Reasons for Knocking at an Empty House: Writings 1973–1994* (Cambridge, MA: MIT Press, 2002), 40.

22. Gilles Deleuze, *Francis Bacon: The Logic of Sensation* (London: Continuum, 2005), 71.

23. Gilles Deleuze, *Cinema 1: The Movement-Image* (London: Continuum, 2005), 50.

24. On the *transcendentalization* of the faculties, see Deleuze, *Difference and Repetition*, 138–148.

25. Ibid.,172.

26. On the concept of strain, see Whitehead, *Process and Reality*, 126.

27. Ibid., 311.

28. In this sense, Viola's reflections on magnification and detail seem to anticipate the idea of a computational infinity of the real:

I was walking home one rainy evening in New York City and I had to stop briefly to wipe the raindrops off my glasses. As I held my glasses up to clean them, a car drove by and I instantly noticed the image of its headlights passing through all the tiny raindrops clinging to the surface of my lenses. I looked closer. Another car went by. I could clearly see within each droplet a perfect little image of the street with the lights and the cars passing by. I cleaned off my glasses and put them on so I could see. I looked around and saw that the water drops on the hood of a parked car were also imaging the street scene. I realized, in fact, that every drop of water, even the falling rain, was doing the same. Seeing the drop images on the lenses of my glasses helped me to realize that these images were not reflections, but were optical images. Each water drop was functioning as a tiny wide-angle lens to image the world around. Exhilarated, I raced back to my studio, got out my video camera and began to experiment with magnifying the image in the water drop. (Viola, *Reasons for Knocking*, 41).

29. Deleuze, *Difference and Repetition*, 141.

30. Viola, *Reasons for Knocking*, 40.

31. For an abstract-spiritual concept of montage, see Deleuze, *Cinema 1*, 49.

32. Deleuze, *Difference and Repetition*, 28–29.

33. On Mandelbrot's fractals, see Gilles Deleuze and Félix Guattari, *A Thousand Plateaus: Capitalism and Schizophrenia* (London: Continuum, 2002), 486–487. In the same way, says Simon Duffy, "Deleuze does not consider this process of differenciation to be arrested with the generation of a composite function, but rather to continue, generating those functions which actualize the relations between different composite functions, and those functions which actualize the relations between these functions, and so on. The conception of differenciation is extended in this way when Deleuze states that 'there is a differenciation of differenciation which integrates and welds together the differenciated' . . . each differenciation is simultaneously 'a local integration,' which then connects with others, according to the same logic, in what is characterized as a 'global integration.'" Simon Duffy, "Schizo-Math," *Angelaki* 9, no. 3 (2004): 212.

34. Brian Massumi, *Parables for the Virtual: Movement, Affect, Sensation* (Durham: Duke University Press, 2002), 138.

35. Ibid., 89–132.

Part II

1. For an account of Deleuze's notions of difference and repetition, in relation to his predecessors Nietzsche, Bergson, and Simondon, see Keith Ansell-Pearson, *Germinal Life: The Difference and Repetition of Deleuze* (London: Routledge, 2003).

2. Gilles Deleuze, *Difference and Repetition* (London: Continuum, 2002), 71. The concept of memory as reproduced particularity proposed here nevertheless deviates from Deleuze's concept, principally for not considering it as having an exclusively qualitative and temporal nature: memory, in *Moving without a Body*, is also quantitative and spatial.

3. Ibid., 71–72.

4. Chris Salter, *Entangled: Technology and the Transformation of Performance* (Cambridge, MA: MIT Press, 2010), 267.

5. Deleuze, *Difference and Repetition*, 173.

6. In these considerations, the body/technology relation is either identified with a threat of disappearance into the rational realm of cyberspace, or with a possibility of cyborgian expansion. Various practical exemplifications of these approaches, and particularly of the cyborgian vision, came out during the Digital Cultures Lab, which was held in 2008 at the Future Factory of Nottingham, UK. Website available at http://www.digitalcultures.org/ (last accessed March 29, 2012). See also Susan Kozel, *Closer: Performance, Technologies, Phenomenology* (Cambridge, MA: MIT Press, 2007).

7. See Erin Manning, "Dancing the Technogenetic Body," in *Relationscapes: Movement, Art, Philosophy* (Cambridge, MA: MIT Press, 2009), 61–76.

8. Manning, *Relationscapes*, 9.

9. Henri Bergson, *Matter and Memory* (Brooklyn: Zone Books, 2002), 20–21.

10. Manning, *Relationscapes*, 6.

11. Roger Copeland, *Merce Cunningham: The Modernizing of Modern Dance* (London: Routledge, 2004), 191.

12. Deleuze, *Difference and Repetition*, 72.

13. Alfred North Whitehead, *Process and Reality* (New York: Free Press, 1985), 52.

14. Ibid., 22.

15. A virtual object is, in this sense, another way to define an idea: a "repeated difference" according to Deleuze, or an eternal object for Whitehead.

16. On the method of extensive abstraction, see Alfred North Whitehead, *The Principle of Relativity* (New York: Cosimo Classics, 2007).

Chapter 10

1. Gilles Deleuze, *Difference and Repetition* (London: Continuum, 2002), 140.

2. See Ann Hutchinson-Guest, *Choreo-Graphics: A Comparison of Dance Notation Systems from the Fifteenth Century to the Present* (New York: Routledge, 1998), 1–4.

3. Brian Massumi, "Event Horizon," in Joke Brouwer, ed., *The Art of the Accident* (Rotterdam: Dutch Architecture Institute/V2, 1998), 156.

4. Transcript of the John Tusa interview with William Forsythe available at: http://www.bbc.co.uk/radio3/johntusainterview/forsythe_transcript.shtml (last accessed March 29, 2012).

5. According to Whitehead, Newton adopted this essentialist conception, considering nature as being designed by a series of external laws, inert and repetitive in itself. For Newton, "space and time, with all their current mathematical properties, are ready-made for the material masses; the material masses are ready-made for the 'forces' which constitute their action and reaction; and space, and time, and material masses, and forces, are alike ready-made for the initial motions which the Deity impresses throughout the universe." Alfred North Whitehead, *Process and Reality* (New York: Free Press, 1985), 94.

6. See Manuel De Landa, "Introduction: Deleuze's World" and "The Mathematics of the Virtual: Manifolds, Vector Fields and Transformation Groups," in *Intensive Science and Virtual Philosophy* (London: Athlone Press, 2002), 1–44. The reading of Deleuze's scientific borrowings given by De Landa is nevertheless grounded on a different presupposition than the one proposed by *Moving without a Body*, in which

the definition given by Deleuze and Guattari for scientific functions as "slowing down" the virtuality of thought is critically compared to Whitehead's direct parallel between the two disciplines. All scientific formulations, for Deleuze, need to be derealized, or transformed into concepts, in order to acquire virtuality. See Gilles Deleuze and Félix Guattari, *What Is Philosophy?* (London: Verso, 2003), 118.

7. This concept emerged in the author's email correspondence with Manuel De Landa.

8. This is not "a regular division of time, an isochronic recurrence of identical elements," but a repetition of "tonic and intensive values act[ing] by creating inequalities or incommensurabilities. . . . Cadence is only the envelope of a rhythm, and of a relation between rhythms. The reprise of points of inequality, of inflections or of rhythmic events, is more profound than the reproduction of ordinary homogeneous elements. As a result, we should distinguish cadence repetition and rhythm repetition in every case, the first being only the outward appearance or the abstract effect of the second. A bare, material repetition (repetition of the Same) appears only in the sense that another repetition is disguised within it, constituting it and constituting itself in disguising itself." Deleuze, *Difference and Repetition*, 21.

9. Gilles Deleuze and Félix Guattari, *A Thousand Plateaus: Capitalism and Schizophrenia* (London: Continuum, 2002), 314.

10. Gilles Deleuze, "Second Series of Paradoxes of Surface Effects," in *The Logic of Sense* (London: Continuum, 2004), 7–13. In the same way, Whitehead's philosophical system delineates a parallel between conceptual and physical feelings (or prehensions): an idea is *only*, as Descartes and Locke also stated, an existence in the mind. Whitehead, *Process and Reality*, 76.

11. On creativity as a transcendent operation, see Whitehead, *Process and Reality*, 85.

12. The notion of intelligent sensation appears in Roslyn Sulcas, "Did William Forsythe Invent the Modern Ballerina?," an interview with Forsythe available at http://api.invideous.com/sso/server.php?action=attach&client_name=CLASSICALTV&client_session_id=9805b7a0bc04c77c2da10f83bd120006&checksum=85c709e1e79e d4dbf129e3a7bbb2b501&redirect=http%3A%2F%2Fwww.classicaltv.com%2Fthe-informer%2Fdid-william-forsythe-invent-the-modern-ballerina (last accessed October 8, 2012).

13. An object or mov-object (as a datum, such as a mov-object in the score) is therefore an entity with a potentiality for feeling and objectification, whereas the subject (or feeler) is that unity which is constituted by the very process of feeling (a superject). For a definition of the superject, see Whitehead, *Process and Reality*, 28.

14. Ibid., 82.

15. Steven Spier, "Introduction: The Practice of Choreography," in Spier, ed., *William Forsythe and the Practice of Choreography: It Starts from Any Point* (London: Routledge, 2011), 3.

16. See Spier, introduction to *William Forsythe*. And as Roslyn Sulcas also remarks, "As difficult as it might be to define or describe Forsythe's oeuvre, one element nonetheless seems clear to me: that his relationship to ballet is the cornerstone of his work, no matter how far from its precepts he might appear to roam." Roslyn Sulcas, "Watching the Ballet Frankfurt: 1988–2009," in Spier, *William Forsythe*, 5.

17. Based on the real limits of the body, this movement crystal outlines an icosahedron, a much more complex figure than the Euclidean circle and square described, for example, by Vitruvius in his *De architectura* (and drawn by Leonardo in the *Canon of Proportions*). His capacity, from this point of view, appears as one of "editing, structuring, and pacing," a capacity for original "arrangement" emerging, for example, when the stiff and straight *pas de deux* seems to ignore the conventional logic of steps. Sulcas, "Watching the Ballet Frankfurt," 6–9.

18. Patricia Baudoin and Heidi Gilpin, "Proliferation and Perfect Disorder: William Forsythe and the Architecture of Disappearance," available at http://www.hawickert .de/ARTIC1.html (last accessed March 29, 2012).

19. Ibid. This model is particularly apt to describe classical ballet, assuming a central bodily point as the axial element.

20. For a parallel between Forsythe's choreography and Kleist's ideas on ballet, see Gerald Siegmund, "The Space of Memory: William Forsythe's Ballets," in Spier, *William Forsythe*, 27.

21. This manifold potential of actualizations takes the ballet algorithm into a non-absolutist physical environment (reflecting, for example, Georg Cantor's theorem that no set of all sets can be given). Drawing on Deleuze and Guattari, we can in fact echo their quotation of Michel Serres's definition of physics as reducible to two totally different sciences, and distinguish "a general theory of routes and paths" (or a closed system of predefined interactions) from "a global theory of waves" (or an open system of creation based on forces and tendencies). Michel Serres quoted in Deleuze and Guattari, *A Thousand Plateaus*, 372. Following this distinction, we shift from choreography as the act of ordering the body's interactions with space and time (choreographic control based on the fixity of the body's center of gravity), to a reconceptualization of dance as a direct plunging into physical complexity (the center of gravity as a shifting and easily replaceable singularity).

22. Paul Kaiser, "Dance Geometry," a conversation with Forsythe available at http:// openendedgroup.com/index.php/publications/conversations/forsythe/ (last accessed March 29, 2012).

23. Paul Kaiser, "Steps," available at http://openendedgroup.com/index.php/public ations/older-essays/steps/ (last accessed March 29, 2012).

24. Sulcas, "Watching the Ballet Frankfurt," 4–9.

25. See http://motionbank.org/en/ (last accessed April 3, 2012).

Chapter 11

1. In 1887, Eadweard Muybridge's photographs could also capture accurate information about the kinematics of a horse's limbs using successive-exposure photography, assembling different cameras along a racetrack in order to measure and study the continuity of a horse's locomotion.

2. Among these instruments was an apparatus built to register the trajectory of the wing of a bird in free flight, a device that would register the up and down and back and forth movements of the wings simultaneously, and which "could transmit to a distance any movement whatever and register it on a plane surface." Paul Allard, Ian A. Stokes, and Jean-Pierre Blanchi, *Three Dimensional Analysis of Human Movement* (New York: HumanKinetics, 1994), 3. By the late 1800s, Marey had begun to use the camera in his scientific studies of human and animal locomotion, slowly replacing his mechanical graphing instruments. But technological invention would continue to be an essential feature of Marey's work, and eventually he was to develop a motion picture camera (the precursor to the commercial motion pictures) to allow him to further refine his studies.

3. Electric sensors located on the animal's body allowed a synchronization of the photography's rhythmic exposures with the movement's rhythm. Together with the sensors, Marey used reflective optical disks attached to key points of the moving body, a technique still used in contemporary motion-capturing devices. Ibid., 5. The traces of movement captured by this complex and sophisticated apparatus allowed Marey to focus more on the inflection and curvature points of motion paths, than on the simple idea of a sequential trace.

4. Digital motion capture systems consist of infrared color-sensible cameras, datagloves, and magnetic sensors attached to the body's joints and limbs, which do not reproduce the whole figure but only capture its motion by tracking the position-angle-orientation, velocity, and pressure of the sensors or infrared markers. Many different devices can be used to record movement: goniometers, electromagnetic and acoustic sensors, devices designed to measure the rotation of a joint, by providing a voltage drop across the ends of a resistor, and tracking the change in the flexion angle of the articulation. The results of this capture trace the temporal changes of spatial coordinates (kinematics), and calculate the forces and critical moments associated with the motion (kinetics).

5. For example, take SIMM (Software for Interactive Musculoskeletal Modeling), a software system that allows the creation and analysis of graphics-based models of the human musculoskeletal system: some of its embedded equations have their origins in nineteenth-century research of physiologists/scientists such as Marey.

Embedded in its complex *knowledge-based systems* (software that uses biomechanical information about how the human body behaves in motion) are mathematical equations derived from the laws of physics as they apply to human movement.

6. "Turbulence appears stochastically in laminar flow." The clinamen is "the minimum angle of formation of a vortex, appearing by chance." Michel Serres, *The Birth of Physics* (Manchester: Clinamen Press, 2000), 6. "Now the first possible angle that we may construct or perceive, or the smallest that may be formed, so that nothing can be inserted between the two lines which open, is that which lies between a curve and its tangent." Ibid., 9. In this question of divisibility, the last division recedes beyond our reach. There can be no atomism without curves, and no curve without a tangent, and no tangent without a minimal angle. The first angle was called by Euclid *clisis*, "inclination." The first differential division appears thus with atomist physics, with Democritus, the Pythagoras of things, the first integrator or calculator who thought that things are formed of "a crowd of subliminal atoms." Ibid., 10.

7. More precisely, calculus is the branch of mathematics that finds the instantaneous rate at which one quantity changes with respect to another (a function derivative of another function). For example, in a body's movement equation, one function, time, is a curve. The rate of change of the other function, the position, with respect to this curve is calculated through the slope of the tangent to the function, an approximating segment whose length is made to approach the limit of zero to derive the instantaneous rate of change. Various experiments deployed this calculus, transforming physics (the studying of the action of forces on the moving body) into mathematical formulas. The formulas are still used in contemporary digital algorithms to interpolate the in-between of movement in animation software. Drawing an analogy to a falling cat observed by Marey, Volterra and other mathematical physicists asked: "Can our Earth change its orientation in space by means of internal motion, just as every other living being?" Giuseppe Peano quoted in J. Goodstein, *The Volterra Chronicles: The Life and Times of an Extraordinary Mathematician 1860–1940* (Providence: American Mathematical Society, 2007), 93. Technically speaking, the formulation of calculus comes to the following principle: that it is possible to determine the speed of a moving body at a particular instant of time, by calculating the instantaneous rate of change of its position with respect to time:

8. A relation between two points is the differential of two discontinuous functions. The function therefore does not satisfy continuity but discontinuity, or the multiplicity of singular points, a singularity being the pole of the function, or its limit point. It is generally believed that these differentials can only be given as vague approximations: already for Leibniz, infinity cannot be construed quantitatively, but only through approximations.

9. Gilles Deleuze, *The Fold: Leibniz and the Baroque* (London: Continuum, 2006), 24.

10. Ibid., 52.

11. Alfred North Whitehead, *Process and Reality* (New York: Free Press, 1985), 29.

12. Paul Kaiser, "Steps," available at http://openendedgroup.com/index.php/publications/older-essays/steps/ (last accessed March 29, 2012).

13. The affirmation of incompleteness and incomputability does not simply apply to physical realities, but to mathematical facts as well. An example of these facts is a diophantine equation, "an algebraic equation in which everything, the constants as well as the unknowns, has got to be an integer." Gregory Chaitin, *Meta Math! The Quest for Omega* (New York: Vintage, 2005), 37. It is impossible to find an algorithm for determining whether this equation can be solved, "an algorithm to decide if there is a bunch of whole numbers that you can plug into the unknowns and satisfy the equation. Note that if there is a solution, it can eventually be found by systematically plugging into the unknowns all the possible whole-number values, starting with small numbers and gradually working your way up. The problem is to decide when to give up." Ibid. This affirmation allows Chaitin to transfer Cantor's mathematical theorem of infinity, or incompleteness, into information science, along a unique principle of incomputability that characterizes all mathematical objects. In this conception, Chaitin also refers to Turing's halting problem, according to which there is no algorithm for deciding if a computer program will never halt.

14. This is the image of a *recursively enumerable* or a *computably enumerable* set generated by an algorithm. Associated with the introduction of Cantor's set theory, topology, for example, explains how there can be infinitely many possible sizes for infinite series (in this case, discontinuity flows into continuity).

15. Defined by Brian Massumi as the science of self-varying deformation (one topological form only being the deformation of another, the two being the different actualizations of the same hyperform), topology is the schema of a paradoxical vision that can be exercised, or performed, on all material (and therefore physical, cultural, even technical) events. Brian Massumi, *Parables for the Virtual: Movement, Affect, Sensation* (Durham: Duke University Press, 2002), 134. The manifold is, for example, a topological model that represents the state space of a physical system, or its range of possible behaviors (or degrees of freedom), in which every spatiotemporal point corresponds to an actual state of the system. In this way, topological analy-

sis maps the distribution of singularities, or points, where the movement function changes direction (*bifurcators*).

16. In topology, one loop (or one progressive set of transformations) deforms into another, and different classes or groups of loops are identified with a continuous function. Relations and homeomorphisms (or reciprocal deformations) between groups are calculated by mapping them with algebraic connections.

17. A return of what stays the same across differences, rather than a return of difference itself (as Deleuze, after Nietzsche, would put it).

18. "Continuity," for Leibniz, is a property of those objects whose extrema are one and the same, whereas "contiguity" is a property of those objects whose extrema simply are together. Mutation, intended as a common, in-between state of continuity, is impossible. Gottfried Leibniz, *Dialoghi filosofici e scientifici* (Milan: Bompiani, 2007), 415.

19. The topological distinction between actual deformations and virtual invariants can be the basis of an immanent philosophy in which experience does not find itself detached from the mental, or the world of ideas: ideas, in other words, are paradoxically defined by topology as the invariant objects of multiple variations.

20. Kaiser, "Steps."

21. When the torso has turned through some angle, the head whips around, suddenly absorbing some of the angular momentum, slowing the rate of turn of the rest of the body. In order to minimize this effect, the head must be kept on the rotational axis, where its moment of inertia is small. Kenneth Laws, *Physics and the Art of Dance: Understanding Movement* (New York: Oxford University Press, 2002), 67.

22. In order to stop, the feet return to the floor so as to increase friction, and the arms extend to slow down the remaining angular momentum. Ibid.

23. In other words, every line (or curve) is the path of a point that changes direction at an inflection (or folding) point. Geometrically speaking, inflection is the true atom, the elastic point, the (metaphysical) critical point where the radius jumps from inside to outside, and a curve feels itself. If, as Whitehead reminds us, Plato already identified the essence of existence with the capacity of being a factor in agency or, in other words, the capacity to make a difference, Deleuze operates a geometric transduction of this concept, and tells us how Paul Klee defined inflection as the genetic element of the active line, or what makes a difference in a curve: the point-fold as the object of differential calculus and, in its developments, of topology. Deleuze, *The Fold*, 15. Mathematically speaking, the differential quantity is a relational limit between two quantities that vary in relation to each other. As a sum or a multiplication of these quantities, movement ceases to be homogeneous and immutable and appears as a heterogeneous and shifting multiplicity of infinitesimal changes.

24. Differential geometry allows us to calculate the inflection points that distinguish, or differentiate, what changes from what stays the same between two transformational events: between two ways of drawing a line, between two ways of moving alongside it, an inflection point is the liminal factor that generates the curves and folds of topological deformations, offering an explanation for their morphological differences.

25. Mathematically speaking, the differential inflection is a relational limit between two quantities that vary in relation to each other. In the differential function, the inflection acts as the limit between what is changeable and what is unchangeable.

26. On the subject of mereotopology, see Edmund Husserl, *Logical Investigations* (London: Routledge, 2003), and also Whitehead, "The Theory of Extension," in *Process and Reality*, 281–333.

27. See Barry Smith, "Mereotopology: A Theory of Parts and Boundaries," *Data and Knowledge Engineering* 20 (1996): 287–303.

28. The basic principles of parthood (P) are: (1) reflexivity (everything is part of itself), (2) antisymmetry (two distinct things cannot be part of each other), (3) transitivity (any part of a part of a thing is itself part of that thing). The basic principles of connection (C) are: (4) reflexivity of connection (everything is connected to itself), (5) symmetry (if a thing is connected to a second thing, the second is connected to the first), (6) monotonicity (any thing is connected to any thing to which its parts are connected). In Whitehead's version of the theory, the primitive, most fundamental element is considered to be that of *connection*: the connected parts are defined by their connections and do not preexist them. In this sense, the mereological and topological components of Whitehead's system cannot be separated, because connection is what always comes first. This is the main, basic question addressed in all mereotopological studies: the predominance of the relations or of the parts (of the topological or the mereological).

29. The entities of mereotopology are abstractive sets topologically composed of an infinite number of members, but their possible extensive relations are universally and systematically schematized according to principles of coordinate division and extensive connection involving qualities in inclusive or exclusive relations of whole and part. After the Einsteinian theory (partly embraced by Whitehead), all events were mathematically conceived as being actually atomic, or instantaneous, and inserted in discontinuous series based on relations of inclusion/exclusion as their main binary possibility. At the same time, topological notions of contact and overlapping describe the connective relations and the potential un/sticking between the durational regions of different events. This double morphology explains the coexistence of process philosophy with atomism, a coexistence flowing into the possible association of Whitehead's mereotopology with Euclidean and Cartesian mathematics (following, for example, the Euclidean definition of a point as "that which is without parts"), but also with Bernhard Riemann's differential geometry.

30. R. Kopperman, M. Smyth, and D. Spreen, "Topology in Computer Science: Constructivity; Asymmetry and Partiality; Digitization," available at http://www.dagstuhl .de/de/programm/kalender/semhp/?semnr=00231 (last accessed April 3, 2012).

31. Whitehead, *Process and Reality*, 32.

32. While Whitehead's concept of ideas is inherently Platonic, the way in which they form a systematic structure resonates with a Kantian category: "No actual entity," Whitehead says, "can rise beyond what the actual world as a datum from its standpoint—its actual world—allows it to be . . . the basis of its experience is 'given.'" Ibid., 83. "Thus every definite total phase of 'givenness' involves a reference to that specific 'order' which is its dominant ideal, and involves the specific 'disorder' due to its inclusion of 'given' components which exclude the attainment of the full ideal. The attainment is partial, and thus there is 'disorder'; but there is some attainment, and thus there is some 'order.' There is not just one ideal 'order' which all actual entities should attain and fail to attain. In each case there is an ideal peculiar to each particular actual entity. . . . The notion of a dominant ideal peculiar to each actual entity is Platonic." Ibid., 83–84.

33. Frequent and unexpected changes of direction characterize Cunningham's style, together with the use of geometrical poses, shape contractions and teetering, and off-kilter movements. The body system is divided into independent tracks: legs, arms, torso, head. On the other hand, according to Bill T. Jones, "Undulation, quivering— . . . micro-isolations are . . . the real and deep juice of dance. That's why dance feels sensuous, that's why it can . . . talk about the wave-like nature of thought and motion. And I think thoughts and motions do come in waves. Even though it may be that a motion feels abrupt and staccato, the way it courses through the body is like a wave or even a smaller particle of a wave." (1998, Cooper Union Gallery sessions.)

34. Kaiser, "Steps."

35. For a technical explanation, see Paul Kaiser, "On Motion Mapping," in Mike Silver and Diana Balmori, eds., *Mapping in the Age of Digital Media* (Chichester: Wiley Academy, 2003), 80–91.

Chapter 100

1. *Synchronous Objects* website, available at http://synchronousobjects.osu.edu/ content.html (last accessed March 29, 2012).

2. Sylvia Staude and William Forsythe, "I Can Dance Again: Sylvia Staude Interviews Frankfurt-Based Choreographer William Forsythe," available at http://www.signand sight.com/features/119.html (last accessed March 27, 2012).

3. William Forsythe and Norah Zuniga Shaw, "Introduction: The Dance," available at http://synchronousobjects.osu.edu/blog/introductory-essays-for-synchronous -objects/ (last accessed March 27, 2012).

4. More specifically, the visualization of the dance data was obtained by the anima- tors by tracking a point on each dancer in the top and front views of the ortho- graphic source video. By combining the coordinates from both views, a 3D data point could be obtained for each dancer's location at every moment of the dance. Location coordinates of all the dancers were thus generated and expressed as values on x, y, and z axes. The corresponding series of coordinates were keyframed through the After Effects software. Another software, File Maker, was used to pull out the data from the database in the needed way, and to interpret it in computer anima- tions, information graphics, and annotated video. In this sense, the website has been defined as a kind of generative tool, for its capacity "to generate new creativity in fields different from its own." Norah Zuniga Shaw, interviewed by the author.

5. For example, see the articles in the *Synchronous Objects* blog available at http:// synchronousobjects.osu.edu/blog/?s=generative&x=0&y=0 (last accessed March 27, 2012).

6. In fields such as graphic or architectural design, "developments in scripting have opened the way to algorithmic design processes that allow complex forms to be grown from simple iterative methods while preserving specified qualities." Michael Meredith, introduction to Tomoko Sakamoto, Albert Ferré, and Michael Kubo, eds., *From Control to Design: Parametric/Algorithmic Architecture* (Barcelona: Actar, 2008), 3. Adopting generative software in architectural design, it is possible, for example, to imagine a whole human body moving in space and then replace it with a single joint: this technique is used to understand how the unit relates differentially to the whole building across a series of frames. In parametric design, this differential rela- tion between variables is computationally processed by reducing it to the binary code, but at the same time by exposing code itself to a whole variable environment. Generative and parametric tools are usually used in architecture to map and manip- ulate the variables of a geometric form into a tuned formal solution: calculating every parameter as the algorithmic evolution of a point in space-time, and then relating multiple parameters among themselves (the movement of a body in space, for example, but also the progressive changes of building materials, the weather, economic and geographic factors, etc.).

7. Norah Zuniga Shaw's comment to the blog post "Laban and Dance History in relation to Synch/O: Student Perspectives," available at http://synchronousobjects .osu.edu/blog/2009/05/synco-laban-and-dance-history-student-perspectives/ (last ac- cessed March 27, 2012).

8. As Michael Meredith clearly explains, "The advantage of the parametric project is not the 'relentless malleability of form . . . but the complex . . . relationships that produce architecture.'" Michael Meredith quoted in Beth Weinstein, "Performative

Opportunities within the Parametric," paper presented at the SEAM2009 Symposium: Spatial Phrases, Critical Path and the Centre for Contemporary Design Practices, University of Technology, Sydney, in association with University of Hertfordshire, U.K., September 7–20, 2009.

9. Forsythe quoted in Erin Manning, *Relationscapes: Movement, Art, Philosophy* (Cambridge, MA: MIT Press, 2009), 14. The initiations and reactions occurring within the body are simultaneous and inextricably linked. According to Shaw, the key to understanding how to dance Forsythe's choreography therefore lies in figuring out which points on the body are initiating movement and which are responding to the initiation. This inner response, which is also defined by the dancers as "residual movement," is like a motion refraction, or the bouncing of a light ray between surfaces. Dana Caspersen quoted in Norah Zuniga Shaw's post in the [-empyre-] mailing list, May 18, 2009, available at http://www.mail-archive.com/empyre@lists.cofa .unsw.edu.au/msg00807 (last accessed March 27, 2012).

10. Meredith, in Sakamoto, Ferré, and Kubo, *From Control to Design*, 121. Design, in other words, no longer works in a linearly evolving fashion but in a complexly emerging one, by establishing relations between relations, and then by linearly extracting, or abstracting, the preemptive variations of an object. According to Mark Goulthorpe, "The base mathematic logic of digital systems would seem to now underpin our base mnemonic 'technology' with an implicitly parametric sense, where re-calculable variability and inter-relational linkage become the norm." Mark Goulthorpe, blog post "On Forsythe and Architecture," available at http://synchro nousobjects.osu.edu/blog/2009/03/mark-goulthorpe-on-forsythe-and-architecture/ (last accessed March 27, 2012). The complexity of this process allows designers to build up not only a model but a conceptual structure to guide the variations.

11. Through the causal efficacy of the algorithm, an idea is actualized as a datum, translated into discrete pulses/units, and then made to follow a logical processual line from past to present.

12. "A new generation of parametric design systems establishes models defined by a collection of constrained relationships between objects." Meredith, in Sakamoto, Ferré, and Kubo, *From Control to Design*, 118.

13. Erin Manning, "The Art of Time," in the catalog of the 2012 Sydney Biennale (forthcoming), 2.

14. Alfred North Whitehead, *Process and Reality* (New York: Free Press, 1985), 29.

15. Manning, "The Art of Time," 4.

16. Alfred North Whitehead, *Modes of Thought* (New York: Free Press, 1968), 88.

17. Steven Shaviro, "Interstitial Life: Subtractive Vitalism in Whitehead and Deleuze," *Deleuze Studies* 4, no. 1 (2010): 109.

18. Erin Manning, *Always More Than One: Individuation's Dance* (Durham: Duke University Press, 2012), 12.

19. Shaviro, "Interstitial Life," 113. The conceptual prehension of ideas corresponds to a valuation of possibilities for change, like an energetic determination by which the data are preserved or discarded; this is a germ of mental activity residing even in the lower levels of matter and unexpectedly interrupting its repetitive codifications (for an electron, the possibility of a slight orbital variation would already coincide with the mental valuation of an idea).

20. For an example of how quantity can become a determinant element of differentiation, see Bridget Riley's paintings.

21. The Alignment Annotations object is available at http://synchronousobjects .osu.edu/content.html# (last accessed October 9, 2012).

22. Shaw, from the *Synchronous Objects* blog, available at http://synchronousobjects .osu.edu/blog/2012/02/sync-objects-installation-in-new-york-city/ (last accessed April 3, 2012).

23. See the Process Catalog for Alignment Annotations, available at http://synchro nousobjects.osu.edu/content.html# (last accessed October 9, 2012).

Part III

1. Gilles Deleuze, *Difference and Repetition* (London: Continuum, 2002), 141.

2. Ibid., 147.

3. Gilles Deleuze, "Che cos'è l'atto di creazione?," in *Che cos'è l'atto di creazione?* (Naples: Cronopio, 2003), 7–24.

4. As a molar entity of organization, the nondivisible unity of the number (the One) accompanies the fixed, unchanging condition of the static body caught in a particular state and rigidly moving from point to point, while using numbers to describe its displacements and quantify the space of its performance. The body/stage space becomes a homogeneous extension drawn with fixed coordinates and organized around an immanent center (for example, the body's center of gravity) and divisible into homologous parts with symmetrical reversible relations. See Gilles Deleuze and Félix Guattari, *A Thousand Plateaus: Capitalism and Schizophrenia* (London: Continuum, 2002), 380–389.

5. Merce Cunningham, "Space, Time and Dance," available at http://cosminmarc uletiu.blogspot.it/2009/03/merce-cunningham.html (last accessed March 28, 2012).

6. Ibid.

7. Deleuze and Guattari, *A Thousand Plateaus*, 388–389.

8. Ibid., 389–390.

9. Abscissae and ordinates, or variables and constant limits, are examples of how science captures this infinity into precise coordinates.

10. On Cantor's conception of number, see Gilles Deleuze and Félix Guattari, *What Is Philosophy?* (London: Verso, 2003), 121.

11. The same conceptual metamorphosis applies, in Deleuze and Guattari's philosophy, to functions such as the differential point of view on infinitesimal calculus, Poincaré's qualitative theory of differential equations, Mandelbrot's fractals, and Lautman's mathematical work.

12. This notion is derived from the geometric theory of analytic functions.

13. Simon Duffy, "Schizo-Math," *Angelaki* 9, no. 3 (2004): 213.

14. Ibid., 210.

15. Deleuze and Guattari, *A Thousand Plateaus*, 390.

16. John Miller Chernoff, *African Rhythm and African Sensibility: Aesthetics and Social Action in African Musical Idioms* (Chicago: University of Chicago Press, 1981).

17. Kleist's "On the Marionette Theater" is available at http://southerncrossreview .org/9/kleist.htm (last accessed March 28, 2012). See also Deleuze and Guattari, *A Thousand Plateaus*, 561 note 80.

Chapter 101

1. André Lepecki, "Introduction: The Political Ontology of Movement," in *Exhausting Dance* (London: Routledge, 2007), 1–18.

2. Roger Copeland, *Merce Cunningham: The Modernizing of Modern Dance* (London: Routledge, 2004), 41.

3. Ibid., 43.

4. Ibid., 45.

5. Merce Cunningham, "Torse: There Are No Fixed Points of Space," in Alexandra Carter, ed., *The Routledge Dance Studies Reader* (London: Routledge, 1998), 29.

6. José Gil, "The Dancer's Body," in Brian Massumi, *A Shock to Thought* (London: Routledge, 2003), 118.

7. In Cunningham's dance performances, the sound/movement relation was also numerically realized in the form of two distinctive, autonomous, and parallel series indirectly connected and without any linear stimulus-cause perceivable link. The sudden appearance of the chance-guided sound score was often pure technical noise for the dancers, a flow striking their perceptual apparatus and affecting performative

linearity. John Cage's sonic compositions accompanying Cunningham's performances were often very rarefied, almost silent, but they could also become suddenly loud and aggressive, making it extremely difficult for the dancers to execute complicated rhythmic counts without having their concentration interrupted by random eruptions of sound (often introduced into the performance only during the last rehearsal, and therefore totally unexpected and unknown). As John Cage remarks, the idea of an independent relation between music and dance comes from the Indian dance tradition, which is based on simple structure points around which music and dance are improvised; the same idea was also developed in the Middle Ages by various studies on rhythm. In Cage and Cunningham's experiments, it is the use of magnetic tape that first allows the relation between space and time to become evident: by visualizing time structure (which is something that both forms of expression have in common), the relation is therefore made evident.

8. Alfred North Whitehead, "Mathematics in the History of Thought," available at http://www-groups.dcs.st-and.ac.uk/%7Ehistory/Extras/Whitehead_maths_thought .html (last accessed March 26, 2012).

9. See John Cage, *Silence: Lectures and Writings* (Middletown, CT: Wesleyan University Press, 1973).

10. Alfred North Whitehead, *An Introduction to Mathematics* (Melbourne: Rough Draft Publisher, 2007), 13. From Whitehead's point of view, the configuration of abstract things in abstract space at different abstract times (in resonance, for example, with Laban's own definition of choreutics in relation to dance) is nothing other than a mechanical and, consequently, an arithmetical operation.

11. Merce Cunningham, *Changes: Notes on Choreography* (New York: Something Else Press, 1969).

12. Ibid., 70.

13. Deleuze and Guattari's concept of a spatiotemporal bloc of sensations is the subject of note 14 of chapter 0.

14. Gilles Deleuze, *Cinema 1: The Movement-Image* (London: Continuum, 2005), 7.

15. Gilles Deleuze and Félix Guattari, *What Is Philosophy?* (London: Verso, 2003), 195.

16. The vision of a continuous motion emerges from Forsythe's affirmation that "You don't start dancing. You dance." Forsythe, interview with John Tusa, available at http://www.bbc.co.uk/radio3/johntusainterview/forsythe_transcript.shtml (last accessed March 29, 2012).

17. Alfred North Whitehead, *Process and Reality* (New York: Free Press, 1985), 228.

18. Ibid.

19. Benjamin H. D. Buchloh, "The Diagram and the Colour Chip: Gerhard Richter's 4900 Colours," in Melissa Larner, Rebecca Morrill, and Sam Phillips, eds., *Gerhard Richter: 4900 Colours* (Ostfildern: Hatje Cantz Verlag, 2008), 66.

20. Ibid., 67.

21. James York quoted in Copeland, *Merce Cunningham*, 109.

22. Carolyn Brown quoted in Copeland, *Merce Cunningham*, 149.

23. In particular, see Whitehead, "The Abstract Nature of Mathematics," in *An Introduction to Mathematics*, 7–14, and also Granville C. Henry and Robert J. Valenza, "Whitehead's Early Philosophy of Mathematics," available at http://www.religion -online.org/showarticle.asp?title=2850 (last accessed April 3, 2012).

24. Whitehead, *Process and Reality*, 24.

25. Ibid., 67.

26. Copeland, *Merce Cunningham*, 154.

27. Matthew Fuller, *Software Studies: A Lexicon* (Cambridge, MA: MIT Press, 2008), 2.

28. Ibid., 6.

29. Ibid.

30. See the abstract of Adrian Mackenzie's paper "Believing in and Desiring Data: 'R' as the Next 'Big Thing,'" available at http://jussiparikka.net/category/new-material ism/page/2/ (last accessed April 3, 2012). The reference here is to the concept, expressed by Cunningham, of a necessary indifference to be maintained in a world of continuous sensorial and informational bombardment. Rather than denoting political inertia, this strategy was in fact adopted by the artist as the only efficacious way to avoid one's own voice, or message, being lost in the ocean of messages of various nature circulating in the media world. If conveying a message appears as a way to contribute to the deafening and dumbing chorus, simply resisting and offering an example of dedication to art and aesthetics is the only counterpractice one can really offer. See Copeland, "From Graham to Cunningham. An Unsentimental Education," in *Merce Cunningham*, 25–51.

31. Matthew Fuller, *Behind the Blip: Essays on the Culture of Software* (New York: Autonomedia, 2003), 11.

32. Copeland, *Merce Cunningham*, 35.

33. Ibid., 42.

Chapter 110

1. See http://openendedgroup.com/artworks/loops.html (last accessed October 4, 2012).

2. See http://openendedgroup.com/artworks/loops_culture.html (last accessed October 4, 2012).

3. Matthew Fuller, *Media Ecologies: Materialist Energies in Art and Technoculture* (Cambridge, MA: MIT Press, 2005), 1. See also Fuller's detailed etymology of "media ecology," and the illustration of the three main senses of the word: as information management, as technologically determined environmentalism, and as the interactive, code-based analysis of cultural processes.

4. Fuller, *Media Ecologies*, 102.

5. Information on the software is available at http://openendedgroup.com/field (last accessed March 28, 2012). A more detailed explanation of the philosophy behind the software is also given in Marc Downie's article "Field: A New Environment for Making Digital Art," available at http://openendedgroup.com/index.php/publications/ (last accessed April 3, 2012).

6. This notion originally assumed importance in algebra, in the familiar letters such as x, y, and z, indicating any numbers.

7. Barry Smith, "Mereotopology: A Theory of Parts and Boundaries," *Data and Knowledge Engineering* 20 (1996): 286.

8. For Hegel's conception, and its relation to Spinoza's notion of the infinite, see Simon Duffy, "The Differential Point of View of the Infinitesimal Calculus in Spinoza, Leibniz and Deleuze," *Journal of the British Society for Phenomenology* 37, no. 3 (October 2006): 286–307.

9. This idea marks the basic difference between Whitehead and Russell's *Principia Mathematica* and the later philosophy Whitehead expounded in *Process and Reality*.

10. These two visions are respectively represented by Hilbert's formalism and Kurt Gödel's Incompleteness Theorem.

11. For many physicists in the field of quantum mechanics, physical systems can in fact only contain a finite number of bits of information, and this number only grows according to the surface area of the system.

12. From this point of view, many mathematical facts and theories cannot be proven and can only be taken as axioms, such as with the theory of the infinity of primes.

13. In this sense, Chaitin's theory of Omega also looks like the direct transposition, in the field of informatics, of Gödel's Incompleteness Theorem, according to which any finite system of mathematical axioms is in fact always incomplete. At the basis of this idea is the necessity to define a kind of logical, mathematical, or structural randomness, as opposed to the physical randomness that is the essential character of quantum physics.

14. Technically, since there is no start or stop button and no compile cycle, it is possible to execute, script, sequence, and manipulate code as Field's integrated Processing Applet runs.

15. "The discrimination of detail is definitely a secondary process, which may or may not assume importance. There is the germ of discrimination, which may or may not flower into a varied experience. The dim decision is a large-scale judgment—namely, avoidance or maintenance. The stage of analysis into details, of which some are to be discarded, others are to be maintained, has not arrived." Alfred North Whitehead, *Modes of Thought* (New York: Free Press, 1968), 110.

16. Alfred North Whitehead, *Process and Reality* (New York: Free Press, 1985), 239.

17. Ibid., 214.

18. Ibid., 212.

19. Ibid.

20. Ibid., 240.

21. Differently from Deleuze and Guattari's continuous line of variation (and . . . and . . . and . . . , this and that). See Gilles Deleuze and Félix Guattari, *A Thousand Plateaus: Capitalism and Schizophrenia* (London: Continuum, 2002), 98.

22. A description of the choreography is also available at http://openendedgroup .com/artworks/loops.html (last accessed March 30, 2012).

23. Whitehead, *Process and Reality*, 240.

A Germ of Conclusion

1. Alfred North Whitehead, *Modes of Thought* (New York: Free Press, 1968), 21.

2. Alfred North Whitehead, *Process and Reality* (New York: Free Press, 1985), 55.

3. Whitehead quoted in Jude Jones, "Provocative Expression: Transitions in and from Metaphysics in Whitehead's Later Work," paper given at the Beyond Metaphysics conference, December 2008, available at https://docs.google.com/viewer?a= v&q=cache:bNd1wQGwZa8J:whiteheadresearch.org/occasions/conferences/beyond -metaphysics/papers/JonesJ-Provocative%2520Expression.pdf+whitehead,+the+infi nite+has+no+properties&hl=it&gl=it&pid=bl&srcid=ADGEEShI8byypPQPKREZrzqe9 S-KUINU-pxJiTN0_8YGajh5kgLvneA7dXxCc0JapfEIJLXD6zRvM28RQN6MXsQD2x 5f861RZgdCdouoBZ0gyr0CJEVGa1XJgnDUjMcSTuB3XlEhYcq2&sig=AHIEtbTnmiH xIXXzBI8XI8TUv7oAanpWuA (last accessed April 3, 2012).

4. Whitehead, *Process and Reality*, 108.

5. Ibid., 149.

6. This conclusion was imagined as a dialogue with William Forsythe's essay "Choreographic Objects," available at http://synchronousobjects.osu.edu/media/inside .php?p=essay (last accessed March 28, 2012).

7. See http://synchronousobjects.osu.edu/media/inside.php?p=essay (last accessed October 15, 2012).

Index